Studies of the Americas

edited by

Maxine Molyneux

Institute of the Americas
University College London

Titles in this series include cross-disciplinary and comparative research on the United States, Latin America, the Caribbean, and Canada, particularly in the areas of politics, economics, history, anthropology, sociology, development, gender, social policy, and the environment. The series publishes edited collections, which allow exploration of a topic from several different disciplinary angles by eminent scholars, and book-length studies, which provide a deeper focus on a single topic.

Titles in this series published by Palgrave Macmillan:

Cuba's Military 1990–2005: Revolutionary Soldiers during Counter-Revolutionary Times
By Hal Klepak

The Judicialization of Politics in Latin America
Edited by Rachel Sieder, Line Schjolden, and Alan Angell

Latin America: A New Interpretation
By Laurence Whitehead

Appropriation as Practice: Art and Identity in Argentina
By Arnd Schneider

America and Enlightenment Constitutionalism
Edited by Gary L. McDowell and Johnathan O'Neill

Vargas and Brazil: New Perspectives
Edited by Jens R. Hentschke

When Was Latin America Modern?
Edited by Nicola Miller and Stephen Hart

Debating Cuban Exceptionalism
Edited by Bert Hoffman and Laurence Whitehead

Caribbean Land and Development Revisited
Edited by Jean Besson and Janet Momsen

Cultures of the Lusophone Black Atlantic
Edited by Nancy Priscilla Naro, Roger Sansi-Roca, and David H. Treece

Democratization, Development, and Legality: Chile, 1831–1973
By Julio Faundez

The Hispanic World and American Intellectual Life, 1820–1880
By Iván Jaksić

The Role of Mexico's Plural in Latin American Literary and Political Culture: From Tlatelolco to the "Philanthropic Ogre"
By John King

Faith and Impiety in Revolutionary Mexico
Edited by Matthew Butler

Aesthetics and Politics in the Mexican Film Industry

Misha MacLaird

Contents

Illustrations

Acknowledgments

For serving as invaluable founts of information and ideas, thanks to Nahún Calleros, Gloria Reverte, Víctor Ugalde, and Blas Valdéz. Nourishment, shelter, and encouragement generously offered by Sergio de la Mora, Yuri Herrera, Patricia Méndez, Fionn Petch, Meg Stalcup, Lise Thogersen, Rosario Vázquez, and Peter and Bonnie MacLaird. Thanks to my academic advisors Ana M. López, Tatjana Pavlovich, José Rabasa, and Dolores M. Tierney. Special thanks to Sadie Ray and Dolores Tierney for their insightful comments on the manuscript.

Research contacts in Mexico: Jorge Ayala Blanco, Pablo Bashkt, Carlos Bolado, Carlos Bonfil, Nelson Carro, Armando Casas, Mariana Cerrilla, Alberto Cortés, Maribel Cristobal, Ricardo Ehrsam, Alexis Fridman, Antonio Helguera, Beto López, Mineko Mori, Inna Payán, Francisco Peredo Castro, Claudia Prado, Luz María Reyes, José Alberto Rodríguez, María Inés Roqué, Érica Sánchez, Jorge Sánchez, Ana Solares, Carlos Taibo, Kyzza Terrazas, Iván Trujillo, Christian Valdelievre, Filmoteca de la UNAM, Cineteca Nacional Centro de Documentación, and IMCINE.

The original research in Mexico City was made possible by a Fulbright-Hays Doctoral Dissertation Research Award (2006–7), with additional funding from the State of Louisiana Board of Regents (2008). Thanks to Tulane University's Department of Spanish and Portuguese, The Stone Center for Latin American Studies, and the School of Liberal Arts and Sciences.

Many thanks to the editorial team at Palgrave Macmillan, especially editorial director Farideh Koohi-Kamali and series editor Maxine Molyneux.

So much gratitude to all of my variations on parents, siblings, cousins, and nieces/nephews for being such a loving, supportive, and patient family.

In memory of Gustavo Montiel Pagés, mentor to several generations of filmmakers in Mexico; and Janice Stalcup, whose inexhaustible generosity continues to inspire.

Introduction

Una época fatal: An Era of Fatality, Tragic Endings, and New Beginnings

In a certain way we could say that [Mexican political culture's entrance into the world of Western democracy] is already a fait accompli: *the conquest, the war for independence and the revolution have already integrated the country into Western culture. Yet that integration produced a revolutionary nationalism that attempted to exalt Mexican culture but instead led it into an implicit acceptance of its semi-Western condition, stained by its officious mixtures, doublings, and twists. What is bleeding out of this wound is the heart of darkness of Mexican culture: the mythical and primeval core whose beating is about to cease.*

—Roger Bartra[1]

Film critic Jorge Ayala Blanco writes, "In Mexico, there no longer exists a film industry, only the remains. NAFTA delivered its coup de grâce" (cited in de la Vega Membrillo 2009).[2] A common response to an inquiry on Mexico's current film industry is, "What industry?" Many consider what exists today to be a specter of its old self and its participants often express nostalgia for what "film industry" meant in Mexico six decades ago. Since the economic changes made in the late 1980s and early 1990s that opened Mexico's industries to trade liberalization, the cinema that was once considered intrinsic to its nationalistic cultural production has been subsumed into a market in which it exists almost exclusively as a marginal genre among Hollywood action films and romantic comedies. But this notion of a contemporary cinematic void does not account for the ongoing critical and box-office successes, domestically and internationally. Like the 2000 presidential elections, a wave of fin de siècle films carried with it the

hopefulness for the industry's rebirth and a drastic change in film-making policy and practice. The entirety of commercial-film production[3] throughout the presidential terms of Ernesto Zedillo Ponce de León (1994–2000) and Vicente Fox Quesada (2000–2006)—the two *sexenios* (six-year political terms) falling on either side of this ephemeral millennial hubbub of cinematic and political renaissance—has been dubbed by film scholar Juan Carlos Vargas as "post-industrial cinema" (2005, 16). He offers the statement that "industry, understood as a dynamic structure that has an economic and artistic infrastructure in order to produce films in a continuous and sustained form, does not exist anymore," but concedes that the artistic talent that produces cinema persists, and concludes that Mexican cinema exists in the twenty-first century *despite* the lack of production infrastructure available to past generations of filmmakers.

The idea of a "post-industrial" era emphasizes the contradiction in the fact that Mexico's cinema received its widest global recognition at a moment when it was almost obsolete. At the same time, Mexican cinema's existence, the fact that films are indeed produced, is a small consolation next to the bigger issue, that the majority of it is not seen. The most substantial changes to Mexico's film industry since 1990 have been to its distribution and exhibition sectors, once state run and now in the hands of multinational corporations, and these changes to the exhibition infrastructure have shifted the film-going audience in Mexico to target a higher socioeconomic stratum. In order to survive, the newest generation of filmmakers has begun to address this new audience with different narrative and aesthetic content, while responding to the new rules of competition with different production models and marketing strategies. What we can observe, therefore, over the course of the past two decades, is the development process of a whole new national cinema.

The North American Free Trade Agreement (NAFTA)[4] was signed in 1994, in the last year of president Carlos Salinas de Gortari's administration, with specific impacts on audiovisual policy and a very broad impact on the social sphere. Although NAFTA was announced as a plan to bring Mexico into the so-called First World by merging its economy with that of its North American neighbor nations, for many critics this was simply laying out a welcome mat for Mexico to be reconquered by Anglo culture. These fears seemed to be confirmed when Salinas's preparations for NAFTA brought sweeping privatization, including both selling off major components of the film-industry infrastructure and allowing the sale of rights to *ejidos* (communal lands) established by the post-Revolutionary government's constitution. To quell criticisms that

the trade agreement would annihilate Mexican cultural traditions, the Salinas administration put forth a cultural program whose central component was the establishment of the Consejo Nacional para la Cultura y las Artes (National Council for Culture and the Arts, CONACULTA), which would administer the Fondo Nacional de Cultura y las Artes (National Fund for Culture and the Arts, FONCA). The most vociferous resistance—not just to these new economic policies, but also the notion that culture could be protected through bureaucratic support for the arts—came from Ejército Zapatista de Liberación Nacional (Zapatista Army of National Liberation, EZLN), who on the day of NAFTA's signing staged an uprising to announce a war against the Mexican government and ask for land rights and autonomous governance for the indigenous communities of Chiapas.

Roger Bartra, as cited in the first epigraph, finds the debates on neoimperialism somewhat moot. He contends that Mexico has long been an active participant in Western culture, but that the nationalism founded on clinging to "mythical and primeval" origins has perpetuated a duplicitous moral reaction regarding Mexico's ability or desire to keep up with global trends, an ideology that served the ruling powers in ignoring the country's uneven development while negotiating for its economic ascension into the world market. According to Bartra, the rhetoric of *mestizaje* that for most of the twentieth century was able to bind rural underdevelopment with urban modernity into a cohesive national identity lost its currency when the Zapatista uprising brought national and global attention to the indigenous communities of Chiapas. He sees the Zapatista uprising's ability to weaken the Mexican state's legitimacy as particularly unsettling for the majority of Mexicans in that it questioned the authoritarian institutional political culture precisely in the moment when cultural identity itself is threatened with oblivion (2002, 19). The result is a disavowal of the "semi-Western" identity label that had kept Mexican culture in a long-term limbo. He writes that the Chiapas uprising "has brought a great mass of Mexicans face-to-face with the possibility of leaving their assigned role as domesticated barbarians behind...With their abrupt intervention, they made it evident that the culture of duality has come to an end: the theater of the institutional revolutionary or semi-Oriental mestizo has openly gone bankrupt" (Bartra 2002, 20). Contrary to affirming that Mexican culture is dying, Bartra suggests that the shamefulness of being depicted by one's own nation as bastard children of Western culture is starting to dissipate; this process is what can more accurately be understood as the renaissance, or reincarnation, of Mexican cultural identity.

And yet in the aftermath of this apex, when the legitimacy of the state and the definition of culture are at once called into question, what can one possibly say about the responsibility of government agencies to protect cinema as national patrimony? This moment of rebirth, much like the unfinished democratic transition, has imbued cultural production with an inevitable ideological ambivalence, which is magnified both by the nature of cinema's already ambiguous standing as art and industry, and by the transition in cultural production from subvention to free-market practices. The debate over Mexico's cultural future, no matter how diametrically opposed its factions, is also full of ambiguity, contradiction, and even hypocrisy. The ambivalence toward modernization was already a key consideration in Salinas's plan for development and imbues the language of the era's cultural policy: "Culture can be valued as a terrain that does not escape the uncertainties and ambivalence that come with the end of this century, but also as the medium *par excellence* from which to express the human diversity of contemporary society" (Tovar y de Teresa 1994, 12). In much of the cinema of this period, the films, filmmakers, stories, and production methods embody this ideological grey area; that is to say, they *are* the transition.

Demarcating the Beginning and End of a Transition

A well-researched body of cinema is that produced in the early 1990s, during the Salinas administration and thanks in part to his plan for cultural development. This was a breakthrough moment for a handful of now world-renowned filmmakers, such as Alfonso Cuarón, Carlos Carrera, and Guillermo del Toro, and was especially notable for debuting women filmmakers, such as María Novaro, Busi Cortés, and Maryse Sistach. This short wave of attention was followed by one of the lowest points in Mexico's production at the beginning of the Zedillo administration, when much of the state's production and exhibition infrastructure had recently been sold off and the economic crisis kept the administration from providing the promised support for the cultural industries. But the latter part of this term witnessed a spurt of film entrepreneurialism, in which the private sector took on the role of producing culture, sometimes unwittingly. The success of this new formula prompted the Fox administration to propose privatizing what was left of the industry, which brought strong protests in the name of cultural protection. In 2006, in response to the growth in the exhibition market as well as to a decade of struggle by filmmakers to

protect national cinema, a new income-tax legislation to stimulate film production, Estímulo Fiscal a Proyectos de Inversión en la Producción Cinematográfica Nacional (Fiscal Stimulus on Projects for Investment in National Film Production, EFICINE 226), officially went into effect and brought more private investment into the industry.

The time period used to delimit this study was 1994–2006, coinciding with the presidential terms of Zedillo and Fox and with the aforementioned watershed moments for film policy. The basic difference between these two administrations pivots on the year 2000, which marked the political transition after 71 years from the Partido Revolucionario Institucional (Institutional Revolutionary Party, PRI) to the Partido Acción Nacional (National Action Party, PAN). It was also the year that one of Mexico's biggest-selling and most widely publicized films, *Amores perros* (*Love's a Bitch*, Alejandro González Iñárritu, 2000), was released, which suggested that the film industry was experiencing an equally monumental transition in passing into the new millennium. This book argues that the cinema and cinematic policy of the time period seen as Mexico's *democratic transition* is crucial for understanding the cultural climate of that period, as it highlights the ambiguities and contradictions of this political and economic shift. While the original objectives in framing my research within this time period was to consider historically the "before" and "after" of this moment of heightened spectacle, with the hopes of demystifying it, the start and end dates are also significant moments for considering cultural policy.

Using this timeframe as the primary period of focus is by no means meant to conclude that Mexico's transitional phase has concluded. According to political analyst Lorenzo Meyer, NAFTA has been an almost 20-year experiment in the effectiveness of free trade in "Americanizing" Mexico, and yet it was doomed to fail (evidenced in the immediate economic crises of the mid to late 1990s) precisely because it was a misapplication of "First-World" models to Mexico's particular economic circumstances without any effort to reform its traditional political practices or its institutional hierarchies. The inherent contradiction of its logic is embodied by the oxymoron in Salinas's plan for "social liberalism," as well as in Meyer's critical response to these policies in his ironically titled book, *Liberalismo autoritario* ("authoritarian liberalism") (1995, 18–23). The Chiapas uprising was only the beginning of a number of incidents that would further incriminate Salinas and his administration, to the point that Mexico's long tradition of presidentialism seemed ready for breaking. While this authoritarianism is what was to be ousted by democratic transition, the transition brought instead a redefinition of the polarities

of tension in Mexico's oxymoronic political–economic system: in the economic sphere NAFTA carried on Salinas's legacy well after he went into self-exile, effecting increasingly elitist policies dressed rhetorically as "freedom," and yet the economy plummeted; politically, when actual electoral reform was implemented under Zedillo in 2000, the freedom of choice offered by the first transparent election in decades ushered in a party of more conservative political and social values than its predecessor.

The height of the political transition between these administrations and the contradictory results of the economic policy throughout both has constructed an interesting public debate about whether the film industry should be fully privatized or subsidized. Questions of progress and paternalism arise, as well as critiques of the contrasting political models as either totalitarian socialism or exploitative neocolonial capitalism. Rather than engage in this debate, I examine the discourse itself, and study how this language circulates to create the myth that a single formula for a successful film industry exists. The same discourse hinges upon and reproduces a series of other ideals, for example that film can solve social injustices, through its ideological content, by either creating jobs, or in generating enough revenue to take the country out of debt. Or even further, that artistic expression can sway government policy, that telecommunications companies are destroying indigenous heritage, that art cinema is trying to keep culture in the hands of the bourgeoisie, that equal access to cineplexes would solve the problems of the poor, that action films are causing urban violence, and so on. The language used in the media, in film reviews, and in debates on NAFTA—using words such as innovative, pseudo-Hollywood, pseudoindie, politically correct, commercial, denouncing, exposing, censored, nationalistic, neorealist, neosensationalist, neocolonial, neoprotectionist, mediocre, mainstream, popular, populist, and so on—perpetuate a stance, whether conscious or not, toward a certain model of filmmaking, toward a set of values that impregnates a film with meaning and responsibilities beyond the actions projected on the screen. The films, film reviews, and press materials included in the research for this book illustrate the reactions of filmmakers to this great responsibility, some choosing to depoliticize their film publicly and others manipulating reactions to the film to generate controversy and publicity.

Researching a Cinema in Crisis

A conversation with a Mexican filmmaker about the industry's politics ended with him calling to my attention a tagline on the *Cinesecuencias*

news bulletin of the Instituto Mexicano de Cinematografía (Mexican Film Institute, IMCINE), a phrase that seems to mediate the tensions between the various expectations placed on cinema as art, as cultural–political expression, and as entertainment. The top of each bulletin reads, "*El cine no sirve para cambiar el mundo, sino a los que cambian el mundo*" ("Film cannot change the world, but can change those who change the world"). The words stand out as an interesting point of entry into film's importance as a medium of expression and film analysis's importance in attempting to hear what is being expressed. It demonstrates that IMCINE, a government agency for film production and dissemination, approaches cinema with a knowledge of its own role as a purveyor of audiovisual culture—something absent from nonstate film industries, such as Hollywood—and that it recognizes film's potential as a tool for societal transformation; and yet the institution cleverly expresses a restrained albeit optimistic sense of what any single production can aspire to. It reminds us that a film's meaning comes from its interpretation by spectators, and that reels of light-exposed, chemically treated plastic strips stored in metal canisters have little inherent power. In this sense, it also points to the major crisis in the current industry, that of distribution and exhibition. The fact that Mexico allows its industry to be dominated by multinational exhibition chains with primarily commercial interests has had the effect of stifling the polyphony of expression in its cinema. The imbalance in programming between domestic and Hollywood cinema leaves a wide gap between how much Mexican cinema is produced and how much is consumed, and poses the question of how to consider those films that do not reach the latter phase.

The body of this book, as film analysis, addresses the limited circulation of many of the films produced in Mexico, while at the same time recognizing it as a limiting factor in the research itself. The analyses presented in the following chapters are almost entirely focused on feature-length (more than 60 minutes) fiction films, rather than on short films or documentaries, precisely because the former category of work has the highest potential to be released in movie theaters and circulate commercially through video/DVD sales and rentals.[5] Taking the films as contributions to Mexico's body of cinematic production over two decades, they are considered here as texts that interact with the industry in various ways—such as through exhibition conditions and pricing, positive and negative media publicity, the support or the restrictions of government policy, and the endorsement or condemnation of the Catholic Church. Also considered is how these interactions affect spectators' interpretations of the films, including the

number and type of spectators who will see them. The research for this book, though limited in itself by the accessibility of the films,[6] was a concerted effort to view both the box-office hits and the films that received little attention from the media and had short theatrical runs, which, in Mexico, is the case of the majority of domestic films. While the lesser-seen films do not necessarily help gauge significant trends in what Mexican audiences want to see or how they react, they can be valuable when considering what a film's production plan proposed to do and what audience(s) it sought to attract. These projects often represent collaborations between key figures in the industry, such as editors, cinematographers, art directors, producers, writers, and actors, all of whom are perpetually seeking to better understand what makes cinema appealing, memorable, and/or successful. In the long process to produce these films, the tastes and production decisions of all of the collaborators were influenced by other audiovisual media in circulation at the time—nationally and globally—and, in turn, certainly had influence on projects that would follow.

One benefit of limiting this research to feature-length narratives was to be able to observe more clearly the intersection of commercial and artistic objectives in film production, particularly with regard to filmic representations of contemporary social and political issues and the attempt to draw domestic audiences who would identify with these representations. Noncommercial cinema operates within different constraints and can often allow itself to be much more overtly political or experimental without the same risk. Many of the analyses here, focusing on changes and emerging trends, consider the ways in which recent commercial cinema attempts to balance the values of art, politics, entertainment, and financial profit while renegotiating the boundaries of audience expectations in order to achieve the optimal combination of surprise and familiarity, to provoke excitement and a sense of advancement without alienating viewers.

Recognizing cinematic stories as traditional fictional genres also allows one to look closely at the changes in preestablished storytelling grammars, on both narrative and aesthetic levels. These various forms, in other historical and geographical contexts, have been tools in cultural movements and acts of resistance, as when comedy is used as a vehicle for political satire; melodrama as an emotional catharsis for complex social issues and to comment on shifting family values; or suspense, horror, or tragedy to confront collective anxieties. Variations on these narrative conventions or their visual language, to mold them to Mexico-specific contexts, reflect an alignment with certain ideological constructs that are prevalent in the media, for

example, how tragedies are structured to address class ascension, or how the documentary-style handheld camera produces a more visceral realism in fictional depictions of urban violence.

Within these parameters, the first three chapters of this book look closely at cultural policy, including specific film legislation. Many of these policies impact questions of spectatorship, as with the aforementioned issues of distribution and exhibition, with the ratings that restrict audiences of different ages based on the morality of human behavior depicted in films, and with the ways in which free trade has transformed the market to raise ticket prices and exclude a large part of the population from film audiences. In some instances, informal policies became visible as recurring but unwritten practices by authoritative agencies, such as indirect film censorship via financial cuts, or the mixed messages from the government to permit and at the same time condemn the sale of pirated DVDs. Some analyses address the very interaction of informal policy with film genre, for example, in looking at what types of films create a language that is threatening to censors or ratings boards.

It is important to note that between the time of this research and the publication of this book, documentary film production in Mexico has grown exponentially to the extent that a handful of feature documentaries have not only made it into commercial cinema circuits, but have also broken box-office records.[7] Also proliferating in Mexico are its film festivals, which serve as a big-screen showcase for short, documentary, and experimental cinema. Digital technology and new media have also allowed for new approaches to distribution, especially for alternative formats, although this is a transition in itself that has yet to come to full fruition. This book's conclusion addresses the integration of nonfiction features into commercial circuits and the new frontier for distribution.

Death and Tragedy, Beauty and Innovation

The title of this introduction plays on the double meaning of the word *fatal* in Spanish. In its most common meaning, *fatal* is used to express negative experiences, like a day when everything goes wrong, an unsuccessful blind date, or how you feel when you have the flu. In this sense, it conjures the attitude of many filmmakers toward the era of film production in Mexico since NAFTA went into effect: an exhausting rough patch. Its more literal sense refers to the oft-uttered statement that Mexican cinema "died" decades ago, and was "reborn" in recent years. Mexico's particular concept of and attitude toward death has been the

topic of endless treatises, including many films, and it continues to be a theme that is central to contemporary cinema. At the same time, recent Mexican cinema is heavy with a sense of *fatalism*, which serves to reveal the ideology of neoliberalism in two separate veins of its narrative and aesthetic content: in this time period we have a proliferation of violent tragedies depicting the lives of "predestined" characters of the lower classes who are unable to transcend their lived damnation, countered by an abundance of romantic comedies showing the upper classes as swiftly moving toward global citizenship by embracing the existential can-doisms of capitalistic entrepreneurship. While chapters 1 and 2 focus on the supposed death and rebirth of the film industry and its audiences in an era of trade liberalization, chapter 3 looks at how censorship policies inadvertently resuscitate the very films that they attempt to suffocate. Chapter 4 sees a link between the fatality/fatalism of tragic narratives and the new wave of aestheticized social realism. Chapters 5 and 6 look at how new models of film financing and storytelling are bringing new life to the industry. One of the objectives in this work was to produce complementary macro and micro readings of cultural production by including the broad influences of historical, political, and economic changes on media and cultural production in general, and on cinema in particular, while also taking textual examples of the films' content as illustrations of how these changes are reproduced in the collective imaginary through media.

This book is divided into two parts, the first of which looks at the political and economic policies carried out in recent years in Mexico, especially those with a specific impact on audiovisual production. Chapter 1 ("Industry and Policy") focuses on Mexican film production over the past two decades and within the context of the broader conditions of economic crisis and trade liberalization, such as changes implemented prior to NAFTA, as well as new film legislation in 1992, 1998, 2001, and 2006. It follows recent film-industry changes, from failed production stimulus plans and privatization attempts, to the 2006 legislation, which has successfully, if controversially, revitalized production. Chapter 2 ("Audiences and Target Markets") describes the transformation of the Mexican film audience brought by neoliberal policies, specifically a shift in spectatorship from the popular to the affluent class, due to new exhibition systems and exponentially higher ticket prices, with a strategic shift in film content to parallel its changing audience. It analyzes how the new production models worked synergistically with the multiplex exhibition system to create the blockbuster success of films such as *Sexo, pudor y lágrimas* (*Sex, Shame and Tears*, Antonio Serrano, 1999), *Todo el poder* (*Gimme the Power*, Fernando

Sariñana, 1999), *Amores perros*, and *Y tu mamá también* (Alfonso Cuarón, 2001),[8] revealing ideological similarities between these seemingly unrelated films. Chapter 3 ("Censorship and Sensationalism") considers film censorship as one of the most interesting intersections of politics, economics, and entertainment, particularly as it manifested during Mexico's democratic transition. It looks at different forms of censorship still in practice, carried out by authoritative bodies in definitive, coercive, or passive methods. After elaborating the history of the Catholic Church's control of moral censorship in Mexico, it considers contemporary censorship as a web of multidirectional prohibitive forces rather than a top-down model of repression, as well as the role prohibition and controversy play in box-office sales. It uses *La ley de Herodes* (*Herod's Law*, Luis Estrada, 1999) as a case to illustrate political censorship and *El crimen del padre Amaro* (*The Crime of Father Amaro*, Carlos Carrera, 2002) as a case to illustrate religious controversy.

The second half of the book focuses primarily on the aesthetic and narrative trends that developed over the course of the past two decades as a result of the new policies and production models discussed in the earlier chapters. Chapter 4 ("Hyperrealism and Violence") takes the most prevalent themes in contemporary cinema—violence and death—and follows the trajectory of narrative and aesthetic treatments of poverty and crime in recent cinema. It discusses the recurrence of fatalistic themes (especially around class ascension) and how they intertwine with the ambivalent intentionality of commercial cinema's hyperrealist visual techniques, in films such as *Amores perros*, *Piedras verdes* (*Green Stones*, Ángel Flores Torres, 2001), *Amar te duele* (*Love Hurts*, Fernando Sariñana, 2002), and *Perfume de violetas: nadie te oye* (*Violet Perfume: Nobody Is Listening*, Maryse Sistach, 1999). Chapter 5 ("Independence and Innovation") considers US independent cinema as an influence on film aesthetics and production models in Mexico. It elaborates the definition of *independent* in both the United States and Mexico, using the overlaps and divergences of the definitions to understand what binds an artist to economic influence and what recourse he or she has to achieve artistic freedom. This chapter considers *youth*—as both as a market and as spectators untainted by preconception—as an important tangent to innovation. It looks closely at how certain independent films explore the theme of sexual coming-of-age, as in the work of Fernando Eimbcke and Gerardo Naranjo. Chapter 6 ("Coproduction and Transnationalism") examines international coproduction as one of several models of transnational filmmaking that has emerged over the past 15 years as a response to some of the major problems faced by contemporary filmmakers, including the influence that this model has

over representations of national culture for international audiences. It looks at treaty coproductions, such as Maria Novaro's *Sin dejar huella* (*Without a Trace*, 2000) and Carlos Bolado's *Sólo Dios sabe* (*Only God Knows*, 2006), as films that address cultural identity in both the narrative and the production model. It also looks at the relationship between foreign-location productions and cultural labor as they relate to the neocolonial dynamic that has come under scrutiny as a problem in North–South funding paradigms. The conclusion discusses the most recent film productions and trends in Mexico, especially changes in the treatment of politics, national history, and violence in cinema.

While the six-year terms are easy markers of policy change to delimit eras of cultural production, one should not underestimate the impact of presidential elections on the social climate in subsequent years. All of the elections surrounding this period mark significant moments of hope and/or defeat for Mexican citizens wanting to participate in shaping their own futures, beginning with the very controversial election of Salinas in 1988, continuing with the assassination of presidential candidate Luis Donaldo Colosio in 1994, then the election reform and regime change of 2000, a near victory of the left and again controversial results followed by months of protest in 2006, and finally the PRI's return to power in 2012, again under controversial conditions. Regardless of the triumphant political party in each case, the questionable legitimacy of the electoral process not only nullifies the idea of democratic participation but also severely weakens the position of leadership of the declared victor.

Throughout these chapters, the idea of *ambivalence* continues to resurface in different forms. It can be read as an embodiment of a historical transition, its consequent tensions, and the attempts by individuals to reconcile recent changes. Without oversimplifying the application of this term, this book seeks to explore the contradictions inherent to the primary themes of each chapter: culture and policy, violence and aesthetics, censorship and publicity, innovation and imitation, and, finally, nationhood and transnationalism. Related to these readings of ambivalence, as well as to the time period used to frame the research, are the concepts of *hopefulness* and *disappointment* as contrasting attitudes toward the possibility of social transformation. An emotional pendulum—swinging between a sense of hope and agency and one of defeat, impotence, and illegitimate leadership—is likely a contributor to the aforementioned persistent ambivalence within both cinema and the film industry itself. As IMCINE's slogan suggests, cinema has the potential to encourage transformation via its spectators, but if the films themselves and the

spectators' level of participation in film culture are fraught with the same contradictions as the electoral process, then the cycle of disillusionment becomes self-perpetuating and frustrating. And yet, as I bring out in my conclusion, Mexican cinema since 2006 has begun to offer more direct and more daring critical responses to its political and social problems, which in itself offers hope for the future of free expression and social change.

From the Heart of Darkness to the Heart of Time

In Bartra's metaphor for the crisis of Mexican cultural identity, the literary allusion of an open wound that bleeds the nation's "heart of darkness" points to the horrific hypocrisies of colonialism buried deep in the jungle by the modern state. After discussing the impact of the uprising in Chiapas's Lacandon jungle, his essay[9] continues with an explanation of late twentieth-century Mexican political factions and their struggle to embrace truly democratic governance. As to idealize neither the Mexico's Mayan indigenous communities nor the EZLN's Marxist/Anarchist leaders as having resolved the issues of democracy, he describes the influence Spanish colonialism had on contemporary indigenous communities, especially their "normative systems...that govern violence and internal conflict" (2002, 28–29). The gesture of his critical analysis is first to dispel images of Mexico's marginalized cultures as either Edenic or quaintly barbaric, as celebratory institutional preservation would hope to embalm them. He sees that after these cultures' struggles to subsist and evolve through five hundred years of coexistence with other, often imposed, political structures, the traces of European authoritarianism and patriarchal oligarchies, as well as military hierarchies, are still prevalent in their normative systems. In this, he questions whether autonomy in the name of morals and traditional values should be implemented in lieu of the representational democracy sought on the national level.

The cover image of this book is taken from director Alberto Cortés's *Corazón del tiempo* (*Heart of Time*, 2009), a feature narrative that stands out among the cinematic productions in the past two decades as eloquently weaving together both the aesthetic and political concerns of the fin de siècle era, adeptly addressing the topics of democracy and cultural identity. Cortes's feature debut *Amor a la vuelta de la esquina* (*Love around the Corner*, 1986) is considered a precursor to the early 1990s New Wave, and he is now credited with making the first fiction film about the indigenous communities and Zapatista insurgents of Chiapas. *Corazón del tiempo*, made 15 years after the

uprising, depicts a time of relative peace but ongoing struggle in the region. Without dulcify daily life, Cortés employs the universalities of love, familial values, and communitarian ideals, rather than violence and suffering, to generate sympathetic characters. Through its script and production choices, the film at once pays homage to a region of Mexico rarely seen on the screen, empowers the community by allowing nonprofessional actors to reenact their own story, and also uses creative visual effects and narrative devices to nuance the subtexts around orality and visibility (see figure I.1).

As conveyed by the cover image, concerns around visibility are in constant tension in Zapatista territory, the desire for representational visibility as a people contrasting the need to veil individual identity under the threat of death or persecution brought by government surveillance (see figure I.2). *Corazón del tiempo*'s narrative touches on the issues of self-representation in politics while its production model speaks to self-representation in media. Segments of the film, in which crowds march with their faces covered in ski masks and bandanas, are in fact real footage of the struggles over land between the government and the communities. Here, the camera is pointed in multiple directions: the army identifying leaders of protests, the protesters

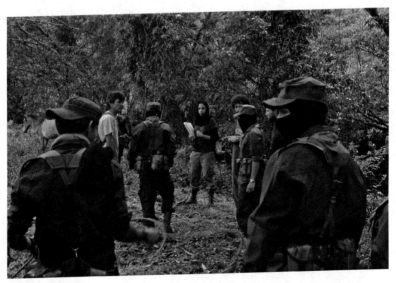

Figure I.1 Photo on the set of *Corazón del tiempo*, including director Alberto Cortés and actors from the village in the roles of Zapatista insurgents. Courtesy of Bataclán Cine.

documenting the military's abuse of power and force, and the film-makers documenting the exchange.

While drawing out the contradictions within the notion of visibility, the story also offers a critical perspective on the existing hierarchies in two groups that have been coexisting for several decades now—the civilians of a Tojolabal village and the Zapatista insurgents in the surrounding mountains—and shows how the two micropolitical systems

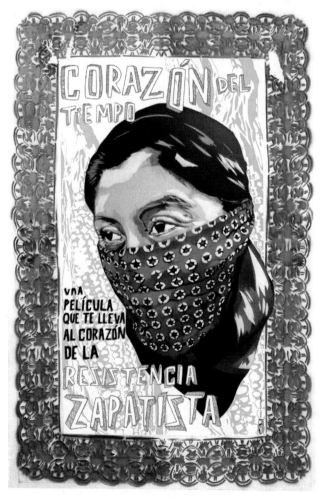

Figure I.2 Poster for *Corazón del tiempo*'s local distribution in Zapatista communities. Courtesy of Bataclán Cine.

attempt to negotiate their conflicts without losing sight of their common goal. By way of a budding clandestine romance between a young woman from the village and an insurgent, and with a particular thematic focus on the clash between progressive values around gender equality and patriarchal marital traditions, the film depicts how the people of this community continue daily to carry out their resistance to the state's repressive systems, to build their own autonomy, and to negotiate their own form of democracy, through trial and error (see figure I.3). Cortés wanted national audiences to witness this "'unknown social experiment' on whose 'success or failure' he believes the future of the nation will largely depend" ("'Corazón del tiempo' retrata" 2008).

Though a great number of documentary films have been made in solidarity with the Zapatista movement (including those made by Cortés himself), as a fiction feature film with an extended run in theaters, *Corazón del tiempo* was an anomaly within the cinema produced since the events of 1994, a challenge to the various mechanisms of formal and informal censorship.[10] And yet the message the film conveys is not simplistic. The story, in bringing to light the point that neither democracy nor culture are fixed but rather are constant negotiations by definition, exemplifies the very nature of culture that eludes the type of preservation sought by protectionist policy. Having spent many years shooting and screening films in

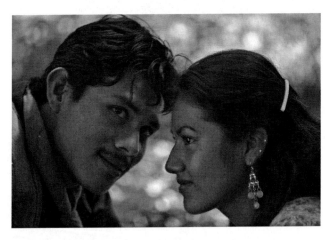

Figure I.3 Film still from *Corazón del tiempo*, a romance that also explores the democratic experiment of negotiating different normative systems, traditions, and values. Courtesy of Bataclán Cine.

Zapatista communities, the director feels that "Mexico's modernity lies there…It is an unprecedented social experiment in the middle of chaos, narcoviolence, and narcopolitics…And [yet] there you have hope" (cited in "Corazón del tiempo´ retrata" 2008). The film's mere existence and its thoughtful use of participatory storytelling and collective production methods convey the urgency of fostering a diversity of stories and styles in national cinemas, for the sake of historical truth and resisting oblivion.

Part I

The Politics of Transition

Chapter 1

Industry and Policy: Privatizing a National Cinema

In his 1994 *Modernización y política cultural*, CONACULTA director Rafael Tovar y de Teresa elaborates the Mexican government's plan to reform national cultural policy during the process of liberalizing its trade policy.

> Mexico has begun to employ a policy for modernizing its political, economic, and social structures…that avoids both the acritical acceptance of change for the sake of change and its rejection in the name of a supposed identity whose permanence could only be maintained in isolation. (13)

In this treatise on cultural production, following the cultural agenda of Carlos Salinas's 1989 Plan Nacional de Desarrollo (National Development Plan), Tovar y de Teresa's rhetoric couches the strategies for modernizing Mexico's cultural identity in language of moderation, promising neither to forge blindly ahead nor to let a stubborn adherence to tradition impede the nation from keeping pace with the rest of the world. Framing the move toward political, economic, and social modernization as a cautious and moderate decision offers a unifying—if ambivalent—platform to appeal to a broad constituency, while also naturalizing these policy changes as inevitable within the temporal currents of globalization. By leveraging a fear of "isolation" to critique traditionalist notions of *mexicanidad*, Tovar y de Teresa condemns at once antiquated representations of national identity and the economic models prevalent throughout Latin America in the latter half of the twentieth century, before the shift toward neoliberalism.

The doublespeak that coheres economic policy and cultural identity is emblematic of the public debates in Mexico throughout the

1980s and 1990s, as the administrations of Miguel de la Madrid and Carlos Salinas (who served as budget secretary under de la Madrid) prepared to enter into NAFTA. Opening up trade with the United States brought concerns of a new wave of cultural imperialism that would lead to the erasure of Mexican cultural traditions, an issue tied historically to the authoritarian reign of Porfirio Díaz (Meyer 1995, 31) and later the presidency of Miguel Alemán. There was also the more imminent fear that large multinational corporations would steamroll the small and medium business sector. CONACULTA proposed to remedy both situations at once: its foundational logic argued that Mexico's uniqueness made its cultural products exportable, which would be an asset to the national economy under free trade. At the same time, channeling this economic growth through an institution allowed the state to maintain a level of control over both the arts and media production. In reality, however, the terms of NAFTA limited the state's ability to intervene in cultural production. This chapter's retracing of Mexican film legislation over the past several decades throws into relief the state's struggle to negotiate changes in the industry that would conform to its new trade policy and still foster national production, a conundrum arising from the legal contradictions between national and supranational policies.

Audiovisual media in general, and cinema in particular, were central to NAFTA negotiations for both Canada and Mexico. Whereas Canada made sure that cultural goods and services were exempt from free-trade policy, the audiovisual industries in Mexico were in fact the main obstacle for such an agreement. The United States has seen Hollywood cinema as its most effective cultural ambassador since the first half of the twentieth century and its foreign markets make up roughly half of its revenue (Falicov 2008, 264). Of these markets, Mexico has the fifth-largest movie-going audience in the world and NAFTA allowed Hollywood's major studios greater access to that audience. From Mexico's perspective, NAFTA was an opportunity for its audiovisual industries to expand into the US Latino market with both film and television content (although only the latter has been done with much success) (Casas 2006, 75).

Mexico's preparations for NAFTA focused primarily on deregulation and privatization initiatives; two examples of action in this direction included selling off large film-industry assets and revising its film legislation in 1992 to reduce screen quotas and deregulate ticket prices. The most significant change overall was the privatization of exhibition and distribution, which changed the demographic of the Mexican spectator and subsequently—though with almost no

delay—the content of its cinema. After new production strategies and the changes in the exhibition system together generated a spurt of success for Mexican cinema, the state put forth several new initiatives to stimulate production, with varying reactions from its trade partners and from its own film industry.

While CONACULTA's injection of entrepreneurialism into cultural endeavors bolstered film production in the early 1990s, the number of films produced in Mexico plummeted to an all-time low of nine features by the middle of the decade. And yet by the late 1990s, a number of films premiered with record success in the box office and critical praise abroad, suggesting that Mexico was experiencing a cinematic renaissance, regarding the quality of its cinema and also its wide audience reach. However, the success of those films must be considered within the context of the industry's infrastructural and policy changes, as well as in the political and economic changes occurring nationally. The international attention to Mexican cinema between 1998 and 2002 coincides with the political transition of 2000—the downfall of the PRI after 71 years—and the aesthetic and thematic novelty of films from this period worked in tandem with the political slogans in favor of regime change. Furthermore, the box-office hits like *Sexo, pudor y lágrimas*, *Todo el poder*, and *Amores perros* were produced primarily or entirely by private production companies using production models and publicity strategies that were relatively new to Mexico, and were circulated in the new multiplex exhibition system. The correlation between these films' box-office revenues and the change in the movie-going demographic following the changes to the exhibition system are more orchestrated than even many filmmakers and industry members are aware.

The end of Vicente Fox's term witnessed a more than 120 percent increase in the number of feature films produced, compared to the previous term. These few years brought more international attention to the productions of several Mexican directors filming outside of Mexico (e.g., Alfonso Cuarón's *Harry Potter and the Prisoner of Azkaban* [2004] and *Children of Men* [2006], Guillermo del Toro's *Hellboy* [2004] and *El laberinto del fauno* [2006], and Alejandro González Iñárritu's *21 Grams* [2003] and *Babel* [2006]), such as when Cuarón, del Toro, González Iñárritu, and production designer Eugenio Caballero competed in the 2007 Academy Awards.[1] The achievements of these filmmakers abroad and of several emerging filmmakers working in Mexico but presenting their films in international festivals helped to improve the image of Mexican cinema in the eyes of its national audiences, its cultural institutions, and the private business sector. In 2007, a new

film law went into effect to offer tax credits to private investors putting money into film production, creating yet another surge in production. By the end of the Calderón term, the number of films in production and asking for the tax credit surpassed the limit allowed by law, with 42 projects applying and only 32 approved (Altamirano 2012). Mexican cinema's production trajectory shows an increase of 711 percent, from a low point in 1997 to 2011, when 73 features were produced (IMCINE 2012b, 14).

Film Policy from NAFTA to EFICINE

The Mexican state's relationship to the film industry has been one of constant flux between support and neglect depending on the priorities of each six-year administration and the extent to which cinema was considered an advantageous medium for promoting political agendas. One of the state's earliest legislative interventions into the industry occurred in 1919 with Venustiano Carranza's policies on censorship, followed by subsequent interventions in the same area through the 1930s and 1940s. During World War II and the postwar recovery, the drop in production in the United States and Europe, as well as in Argentina, allowed Mexican cinema to dominate the Latin American markets. Mexico's film industry received support from the US State Department, and in exchange the content of its cinema provided anti-Axis propaganda; during this same time, Argentina was sanctioned for its declared neutrality (Peredo Castro 2004, 75–129; Lay Arellano 2005, 41). In 1942, the Banco de México, with the Alemán administration's approval, established a lending reserve for filmmakers known as the Banco Nacional Cinematográfico (National Film Reserve, BNC), which became a national institution in 1947 (Saavedra Luna 2007a, 17). Taking advantage of this climate, the private sector established several major studios and the distributor Películas Nacionales (PEL-NAL) between 1944 and 1947. At this time, a chamber to oversee industry activity and arbitrate conflict, the Cámara Nacional de la Industria Cinematográfica (National Chamber for the Film Industry, CANACINE), was also established.[2] In 1949, the state passed its first film law, which was reformed in 1952. The new reform specified that the state's role was to be "an arbiter that could establish the harmony between the different film sectors and defend national heritage" (Lay Arellano 2005, 62). In 1961, the government nationalized the exhibition chains Compañía Operadora de Teatros S. A. (COTSA) and Cadena de Oro, consisting of a total of 329 cinemas (Lay Arellano 2005, 67).

The 1970s offer the most exaggerated examples of the state's fluc-
tuating participation in the film industry, thanks to President Luis
Echeverría's efforts to win back the support of the intellectual middle
class following his role, as secretary of state, in the violent repression of
the student movements during the previous decade. The appeasement
involved extensive support to film production, including a major finan-
cial investment in reforming the BNC, the opening of the Cineteca
Nacional and the film school Centro de Capacitación Cinematográfica
(Center for Film Training, CCC), and the creation of three state-run
production companies (Lay Arellano 2005, 51). This support helped
launch the careers of some Mexico's most important auteurs to date
(considered Mexico's original New Wave), including Arturo Ripstein,
Jorge Fons, and Jaime Humberto Hermosillo; however, it also spurred
an ideological rift between those filmmakers willing to work within
the state apparatus and those who saw accepting subvention as com-
plicity with the government's repressive politics, particularly regard-
ing freedom of expression. Nonetheless, the former group exploited
the support and was able to create films of significant political and
social critique from within. Gustavo Montiel Pagés points out that
"the struggle between independent and official cinema was...fought
on cultural terrain, in the field of expression, not in the realm of the
industrial," suggesting that filmmakers use the content of their films to
push the limits of the possible given their particular means (2010, 56).
Despite the categorical division between filmmakers, these two sec-
tors that sought to create high-quality and creative cinema still shared
a common enemy, "the old private sector," whose massification of
low-budget commercial cinema was seen as the demise of the Golden
Age (Montiel Pagés 2010, 56). President José López Portillo virtually
reversed the efforts of his predecessor with a combination of delib-
erate strategies (such as initiating the dissolution of the BNC, which
allowed the private sector to spring back into its industry dominance)
and accidents stemming from acute negligence (under the leadership of
López Portillo's sister, Margarita, the archives of the Cineteca Nacional
burned down). During de la Madrid's presidency, IMCINE was estab-
lished as the new government agency to oversee the production and
promotion of national cinema.

Having served under de la Madrid, when his own presidency
began Salinas was already immersed in the debates around NAFTA's
potential impact on cultural traditions and industries. His Program
for Cultural Development sought to decentralize responsibility and
create more self-organization in a postquake Mexico, and at the same
time spur entrepreneurship in cultural production (Miller and Yudice

2002, 131). He established CONACULTA in December 1988 as the institutional backbone of this plan, operating as part of the Secretaría de Educación Pública (Secretariat of Public Education, SEP). In 1989, IMCINE, which had operated as part of the Secretaría de Gobernación (Secretariat of Governance, SEGOB), transitioned into CONACULTA. The new goals of IMCINE under the direction of Ignacio Durán Loera (1989–94) were largely responsible for the next incarnation of a "New Wave" in the early 1990s, including *Como agua para chocolate* (*Like Water for Chocolate*, Alfonso Arau, 1992), as well as a number of films by first-time filmmakers and women directors (de la Mora 2006, 140). The success abroad of several of these films is due largely to the superficial optimism with which they represent Mexican cultural history, making it easily consumable. Following global trends of food–fantasy cinema,[3] *Como agua para chocolate* offered up a romanticized gastronomic version of the Mexican Revolution. Two years later, the EZLN's demand for land rights and social equality in the name of Emiliano Zapata and the state's violent response to these demands created a stark contrast between cinema's nostalgic exportable images of revolution and the very real conflicts taking place. Other films, such as *Sólo con tu pareja* (*Love in the Time of Hysteria*, Alfonso Cuarón, 1992) and *Cilantro y perejil* (*Recipes to Stay Together*, Rafael Montero, 1995) use the romantic-comedy genre to playfully present the impact of NAFTA on Mexico's middle class as a central concern, yet managing to reconcile a coexistence of US business culture with family-centered traditions and values.

In addition to establishing CONACULTA, Salinas made a number of gestures to win the approval of artists and public intellectuals by underscoring an interest in national culture and presenting a persona of progressivism, such as public appearances with celebrities and authorizing the exhibition of previously censored films (Saavedra Luna 2007a, 29). Much like in the Echeverría period, the administration's attention to the arts was successful in as much as it fostered the production of a large number of high-quality films that, as opposed to that being produced by the private sector, would allow cinema to reenter the realm of cultural patrimony. While the critique of intellectuals and artists working in the service of the state is not new to Mexico, the contradictions of the periods of Echeverría and Salinas can be seen as antecedents to the ambivalence of the contemporary filmmaker toward state support: one can deny neither the caliber of the cinema nor the extreme abuse of power and prevalence of corruption during both presidencies.

Immediately following IMCINE's transition from SEGOB to SEP, Durán oversaw the organization's restructuring, which involved

consolidating, liquidating, and redefining the federal film agencies under IMCINE's institutional umbrella (de la Mora 2006, 137–42; Saavedra Luna 2007a, 77–90). This included the dissolving of state producers Corporación Nacional Cinematográfica de Trabajadores y Estado Dos (National Film Corporation of Workers and State II, CONACITE) II and Corporación Nacional Cinematográfica (National Film Corporation, CONACINE), as well as selling Estudios América, theater chain COTSA, and television station Imevisión. At the same time, resources of the Centro de Producción de Cortometraje (Short-Film Production Center) were relocated within the CCC film school. The institutional objectives of CONACULTA included diversifying cultural production by literally decentralizing funding resources and responsibilities to other cultural agencies, such as state and municipal-level film commissions.

Durán's vision for IMCINE followed the agenda of geographically decentralizing production, while also reducing the federal agency's level of participation. He felt strongly that the institution's role was to facilitate the initial development of projects and to promote finished projects as national culture, but not to have creative control or financial responsibility for the productions. At this time, IMCINE began to operate solely as coproducer, supplementing financing for projects whose funding was managed by the film's primary producers.[4] At the same time, as an institution it assumed tasks of former agencies, including distribution, programming, and cultural promotion with the goal of drawing national and international audiences back to Mexican cinema with high-quality productions. With a great increase in visibility and awards at international festivals and through overseas distribution, IMCINE was indeed successful at shifting the foreign market from being primarily Spanish speakers (such as in Spanish-language cinemas in the United States, which were rapidly disappearing), and instead presenting Mexican cinema as having the sophistication and aesthetic value needed to reach the art-house/foreign-film niche (de la Mora 2006, 139–41).

Durán was also responsible for promoting the deregulation of ticket prices and screen quotas, which followed with the Salinas administration's legislative strategies toward opening up Mexico to foreign investment. Salinas's 1992 Ley Federal de Cinematografía (Federal Film Law, LFC) was the first film legislation passed since the 1952 reform, was drafted with little or no input from the production sector, and was expedited through the legislative channels and approved by congress in less than 20 minutes (Lay Arellano 2005, 69; Saavedra Luna 2007a, 66). Its primary focus is exhibition, both deregulating

ticket prices and decreasing the 30 percent screen quota for national films by increments of 5 percent per year until 1997, when it would stay at 10 percent.[5] Prior to NAFTA, the two distributors for national cinema, state-operated Películas Mexicanas (PEL-MEX) and the private PEL-NAL, were barely surviving internal conflicts and the economic crisis of the 1980s. PEL-MEX went bankrupt and was dissolved during de la Madrid's term; PEL-NAL survived until 1991. In surveying IMCINE's assets, Durán observed that the bureaucratic systems controlling distribution and exhibition were outdated, dysfunctional, and consequently, costly; this parallels the observations of many that the theaters themselves were physically deteriorated and almost inoperable—certainly unappealing to the public—thanks in part to bureaucratic system's inefficiency and neglect for its facilities. In 1993, the government packaged COTSA, Estudios América, and Imevisión, along with a newspaper, and sold it to Ricardo Salinas Pliego, who would go on to form TV Azteca. The once-popular movie houses were originally intended to be renovated under private ownership, but some of the theaters were converted to other uses or sold, and the chain eventually was completely dismantled in 1994 (Saavedra Luna 2007a, 138–39). Exhibition then transitioned to newly built multiscreen cinemas with state-of-the-art seating and projection equipment, following the US model for film consumption.

Elected president in 1994, Ernesto Zedillo inherited NAFTA, the Zapatista uprising, and the aftermath of a scandalous election year that included political assassinations. The combination of accumulated election-year debt, social unrest, and exposed political corruption resulted in an acute withdrawal of foreign investment that wreaked economic havoc; Zedillo attempted to rectify this by devaluing the peso in December of 1994. During his administration, film production dropped to just five films produced by the state in 1995, seven in each of the next two years. In 1998, state production finally began to increase slightly, although within the new exhibition system reception skyrocketed for a few key films.

Beginning in 1995, members of the film industry who felt their opinions had not been considered in drafting the 1992 LFC came together to create a new bill that would make crucial changes to the law. Headed by film director Marcela Fernández Violante and writer Víctor Ugalde, the group drew together a number of film-related organizations and "called itself the Social Community for Film, being that they distanced themselves from films based purely on entertainment, while striving to fortify Mexican cinema of a more educational and cultural nature" (Lay Arellano 2009). The draft bill had the three

objectives to "a) recover [previous] levels of investment and refurbish the mechanisms for film production; b) openly exploit the capabilities of the national film industry; and c) preserve national heritage" (Lay Arellano 2005, 73). In the 1997 midterm elections, actress María Rojo took a seat in the Chamber of Deputies representing the Partido de la Revolución Democrática (Party of the Democratic Revolution, PRD), and as head of the Cultural Commission, she helped to move the project through political channels. The main opposition to the group came from CANACINE, which challenged the initiative on three specific proposals: reinstating the 30 percent screen quota for national productions, prohibiting dubbing of foreign films into Spanish, and creating a box-office tax to fund national film production (Lay Arellano 2009).

In January of 1999, the *Diario Oficial de la Federación* published the Federal Film Law of 1998, which included many of the original articles of the 1992 version, but with numerous additions and changes. The ban on dubbing, which was intended to give a competitive advantage to Spanish-language films, was not included in the final version and the diminishing screen quota (holding final at 10% as of 1997) remained. While the new initiative proposed to implement a box-office tax as revenue to be funneled into film production, this was also rejected by congress. Nonetheless, an important new fund with a fixed amount allocated by the executive branch was put in place: Fondo de Inversión y Estímulos al Cine (Film Investment and Stimulus Fund, FIDECINE). Due to the problems within IMCINE surrounding the censorship of *La Ley de Herodes*, Zedillo did not approve the new law's regulation (Reglamento de la Ley Federal de Cinematografía, RLFC), which specified how the fund could be administered; consequently, the regulation did not go into effect until Fox's presidency in 2001, at which time FIDECINE was able to begin soliciting applicants (Ugalde, personal communication, December 2011).

The new fund was meant to address different needs than IMCINE's existing Fondo para la Producción Cinematográfica de Calidad (Fund for Quality Film Production, FOPROCINE), created in 1997. FIDECINE would focus on commercial and potentially profitable films ("foster primarily the production of good commercial cinema"), whereas FOPROCINE would support films considered to be of higher risk but with artistic, cultural, and/or educational value ("support primarily first works as well as auteur and experimental cinema"), including documentary productions.[6] The two funds' objectives reflect dual driving forces in industry development, which are opposing factions in lobbying for audiovisual policy: those who believe the state should

support films of high artistic quality and those who feel that only commercial cinema will allow the industry to thrive and contribute to the national economy. The existence of both funds positions IMCINE as a proponent of both sides, and follows with CONACULTA's foundational ideology.

The international attention to Mexican cinema in the years of millennial transition seemed to renew hope for the industry. The success of films such as *Amores perros* and *Y tu mamá también* piqued the interest of foreign and domestic investors, and Fox's administration directed more attention to the industry than his predecessor did. The budget allocations to FIDECINE in 2001 were not yet regular, and in 2002 it received no funding (Ugalde, personal communication, December 2011). Instead, the production stimulus that was refused in the 1998 LFC negotiations was again proposed and this time approved: a one-peso tax would be retained from every movie ticket sold and redirected toward production funding. The hope of the stimulus's proponents was that this would eliminate production funding's dependency on annual budget allocations. The immediate result was that exhibition chains raised their prices. However, the major studios of the Motion Picture Association of America (MPAA) were not happy with this legislation, and foreign and domestic distributors alike filed suits of appeal on the basis of *amparo* (protection) (Vargas 2005, 18; Casas 2006, n78). In fact, MPAA president Jack Valenti sent a polite warning to Vicente Fox stating that "government intervention" would be upsetting to film investors, consequently rocking economic stability, and that market adjustments are best left in the hands of industry professionals:

> Given this burden, and the fact that the new legislation was adopted without any warning or opportunity for public debate, the United States distributors that operate in Mexico could see themselves obligated to look for protection by legal means in order to defend their interests. It is also regrettable that some integral companies of the MPAA that participate in coproduction and distribution of Mexican films both in Mexico and abroad would possibly see themselves forced to cancel or postpone new projects as a result of the uncertainty created by government intervention into film industry activities in Mexico. (Valenti cited in Montaño Garfias)

The appeals were approved in 2004, and the legislation deemed "unconstitutional" by the Comisión Federal de Mejora Regulatoria (Federal Commission for Regulatory Improvement, COFEMER),[7] an agency whose policy objectives were initiated under Salinas to facilitate

deregulation and privatization (Vargas 2005, 18; COFEMER website). As Rodrigo Gómez García points out, the rejection of this stimulus plan—which has worked successfully in other Latin American film industries and was projected to generate a yearly fund the equivalent to ten feature-film budgets—was a disparaging message regarding the state's impotence when intervening in the market. It is a key example of the conflict of interests between Mexico's national governing bodies and its adherence to an international trade agreement, with "constitutionality" being adjudicated by an agency set up to protect the latter. In November of 2003, in a 180-degree turn, Fox announced that for the sake of national spending, he would sell the remaining state film assets (IMCINE, Estudios Churubusco, and the CCC) to private investors. The budget cut sparked a reaction of protest from the film community and outspoken condemnation from a number of intellectuals, some equating the proposal to one of selling "the national university, or the ruins at Teotihuacan," or any other unquestionably essential component of Mexico's historical artifacts ("Mexico's Government" 2003).

In 2003, FIDECINE recovered its funding and it has continued to support commercial cinema since that time. The increase in production during the second half of Fox's term brought annual output back to 60 features in 2006, considered the minimum for stabilizing the domestic market, (slightly higher than one premiere per week, if exhibition programming were not a factor). During this period, several high-profile production houses sprang up as well, including Lemon Films and Canana Films, both of which followed recent private-production models but were run by the industry's youngest agents and with honed objectives regarding their contribution to the future of Mexico's audiovisual culture. And as the so-called Three Amigos of Mexican cinema (Cuarón, del Toro, and González Iñárritu) generated media attention with their international prestige productions, emerging directors such as Eimbcke, Carlos Reygadas, and Julián Hernández were also garnering significant praise from international film festivals, though working with much different aesthetics and lower budgets.

While the period's mix of artistic and commercial appeal demonstrated without doubt the strength of Mexico's talent pool, the sustainability of the film industry, with or without state regulation, became the central object of debate. While production had increased, distribution remained a serious challenge for domestic films and exhibition was unfavorable to independent producers. The state's participation at the level of production was now seen as token and it was

criticized for its reluctance to support any policy that could have a genuine impact on the industry as a whole. In December 2004, congress passed new income-tax legislation to encourage investment in film production, Article 226 of the *Ley del Impuesto Sobre la Renta* (Income Tax Law). Officially referred to as EFICINE (or EFICINE 226), it would allow "a 10% credit toward a payment on Income Tax to any person who individually or as a business invests money in Mexican cinema, provided that this investment does not surpass, in its entirety, a maximum sum of 500 million pesos annually" (Casas 2006, n78; IMCINE 2012a, 3). However, due to a number of revisions to the law's unclear language, it did not take effect until 2007.

In contrast to the groundbreaking aesthetics of the recent years, films with primarily commercial appeal but lacking strong artistic, narrative, or conceptual distinction proliferated during the Calderón *sexenio*, and many blamed EFICINE: "The increase [in investment] was such that producers like Epigmenio Ibarra, of Argos Cine . . . began to question whether the tax exemption's effect on the quantity of films produced wasn't inversely proportional to the quality" (Peguero 2009). A report put out by IMCINE in 2012 stated that private investment has not increased beyond what the state matches in credits. The report summarized the negative impact of the stimulus on the production sector, including that it has lowered production standards while driving up the cost of production (from an average budget of Mex\$3.3 million in 1995 to Mex\$22.4 million in 2011 [2012b, 21]). It also noted the new role of "brokers" in film production and the misappropriation of funding intended for creative work toward commissions to financial agents. It observed a tendency of films produced with EFICINE funding to align ideological content with the views of investors and lamented that because the tax credits were given for investment in production, there was no real commitment to distributing the film once produced (IMCINE 2012b, 17). In sum, the stimulus has acted more as a tax shelter than as an incentive to invest in cinema, as was the case when Canada introduced tax credits for film production in the 1970s.

Nonetheless, a number of benefits to production are also ascribed to EFICINE, including the fact that throughout Calderón's *sexenio*, annual production steadied at around 70 features (see table 1.1). However, because many of these projects received support through EFICINE, the percentage of films with state involvement has also increased (IMCINE 2012b, 14). Of the films supported by the fund, 83 percent were for *opera prima*, 16 percent for second and third works, and only 1 percent for career directors (IMCINE 2012a, 19).

Table 1.1 Feature films produced in 1995–2011

Year	Produced with state support	% of total	100% private funding	% of total	Total
1995	5	31.2	11	68.8	16
1996	7	41.2	10	58.8	17
1997	7	77.8	2	22.2	9
1998	9	81.8	2	18.2	11
1999	11	57.9	8	42.1	19
2000	17	60.7	11	39.3	28
2001	7	33.3	14	66.7	21
2002	7	50.0	7	50.0	14
2003	17	58.6	12	41.4	29
2004	25	69.4	11	30.6	36
2005	42	79.2	11	20.8	53
2006	34	53.1	30	46.9	64
2007	41	58.6	29	41.4	70
2008	57	81.4	13	18.6	70
2009	57	86.4	9	13.6	66
2010	59	85.5	10	14.5	69
2011	59	80.8	14	19.2	73

Note: Feature film production increased overall by 711 percent from its low point in 1997 to 2011, although dependence on state support has increased significantly since 2007.
Source: IMCINE (2012b).

The fund has supported 239 productions, 115 of which had premiered as of October 2012 and had drawn a total of nearly 43 million spectators (IMCINE 2012a, 41). Despite the tendency toward commercial content, projects by directors such as Reygadas, Eimbcke, Amat Escalante (*Los bastardos*, 2008), Enrique Rivero (*Parque Vía*, 2008), and Gerardo Naranjo (*Miss Bala*, 2011) received funding through the tax credit and went on to receive positive critical reception and awards internationally.

The Multiplex Empire versus National Production

The commercial and artistic strength of Mexico's film production stands in contrast to the limited possibility the films have for theatrical exhibition or distribution. With exhibition now in the hands of the private sector, it is challenging for domestic films to reach Mexican viewers, and near impossible for them to succeed in financial terms. The loss of Mexico's own distributors and exhibition chain in the early 1990s, systems which "in spite of being corroded and rickety, were used to promote national films" (Vargas 2005, 16),

marked a major shift in the market from working-class to middle- and upper-class spectators. The new multiplex cinemas, with upgrades in sound, projection, concessions, and seating, were strategically erected in more affluent neighborhoods (Joskowicz 2009, 18) and concentrated in major metropolitan areas, making them geographically accessible to just over half of the population (IMCINE 2012b, 9). The higher-quality theaters justified a higher ticket price, from roughly Mex$20 in 1992 to around Mex$40 in 2008, leaving only 25 percent of the market at prices affordable to the previous film-going public (Gómez García 2005, 264; Ugalde 2009, 22–23).

But privatizing these systems did not shrink the audience; on the contrary, Mexico has the largest Spanish-language audience and the fifth-largest film market in the world. With the multiplex system, between 1994 and 2011 the number of screens more than tripled, from 1,432 to 4,818, and its spectatorship more than doubled, from 82 million to 189 million (Joskowicz 2009, 18–19; Ugalde 2009, 23; COFEMER 2011). With the drop in production in the mid-1990s, the tariffs on imports lifted by the trade agreement, the increased revenue due to the deregulated ticket price, and the protective screen quotas for national cinema all but eliminated, this new exhibition system became an extremely lucrative foreign market for Hollywood blockbusters, which pushed out national productions through traditional block-booking tactics. As of 2011, MPAA distributors control 80 percent of film distribution in Mexico.[8] Of the ten theater operators in Mexico (and 88 independent cinemas nationwide), three exhibitors, two of which are owned by US or multinational corporations, control 93 percent of the market (Gómez García 2005, 264; Ugalde 2009, 23; COFEMER 2011).[9]

In the cases where distribution is possible for Mexican productions, the gravely disproportional repartition of revenues between the three sectors generally leaves the producer with around 12 percent, after the distributor's costs for prints and publicity are taken out (Joskowicz 2009, 19). That is all to say that if only 15 percent (in a good year) of ticket sales in Mexico are going toward domestic productions, less than one-eighth of that sum ends up in the hands of Mexican filmmakers, from which the cost of the entire production, including actors' salaries, are subtracted (Casas 2006, n78). US studio productions are typically distributed by their own subsidiary, and therefore are not positioned with the same disadvantage in Mexico as domestic productions. US screen dominance multiplies when the number of copies released of a particular film is factored in. Though the cost of film copies make it prohibitive for most national productions to have a wide

release or to occupy multiple screens in one complex, in an effort to compete with Hollywood films, by 2008 the larger-budget Mexican productions, such as *Rudo y Cursi* (*Rudo and Cursi*, Carlos Cuarón) and *Arráncame la vida* (*Tear This Heart Out*, Roberto Sneider), had contributed to a significant increase in Mexico's copies-per-title average, which reached 162; and yet the average copies per title for US films released in Mexico the same year was 231, giving US producers 88 percent of box-office revenues (Ugalde 2009, 22).

The frustration for Mexican filmmakers when faced with the double economic disadvantage since the effectuation of NAFTA is that it stemmed primarily from an economic agreement aimed at bringing down the cultural and political barriers separating US and Mexican film markets and letting market demand determine success, regardless of a film's national origin. However, in reality the infrastructure of the industry makes this equality impossible. US investment in Mexican film productions has been limited, the United States has no official coproduction treaty, and according to data summarizing the bilateral exchange as of 2007, for every one film Mexico exports to the United States per year, it imports (tariff free) roughly 250 (Casas 2006, 75). NAFTA's repercussions on exhibition and distribution opened floodgates to allow Hollywood studios to monopolize the market and as a result solidified the national divide between the two cinemas. Although two of the major exhibitors are Mexican-owned, the industry rift of exhibitors/distributors versus producers often reinscribes the national categories: Mexican producers accuse exhibitors (including television networks) of favoring US content, whereas exhibitors accuse Mexican cinema categorically of being of inferior quality. For example, in October 2011, in response to the film community's lobbying in favor of screen quotas for national cinema, Alejandro Ramírez, CEO of Mexico's largest theater chain, Cinépolis, and also president of CANACINE, declared to the press that most Mexican cinema was "garbage" and that Mexican filmmakers ought to make better films if they want to succeed (Badillo 2011).

Given the saturation of the audiovisual market with US products, the concerns are more than simply economic and the cultural imperialism presented as a concern in the pre-NAFTA debates seems to have become a reality, despite state cultural institutions' ability to increase production. The value of the government support for national production is clear, and yet the logic of subsidizing cinema as cultural patrimony is flawed in two clear ways, the first being that the state's economic policies have created a market in which it is nearly impossible for its own productions to succeed financially. In most cases,

the administrative costs of operating the funds and also managing a film's distribution is more than the revenue generated by the film and as a result the funds are not self-sustaining (IMCINE 2012b, 16). Another contradiction is that the production of national cinema in the name of cultural patrimony is futile if the productions have no circulation and therefore offer no countervoice to foreign or global culture. Put another way, we can recognize this divide between production and dissemination in cinema as a contradiction in the Mexican state's internal policies and another example of the tension between national and transnational interests.

Seeking ways to reconcile the contradictions between trilateral economic policy and national cultural policy, many turn to consider Canada's cultural exemption from NAFTA and its government support for production. For example, Mexican scholar Enrique Sánchez Ruiz writes, "Only with national public policy, oriented toward the development of the domestic sector, can we resolve the problems in the market brought on by the implementation of blind neoliberalism" (1998, 84). Using Canadian audiovisual policies as a model, he states that

> they are not "neoliberal" in that they do not leave the entire sector's future at the mercy of market forces, and yet neither are they comparable to the economic protectionism applied in past decades. These policies could be referred to as "neo-protectionist" in the sense that they include an important component of promotion and support for the development of the [audiovisual] sector in its different phases. (1998, 84)

Presenting "neo-protectionist" as a hybrid neologism reconciles the opposition between an unbridled plunge into free-market capitalism and the orthodoxy of economic isolationism, framing Canadian film policies as taking the best of both worlds. This idealization of Canada's film industry from the Mexican perspective often concludes that cultural exemption from free trade would achieve the same balance; the revision of Mexico's treatment of culture under NAFTA has been championed by the likes of director Guillermo del Toro. Unfortunately, Canada's film industry suffers the same imbalance in the exhibition sector that Mexico's does, its public funding for feature films receives similar critiques regarding favoritism and conservative selection, and its production sector has become a "*maquiladora*" for Hollywood studio films, offering large tax incentives for foreign production (Dorland 1996, 115–16; McIntosh 2008). As is the case with

Mexico's existing 10 percent screen quota, the difficulty in cultural protection is in the state's willingness to enforce its own policies.

Privatizing Cultural Production

While exhibition has been privatized, film production remains in a certain limbo, and has taken up hybrid forms involving state and private funding. A debate has continued regarding what the state should provide, what its obligations are, what kind of cinema it should prioritize, what its selection criteria should be for funding productions, what the risks are of producing with the state, and, of course, what is at stake when considering complete privatization of production and the elimination of government support.

The social and political climate in the late 1990s and into the millennial transition is essential for understanding the context under which the privatization of production was discussed. Though labeled a renaissance by the international press, Mexican film production represents the confluence of unprecedented changes and unexpected events: the downfall of the PRI (and its tight institutional control over the media) beginning with losing its majority in congress in 1997 and then the presidency in 2000, Fox's powerful presidential campaign based on a coalition for "change," the arrival of the multiplex exhibition, the box-office success of several films, and the launch of new privately funded producers and distributors with a different approach to marketing and publicity. The most-attended film of the late 1990s was *Sexo, pudor y lágrimas* (5.3 million spectators), a romantic comedy produced with a combination of state and private funds. During the same time period, leading entertainment enterprise Corporación Interamericana de Entretenimiento (CIE) opened the production house Altavista Films and distributor NuVision, together known as Estudio México Films, as part of their new model for simultaneous film production and distribution, focusing on new actors and directors and targeting the multiplex market. Altavista first launched the satirical thriller *Todo el poder*, which offered a lighthearted critique of the Mexico City police force while also speaking to the growing fears of the new upper-middle-class spectator. In the summer of 2000, during the months before the presidential elections, Altavista launched their second film, *Amores perros*, with an unprecedented media and merchandising campaign. The international success of *Amores perros* and *Y tu mamá también*, both financed by new independent producers with private backing, was at once an argument in favor of the creative freedom open to independent filmmakers—or

at least those with financing—and a gleam of hope for the viability of overall industry success should the whole process be given over to market demands. But the apprehension expressed by many veteran filmmakers when the topic of privatization was set forth by Fox in 2003 is illustrative of the skepticism regarding the fate of artistic and cultural production under neoliberal policy.

Miller and Yudice point out the complexity of cultural production and policy during political–economic transitions, giving examples from Latin America nations in which authoritarian political were phased out in favor of democracy and free markets, and as a result lost institutional state support for mass-media, such radio, television, and cinema (2002, 100–104). They compare Mexico's cultural policy to that of Brazil, where the continuation of the arts through economic crisis has largely been due to corporate sponsorship, a co-branding of industry and philanthropy similar to the US concept of "corporate philanthropy" (2002, 132–33). In the name of democratization, Brazil's legislation on cultural funding follows a "philosophy of giving greater responsibility toward civil society, largely under the guardianship of the private sector" (2002, 133). In other words, as both political and economic models move toward decentralization, civil society and the consumer market are conflated in their role of legitimizing this process.

Néstor García Canclini sees a similar division of labor and similar consequences, though discussing here the continued role for the state under neoliberal policy:

> While traditional patrimony continues to be the responsibility of states, the promotion of modern culture is increasingly the task of private corporations and organizations. From this difference two styles of cultural action derive. While governments understand their policies in terms of protection and preservation of the historical patrimony, innovative initiatives remain in the hands of civil society, especially of those with the economic power to finance risk. Both seek two types of symbolic yield in art: states seek legitimacy and consensus in appearing as representatives of national history; corporations seek to obtain money and, through high, renovating culture, to construct a "disinterested" image of their economic expansion. (García Canclini 1995, 59)

By the end of the 1990s, these two "styles of cultural action" certainly coexisted as production models for Mexican cinema, with state production subsidizing cinema as cultural and artistic heritage and new producers catering to the new globalized audience's demand for aesthetic changes. However, the Mexican state's interest after 2000 extended beyond the aforementioned role, and the implementation

of FIDECINE in 2001 and EFICINE 226 in 2007 is also evidence of the state's interest in participating in and stimulating the latter model: as a participant, it is even further legitimized as helping the nation keep pace with the global media market, while the legislation to stimulate private investment fosters economic growth.

But even the gestures of support for cinema are not without their contradictions, as is illustrated by the fact that the same year that FIDECINE became an annually renewed fund, Fox proposed to privatize the remains of the state-run industry. The public response was mixed. Many filmmakers and investors do not see the state's remaining production infrastructure as an "industry," and doubt those remaining national assets would generate profits whether under state or private ownership. At the same time, the outcry of objections to Fox's proposal in the name of national patrimony indicates that despite critiques of IMCINE's bureaucracy, many still hold the state accountable for Mexican culture's growth, diversity, and quality. The dominant fear is that a fully market-driven industry would take opportunities away from the more marginalized voices, including artists, underrepresented communities, and young filmmakers who have not yet proven themselves worthy of capital investment. The latter concern is generally seen as the most important contribution of IMCINE and the CCC to developing the industry: giving education, training, and seed money to students and first-time directors who will push domestic production in new directions. The question then was whether these two models of cultural production could coexist or be consolidated in the industry's current condition: Could a state production system plagued by bureaucracy, budget crises, and accusations of favoritism, and whose mission was to create audiovisual cultural patrimony, also create a cinema strong enough to compete in a global market and contribute to the national economy?

IMCINE itself addressed some of the former concerns with administrative restructuring and selection-policy changes, while the new film legislation allowed it to expand the scope of its support by dividing allocated resources into two different trusts: FOPROCINE, promoting artistic, educational, and cultural value, regardless of risk; and FIDECINE, focused on competing within the commercial market and potentially generating profits. This is not to say that FOPROCINE productions were completely limited to art-house cinema prior to 2001; in fact, it supported *Sexo, pudor y lágrimas* and *El crimen del padre Amaro*, two of the top three box-office successes in the history of Mexican cinema. But FIDECINE's existence has changed the nature of the selection process simply by virtue of

allowing films to compete within separate, appropriate categories, and IMCINE continues to calibrate the defining criteria between and within the two funds. For example, not long after FIDECINE became a permanent annual fund, FOPROCINE was subdivided into categories of Fiction and Documentary, and subsequently Digital Documentary as well, so that applicants could compete within their genre rather than simply as artistic and/or educational cinema.

Despite the change of ruling political party in 2000, the overarching trend in economic policy impacting the film industry follows a somewhat consistent pattern of limited privatization. Under Salinas, IMCINE reduced its role to that of coproducer as part of CONCULTA's efforts to foster entrepreneurial endeavors in national cultural production while decentralizing state responsibility. After 2000, the success of private production brought about the state's increased willingness to stimulate—and therefore regulate—commercial film production. In "The Globalization of Culture and the New Civil Society," Yudice outlines the neoliberal theories that in part explain how relinquishing a certain level of state control (or dependency) in both the political and economic spheres is mutually legitimizing for these spheres. Yudice cites Alejandro Foxley's explanation that "political legitimacy" is essential to economic development and eventual prosperity, and yet individual neoliberal policies, such as privatization, lead to an increase in unemployment, a decrease in wages, and a general negative impact on the quality of life (as seen since NAFTA), especially for the lower classes (Yudice 1998, 362–63). Foxley states that a strong, well-organized civil society is necessary to offset these negative effects, and therefore maintain the political legitimacy of the state. And yet, according to other theories, it is still the state's job to "manage" civil society, allowing social networks to grow yet keeping them "linked to the market," in order to ensure that capitalism is not undone by political resistance (Yudice 1998, 364). EFICINE 226 in particular allows IMCINE to act as a state apparatus that at once puts film production in the hands of private investors while still requiring committee review of a film's proposed content and production process in order to qualify for the stimulus. The prevalence of neoliberal ideology within the narratives of recent cinema (as I elaborate in subsequent chapters) illustrates that the state, to some extent, has been successful in generating self-legitimizing audiovisual content in an era of increasing economic disparity.

Another recent transition in García Canclini's aforementioned roles of the public and private sectors is a gradual shift toward the latter taking up that of the former. Paul Julian Smith notes a certain

displacement of nation-legitimizing onto private film productions, as he explains the elements of informal transatlantic coproduction in *Amores perros* and *Y tu mamá también*. While films financed privately with transnational capital are not required to adhere to the strict cultural protectionism of coproduction between nation-states, they seem to adopt an unofficial cultural policy. Smith's example is that in both films, the roles of the Spanish actresses are "spectacularly visible" and yet "covertly undercut in the narrative," following that the "fetish of Europeanness stands in for a globalization of the audiovisual industries which cannot be directly represented in films whose claim to authenticity is based on national specificity" (2003b, 398). Smith points out the shift in production paradigm in Mexico, from the protectionist model (preserving cultural authenticity) to the promotion–innovation model (making films with commercial viability), the latter model being US-inspired and impossible for a statist bureaucracy (2003b, 395). However, given these examples, the two are not mutually exclusive and private production can take on the role of reinforcing the film's heritage value.

Reflecting on this period, Montiel Pagés recalls that he and other veteran filmmakers found this period to be disquieting, as they viewed Altavista as the return of the old private sector in the guise of novelty and innovation while taking advantage of the new economic climate (Montiel Pagés, personal communication, Oct. 2011). In some ways, the new form of private production seemed to be offering the potential to do everything the state did, and more. Altavista and Anhelo, both supported by two of Mexico's largest corporations, combine the need for artistic innovation and commercial viability in their products, including their desire to give work to new talent and explore new topics and visions (Smith 2003b, 395). As previously mentioned, the success of the films presents an argument for the interdependence of these two elements—which are designated as antithetical by IMCINE's division of funding. For Smith, Bordieu's notion of *habitus* explains the reaffirmation of economic alignments, making artistic freedom appear to be both the *result* of nonstate production and the *route* to profitability. The correlation of concepts is not spontaneous and organic, but is naturalized through its concurrence. However, it is clear that these private corporations were *looking for* artistic innovation, defined the products as such, and integrated the idea into their marketing campaigns (Smith 2003b, 399), reaffirming García Canclini's assertion that they want to "construct a 'disinterested' image of their economic expansion."

In his 2005 definition of postindustrial Mexican cinema, Juan Carlos Vargas comments that there are four aspects of the industry that have kept it afloat despite its economic decline since the Salinas years:

> Government support through the Mexican Film Institute [which acts as] coproducer and point of contact for securing financing, as well as channels of distribution and promotion;...coproduction with other countries, particularly Spain; [the] emergence of various private production companies with fresh ideas, such as Producciones Amaranta, Titán Producciones, Argos Cine and Altavista Films, and two more started by directors, Tequila Gang (Guillermo del Toro) and Anhelo Producciones [sic] (Alfonso Cuarón)...; [and the] efforts by filmmakers to produce their own projects. (16)

Regarding the last of these elements, he notes that the producers "promoted the release of these films with strong Hollywood-style marketing campaigns" (Vargas 2005, 16). Vargas's summary of the changes is representative of a common perspective among artists and filmmakers, and the language of his outline embodies all of the same contradictions inherent to this moment of transition (and deconstructed by Smith): the efforts of *individual filmmakers*, acting as members of civil society, are propelling the struggle for *state support*, while the independent production companies—a collaboration of artists, investors, and marketing professionals—are the source of the "fresh ideas" that have kept interests in film production piqued in the past decade.

Democracy and Transparency

Various examples indicate that neoliberalism's tendency to conflate consumer and citizen, or the private business sector and civil society, has been naturalized into common models for understanding the consumption and production of culture, especially in those fields impacted by the policies of neoliberalism. Yet it would be cynical, and dangerously disempowering, to view the mobilization of civil society in Mexico purely as a mechanism of conservative political–economic power. In fact, the organization of the public sector has been essential in influencing positive political change over the past two decades, from electoral reform to recent progressive legislation such as the legalization of abortion (in the Federal District) and same-sex marriage.[10] We can see two examples within the film industry of how civic participation has influenced policy and the democratization of state institutions: the work on behalf of the film community to change legislation and IMCINE's internal reform.

Both Lay Arellano (2005; 2009) and Gómez García (2005) point to the film community's influence over the revision of Salinas's 1992 LFC as an important manifestation of an overall democratic opening in Mexico. The 1992 law represented more than just drastic changes to long-standing legislation; its implementation without outside input or public debate illustrated that Mexico's unmitigated executive power was in full effect, under an administration notorious for repression of media criticism. Aided, and likely inspired, by the general weakening of the party itself after the turmoil of 1994 and the PRI's loss of the congress majority in 1997, filmmakers openly rejected that concentration of power by organizing themselves, conducting public forums, and working with legislators to offer input on the new law in 1998 and its regulation, even gaining additional funding for production. In 2003, when confronted with both negative press and organized public protests, Fox revoked his proposal to sell industry assets, undoubtedly in an effort to preserve his public image. This mobilization of film-industry advocates has continued into the present. In 2011, filmmakers again came together and proposed a reform to current film legislation, hoping to increase the 10 percent screen quota to 30 percent.

Under new attention directed toward Mexican film production and following the unexpected success of several privately funded films and directorial debuts, IMCINE was forced to reevaluate its own criteria for distributing funds and to respond to public criticism that saw the institution as representing an antiquated statist model of cultural production. During the tenure of General Director Alfredo Joskowicz and Director of Production Carlos Taibo, IMCINE began the process of restructuring of its organizing committees and revising its selection rules, and made other internal reforms to promote transparency and forums for public discussion. The results can be seen in a 2008 report on FIDECINE, which declared the effectiveness of the "inclusion and participation of civil society" in influencing how the organization is run, how films are selected, how information is dispersed (including annual reports and calls for funding applicants), and how funding is allocated ("Reconocimiento" 2009) [11] The report rated FIDECINE compared to similar government bodies on factors such as transparency, representation, and social impact, and reported that "FIDECINE is considered an effective trust in which the federal government, private initiative, and organizations of civil society take part; it guarantees transparency in the use of its resources and its achievements create an economic impact within its sector and on the economy and culture on a national level." It continues that "its existence contributes to the democratic strengthening propelled by the

Federal Law for the Growth of Activities Undertaken by Organization of Civil Society" ("Reconocimiento" 2009). IMCINE's efforts to reform the agency follow the general shift in Mexico toward the professionalization of film production, and at the same time present a level of interaction within the social sphere absent from corporate-run production companies. The same report concludes that this efficiency and transparency is rare among similar institutions in Mexico: "23.25% [of registered public institutions] do not function and the rest operate with grave deficiencies: 'they are minimally functional and serve little purpose'" ("Reconocimiento" 2009).

Historians Gilbert Joseph, Anne Rubenstein, and Eric Zolov propose a need within Mexican cultural and historical criticism to rethink post-1940s Mexican culture as more than just a master narrative put forth by a monolithic state, and instead view the state itself as a fragmented entity riddled with fissures and contradictions: "Cultural and political relationships between Mexicans themselves, between Mexicans and their government, between Mexicans and a host of actors and agencies in the United States, and between Mexicans and rest of Latin America are far more complicated and ambiguous than the revisionist metanarrative will allow" (2001, 6–7). They contend that not just the state, but also cultural production and the mass participation in it, are necessary to keep up a unified nationalism, and in that sense, the national narrative is never purely authoritarian and uncontested. Rather, it is useful to think of Mexican cultural production as a dialectical dynamic between various forces, with fluctuating coalitions, including US culture itself. While the economic imbalances brought on by the free-trade agreement are undeniable, responding with nostalgia for a bygone era ignores the new aesthetic and political ground broken in cinema over the past decade, and calling for the simplistic solutions of creating a "cultural exemption" or protecting "cultural heritage" forgets the very contestation of cultural preservation brought by Zapatistas and other indigenous communities. Even institutions such as IMCINE, rather than functioning as a machine that conforms cinema to national standards, in fact, represents a nexus of interests, whose decisions and actions are taken by individuals of varying personal and political priorities. Thus, a critical analysis inclusive of both the influence of public opinion and of alternative (both independent and private) modes of production on Mexico's body of cinema recognizes the possibility of intervention, however minute, into the national and transnational systems that exert force over cultural policy.

Chapter 2

Audiences and Target Markets: On Spectatorship and Citizenship

In 2011, Mexico's COFEMER released a report analyzing the impact of the 1992 Federal Film Law's deregulation of movie ticket prices. While recognizing the dominance that just a few multiplex chains have over the exhibition market, as well as the difficulties that national producers have in recouping their costs, the report nonetheless concludes without reservation that deregulating ticket prices has had a positive effect on the industry: "Thanks to the industry policy changes and the deregulation of box-office prices, a more competitive environment is favored and there [now] exist more incentives for investment, which to date has detonated favorable development in film exhibition with direct benefits in quality and diversity for filmgoers" (2011, 2). The report presents the deregulation of ticket prices as the key factor that led to the investment of multiplex theaters in Mexico, which in turn increased both the number of screens and consumers' interest in going to watch cinema in theaters.

As mentioned in the previous chapter, the deregulation of ticket prices, as a new implementation of neoliberal policy in preparation for NAFTA, raised ticket prices, on average, to the equivalent of Mexico's daily minimum wage. If the state's subsidies for production indicate cinema's status as cultural patrimony, this shift left roughly 25 percent of the population excluded from this type of cultural consumption for economic reasons. Furthermore, the concentration of multiplexes is limited to urban centers where 58 percent of Mexico's population lives, leaving 42 percent without any movie-theater facilities. Together these two factors result in the fact that "only 28 percent of the population goes to movie theaters at least once a year" (IMCINE 2012b, 9). COFEMER's report does not address this issue; the agency's findings

on household expenditures on cinema between 1992 and 2008 shows an overall increase since 1992, as well as a relative increase with each income bracket. But the analysis of this data fails to mention that the lowest-three income brackets all decreased their spending on cinema between 2000 and 2008, and that only the top-three income brackets show an average spending of more than four tickets per household per year (2011, 46). In contrast, IMCINE's 2011 *Statistical Yearbook of Mexican Cinema* makes explicit the significance of this shift in film consumption: "67% [of spectators in movie theaters] belong to the middle or upper middle class," and that "65% of the people who watch movies on open [broadcast] television belong to the lower and lower middle classes" (IMCINE 2011, 193). Thus, although the deregulation of ticket prices may have been the impetus for previously hesitant investors to change Mexico's exhibition system from single-screen movie houses to multiplexes, therefore increasing the number of screens nationwide, the industry growth is also due to the change in audience that this overhaul brought, shifting the movie-going demographic to those with more disposable income, and making the activity more of a consumer, rather than cultural, experience. While the state's plans to increase the entrepreneurial drive of the cultural industries were said to protect national patrimony, this deregulation had the effect of restricting the general public's access to this realm of culture.

The increase in privately funded film production (and the state's subsequent interest in supporting and stimulating commercial films) was a strategic response by the business sector to the changes in exhibition, and in some cases in anticipation of these changes. This chapter looks closely at how the new exhibition market has effected a significant transformation of Mexico's film industry, a transformation that would be perceived internationally as a renaissance: the new audience, the content of films produced for that audience, the model for producing such films, and the methods for drawing the intended audience to see the films. It considers how that audience has been shaped by socioeconomic and sociogeographic parameters, and how the change has been reflected in the content of the films, through casting, narrative structures, and aesthetics. It traces out several genre trends that have sought to target specific aspects of the new audience demographic, such as class (romantic comedies) and age (youth-oriented films), and uses individual films to illustrate these trends. It discusses how the rise in private production coincides with other important transitions, including the emergence of a younger generation of filmmakers and the professionalization of the industry and of film education. This generation of producers has taken up the newly required emphasis on

marketing and publicity and come up with innovative approaches to targeting their own niche audiences.

Projecting the New Audience

The positive international reception of the Mexican cinema of the mid-1990s allowed for a certain optimism regarding the potential of future productions, despite extreme economic hardships nationwide and the drop in state support of the industry. The market offered by the new exhibition system started in 1994, was enough to generate corporate media's interest in film production. Altavista Films was established in 1998 as part of CIE, one of Latin America's most expansive media and entertainment corporations, headed by Mexican billionaire Carlos Slim.[1] The new wave of privately funded film production was most significant in establishing a new approach to the market, both in identifying the most lucrative target audiences and in a drastically increased budget for reaching this audience with publicity and merchandising. Following the successful bout of Hollywood's romantic comedies in the 1990s and Mexican audiences' positive reactions to a handful of Mexico films of the same genre, this became one of the first models for successful films seeking to reach the urban upper-middle-class audience. A second target audience was Mexico's youth, who were increasing their purchasing power throughout the decade, especially in consumer media. For this reason, the music soundtrack became an essential element for the new production model, compiling tracks from the bands and musicians who were popular on radio and music television and integrating them into the film content by linking lyrics to narrative and thematic elements. Corporations like CIE were able to market these films exceptionally well with the resources of their various media subsidiaries, coordinating a film launch with television campaigns, the CD release of the soundtrack, concerts, and music videos (Smith 2003a, 16).

Sexo, pudor y lágrimas is one of the most exemplary models of Mexico's new production strategies and the tailoring of content to the multiplex audience. Released in June 1999, it instantly took the position of the highest-grossing film in Mexico's history (bumped to second place in 2002 by the religious controversy of *El crimen del padre Amaro*). The story revolves around two upper-middle-class couples who both receive unexpected houseguests, visitors whose arrival throws off the sexual dynamic in each of these already troubled relationships and divides the couples into warring battle-of-the-sexes factions that bunker into separate apartments. Filmed in Mexico City's upscale Polanco, it constructs the lives of the six characters as integral

to this identifiable urban space, dividing the majority of the sequences between two facing apartment buildings, with some in the street below. First-time producer Christian Valdelievre insists that he "followed his instinct" in deciding to invest his own and his associates' money in director Antonio Serrano's script (personal communication, June 2007). But as film critic Fernanda Solórzano points out, "The six characters from *Sexo, pudor y lágrimas* seem to have been conceived precisely as points of identification for the contemporary audience" (1999). "Contemporary audience" refers to the new cineplex-goers, a market on which Valdelievre was one of the most informed in the country. In 1993, when the Cinemex cofounders (three Harvard MBA graduates) were looking for a way into the theater-chain business in Mexico, Valdelievre, then an experienced broker at J. P. Morgan, pitched the trio's proposal to colleagues and convinced the firm that it was a sound investment. Although Valdelievre's script intuition was informed by his lifelong love of European cinema, his market assessment was backed up by the success of two previous Mexican romantic comedies: *Sólo con tu pareja* and *Cilantro y perejil* (personal communication, June 2007). These films can both be seen as transition films, grounded in PRI-era production practices while also breaking into new thematic territory by looking at sexuality among upper-middle-class couples in the context of Mexico's changing consumer culture, in contrast to the economic plights of the working class and more traditional representations of Mexican culture. Valdelievre points out that return viewers made up much of the *Sexo, pudor y lagrimas*'s box-office figures, to him an indication that there was not just a market need, but a plea for this type of film (personal communication, June 2007).

Francisco Sánchez's *La luz en la oscuridad* elaborates a formula for this new genre, the *comedia light*, seeing it as directly pertaining to the desires, aspirations, and experiences of the new film market. The genre, first visible in *Sólo con tu pareja*, gives a lighthearted and entertaining touch to sophisticated and timely topics (in this case, sexuality in the time of AIDS) to create uniquely Mexican scenarios and attract a national audience. Using *Sexo, pudor y lágrimas* to illustrate the evolution of the formula, Sánchez draws out the following key elements: comedy, light tone, quick pace, urban setting/locations, thirtysomethings of middle- to upper-class standing, familiar and sentimental themes, conflicts regarding sexuality or parental figures, superficial levels of narrative and/or character reflection, permissible social critique of corruption and crime, drug use and excessive sex as vices, modern foreground showcasing an abundance of visible commercial brands and consumer technology (CDs, computers, etc.), and a backdrop of a picturesque and folkloric Mexico (2002, 229). The elements of the

new genre, particularly the contrast between consumer technology and folkloric art, and the critique of crime alongside the allowance of fashionable vices, mark the films as key illustrations of how the NAFTA-era infatuation with cultural origins overlaps with the consumer context of box-office stratification. Evidence of economic prosperity and global consumer identities is visible, yet a certain level of nationalism is maintained through geographical reference, legitimizing (albeit from a safe distance) the existence of the popular classes that were the mainstream representation of Mexican national identity throughout the twentieth century, especially in its cinema.

According to Sánchez, the new spectator, beyond the class status and disposable income, is a professional employed within the global economy in the growing fields of technology and mass communication, which makes for a more demanding viewer with regard to the audiovisual and intellectual aspects of the films. While the sets, props, and fashion in the new comedies integrate changes in consumer trends into the diegesis (and the extradiegetic via soundtracks), the changes in cinematic style are more apparent in the shooting and editing style of the urban realism represented by *Amores perros* and similar films (see chapter 4). Within a short period of time, these two styles saturated the market. Throughout the latter half of the 2000s, producers went on to explore new aesthetic and narrative trends, such as animated all-ages films as well as horror, suspense, and sci-fi genres, all of which take advantage of technological advances in visual effects and stylization in an effort to keep up with the changing aesthetics of Hollywood imports.

A Brief History of the Postindustrial Blockbusters

Hollywood studios use their dominance over foreign markets as insurance for when large-scale productions with budgets in the hundreds of millions do not recoup their costs in the US box office. The economic need for foreign sales exists because, despite decades of blockbuster successes, predicting box-office sales is still very difficult for film producers, due in part to the fact that film consumption is not based a consumer's immediate familiarity with the product, but with his or her speculation as to what the characteristics and quality of the film will be. The elements that tend to push a film toward profitability are those that are tangible and intriguing to the spectator during the process of choosing which film to see. Aside from the title, most of what grabs the attention of a listings browser cost money: recognizable cast, experienced director and crew, an eye-catching poster or engaging trailer, plus any additional publicity and marketing. A positive experience in the theater—due to the contributions of any of the above and/or a well-executed, memorable

story; believable characters; situations and locations that are either rec-
ognizable or desirable to the viewer; high-quality visual production; and
well-met genre expectations—can lead to a second wave of publicity,
including word-of-mouth and positive reviews.

Between more challenging economic conditions and fierce compe-
tition from US product, the success of a Mexican production is even
less predictable in the box office than that of a Hollywood film. The
result of programming marginalization within theaters and of produc-
ers' hesitance, until recent years, to take risks on film content, domes-
tic audiences have seen "Mexican" cinema as a subgenre that often
generates expectations of inferior production values than competing
films, and carries a stigma of being too dependent on the conventions
of melodrama and/or social realism. To some extent, the changes in
the industry have begun to reshape audience perceptions and allow tra-
ditional spectator-drawing elements to function for Mexican films as
well. To the industry's benefit, the increase in production in the early
1990s under Salinas was able to help rebuild a national star system,
launching the careers of such actors as brothers Bruno and Demián
Bichir, Salma Hayek, Daniel Giménez Cacho, and Damián Alcázar;
box-office hits later in the decade and into the 2000s, with the help of
television, brought attention to younger actors such as Diego Luna,
Gael García Bernal, Ana Claudia Talancón, Cecilia Suárez, and Ana
de la Reguera. At the same time, the decrease in cost of filmmaking
technology has made it more feasible to produce films of effects-heavy
genres that were previously considered inconceivable in Mexico; the
release of several successful genre films since the early 2000s helped
to create a more heterogeneous image of national cinema. The new
star system, changing genre trends, and the new attention to public-
ity have combined well with other, sometimes unforeseen, elements,
such as the extrafilmic political atmosphere at the time of a film's
release and subsequent public controversy; the top box-office films of
the postindustrial period have benefited from these combinations in
varying dynamics, as the following chronology details.

El callejón de los milagros (Midaq Alley, 1995)

El callejón de los milagros, released in May 1995, was director Jorge
Fons's first major film since the politically charged Rojo amanecer (Red
Dawn, 1990). Despite several scathing reviews from Mexico's top film
critics, filmgoers responded enthusiastically to one of the year's five
domestic releases, likely the result of a well-formed cast drawn from a
new star system that was coalescing since the beginning of the decade.

The film transitioned Salma Hayek from television to film actress, casting her opposite Bruno Bichir, whose career had been building since his role in *Rojo amanecer*. Other young and attractive actors included Juan Manuel Bernal, who was following up a lead role in *Hasta morir* (*Until Death*, Fernando Sariñana, 1994); Daniel Jiménez Cacho after his lead in *Sólo con tu pareja*; and Luis Felipe Tovar, who would go on with Bernal to shoot *Cilantro y perejil* later that year.

The sordid story was shot in Mexico City's Centro Histórico district, lending a geographical authenticity for local audiences, especially in a moment of increasing criminal activity in the capital. However, winning the audience awards at festivals in Chicago and Guadalajara, a Goya for best Spanish-language foreign film, several awards in Havana, and awards and nominations at other international festivals, is indicative of a certain appeal to both viewers and critics beyond the city where it was set. Fons worked with a script adapted by Vicente Leñero from the novel *Midaq Alley* by Egyptian Nobel laureate Naguib Mahfouz, whose earlier novel was adapted for Arturo Ripstein's *Principio y fin* (*The Beginning and the End*, 1993). Based on this connection, Fons's previous work as an assistant director to Ripstein, the fact that both films were produced by Alfredo Ripstein Jr., and a series of aesthetic and thematic similarities, a number of reviews commented that *El callejón* was too "Ripsteinian," or just a spin-off of *Principio y fin*. The film was criticized as being overly melodramatic and fatalistic, and for having a pseudo-postmodern time structure, making it unnecessarily repetitive. The content of some stories was seen as both homophobic, with gratuitously violent scenes inserted into an overall forcedly tame script, and classist, painting the *vecindad*'s poverty and the vice and poor judgment of its characters as a microcosm of Mexico's lower class. Despite criticism, the film was notably influential. *El callejón de los milagros*'s stylized linking of nonsequential narratives to describe the tragic "destiny" of the poor became a model for films to follow in the late 1990s and early 2000s. Not entirely new, these more recent portraits of the struggling of lower classes cite both the popular cinema of the Golden Age and the social realism of the 1970s; yet as produced for multiplex audiences, the voyeuristic gaze intensifies with new editing styles, as does the condemnation of poverty, making this cinematic trend the tragic counterpart to the new comedies depicting the Mexico's nouveaux riche.

Cilantro y perejil (1995) and Early Romantic Comedies

Shot in the same year as *El callejón de los milagros*, but not released until summer of 1997, Rafael Montero's *Cilantro y perejil* was considered in

its moment as one of Mexico's top films, drawing six hundred thousand spectators in 15 weeks ("'Cilantro y perejil'" 1997). (Comparing this to the later three-million-plus spectators for *Amores perros* in the same number of weeks gives an idea of rapid audience growth in just three years). This IMCINE–Televicine coproduction is a well-assembled romantic comedy about couples in crisis, whose success follows that of several films of the same ilk released in years prior, such as *Sólo con tu pareja*, *El anzuelo* (*The Come On*, Ernesto Rimoch, 1995), and *Entre Pancho Villa y una mujer desnuda* (*Between Pancho Villa and a Naked Woman*, Sabina Berman and Isabel Tardán, 1996). Montero, the director of the second phase of the project, left much less of an authorial mark on the film than did the original producer–screenwriter/husband–wife pair Fernando Sariñana and Carolina Rivera, whose later *El segundo aire* (*A Second Chance*, 2001), directed by Sariñana, would rework much of the same themes. In *Cilantro y perejil* (aptly titled *Recipes to Stay Together* in English), Susana (Arcelia Ramírez) asks for a separation from her neglectful husband Carlos (Demián Bichir), who is absorbed with his career and with closing a deal with his firm's foreign clients. Carlos's sudden bachelorhood generates a series of antics around his domestic ineptness. Loving sentiments resurface between the couple when Susana rescues Carlos, who cannot tell the difference between cilantro and parsley, by impressing his clients with her cooking skills. A comparison of Rivera's two scripts highlights a multilevel allegory of political values, audiovisual media, and relationships: the visual technique in both films—animating old photographs in *El segundo aire* and simulating old home movies in *Cilantro y perejil*—underscores the nostalgia felt by the couples for their happy beginnings, when they were in love and their principles were not corrupted by workaholic behavior. In both stories, the politics of trade liberalization and economic crisis is addressed by way of the characters' conspicuous materialism and the negative impact it has on the family unit, showing a father who is too busy trying to impress foreigners to spend time with loved ones and a wife who nonetheless saves the day, thanks to her adherence to traditional womanly duties.

Cilantro y perejil and *El anzuelo* mark an early phase in Mexico's development of the romantic comedy, in which the status quo to be ruptured is the married middle-class heterosexual couple, later to be bumped up in class status and the moral leniency by *Sexo, pudor y lágrimas*, and nearly undone by the wave at the end of Fox's term of "single-thirtysomething" comedies that center on bachelorhood and identity crisis and present a more mainstream image of casual sex. Similar to *El anzuelo*, which uses the visual gimmick of showing much

of the film from the point of view of the bride's brother, who is video-taping the wedding, *Cilantro y perejil*'s aesthetic elements (including the home-video footage) and structure pivot on the idea that Susana's sister is doing a video project on love relationships. The concept justifies the insertion of otherwise disjunctive interviews on the psychology of human mating rituals via a cameo role by writer Germán Dehesa, a tinge of irony and intellectual profundity within the thematics of romantic crisis. The film's visual and narrative novelty do not move beyond the superficial, and the story ultimately mourns the loss of family values in Mexico's modern, highly competitive economy.

Sexo, pudor y lágrimas (1999)

Cilantro y perejil's audience served as a useful test-market for the record-breaking *Sexo, pudor y lágrimas*, which would eventually accumulate 5.3 million spectators. As previously mentioned, the formula for romantic comedies *a la mexicana* comes to its apex here, and in a way can be seen as a calculated assemblage of audience preferences. So why did so many people want to see it and why did so many pay to see it again? To start, the title has the grab of a risqué *telenovela* but turns ironic in light of the film's comic tone. However, the explicit examination of sex and its emotional consequences (shame and tears), here as dark comedy, recalls an Almodóvar-style moral honesty by presenting itself as a refreshing respite from socially acceptable representations of romance and showing the true neurosis of sexual behavior: Carlos Bonfil defines the Mexican romantic comedy as a cross between "the impudence of Madrid" and "the superficial morals of Hollywood" (2006). The story begins to explore the loneliness and alienation of troubled amorous relationships, but stops short of addressing these conflicts with any significant insight.

The approximation of reality by updating sexual (and other) activities to reflect late-1990s lifestyles is closer to verisimilar fantasy than it is to glossy realism (e.g., *Amores perros*).[2] It is consistent with trends in television at the same time, such as TV Azteca's move to address more contemporary themes with their *telenovelas*—similar to what Brazil's TV Globo had already begun—by creating stories that addressed such issues as political corruption, homelessness, and domestic violence. Thus, it is not coincidental that Serrano, while mostly lauded for his work in theater, had also directed two of Azteca's breakthrough *telenovelas*, *Nada personal* (*Nothing Personal*, 1996) and *Mirada de mujer* (*A Woman's Look*, 1997–98). While these stories eschew neither their primary function of constructing a fantasy of class ascension nor

the use of melodrama as a means to affect, the characters' milieu is depicted in such a way as to be identifiable to the contemporary urban audiences, and the concerns are timely (a political assassination and an abandoned housewife's struggle to find her self-worth). The topics covered in *Sexo, pudor y lágrimas* are equally split between marking an of-the-moment setting and playing through, within this setting, traditional sentimental conflicts. In the film, Brigette Broch's art design and Xavier Pérez-Grobet's cinematography, though downplayed by Serrano's theatrical directorial vision, provide and foreground the conspicuous technological consumerism that characterizes this new genre. Relegating nearly the entire setting to the two apartments reveals Serrano's theatrical and television influences, seen also in the acting; rather than fragmenting the actions through editing, the camera explores the space as a stage (or sound stage) in order to focus in on the details of these characters' movements, habits, material possessions, and preferences (Foster 2002, 40).

This hybridization of television, theater, and film can be seen on other levels, including the mixed performances of the cast, many of who had worked primarily in television. According to an article in the *New York Times*, producer Matthías Ehrenberg "said the film benefited from strategic marketing. The cast was carefully selected to include actors associated with both of Mexico's national television networks, so neither one refused to carry advertising for the movie" (Preston 1999). This mix can also be seen in the coproducers and funding sources: IMCINE's FOPROCINE fund; film upstart Titán Producciones, a collaboration of new producers Valdelievre and Ehrenberg; Argos Cine, part of the larger Argos Comunicación, whose television side coproduced the two *telenovelas*; and Tabasco Films, one of Mexico's more successful productions houses since the early 1990s, having produced the work of María Novaro and Carlos Carrera, and backed by Carlos Slim. As one of the lead financiers, Valdelievre insisted on following a US business model, factoring into the budget for publicity and the production of a music soundtrack, which sold 120 thousand copies (personal communication, June 2007).

La ley de Herodes (1999) and *Todo el poder* (2000)

Within the time of just two months, two films were released in Mexico that revealed new approaches to the denouncement of political corruption, which was already a prevalent topic. Both use satire to broaden their audience and dulcify their critiques with laughter, but the paths

toward reaching audiences differed. Luis Estrada's *La ley de Herodes*, premiered in December 1999, telling the story of an aspiring politician in the era of Miguel Alemán who starts out honest and finds himself complicit in, and then even exceeding, the typical corruption of his superiors. Its newness and the strength of its critique lie in that it was the first film to explicitly use the PRI party name when representing, also explicitly, political corruption, nepotism, bribery, extortion, embezzlement, and murder. Despite its approved cofinancing from IMCINE from script phase, the final cut generated unease. When it was pulled at the last minute from its premiere in a festival in Acapulco, the film caused an uproar over the topic of censorship, which in official terms was no longer in practice in Mexico (see chapter 3). The film's premiere was then delayed and eventually took place, but with a very poor-quality—perhaps deliberately so—projection. *La ley de Herodes* eventually secured wide theatrical release, including in the United States, and enjoyed a positive critical and audience reception, with an extra boost in ticket sales due to its controversy's timing within an election year. Some speculate that the film's wry humor and the widely publicized controversy were factors in the PRI losing votes in the year of their downfall.

Opting for the lighter side of political satire and a more diffuse critique, *Todo el poder* was the first release of Altavista Films and distributor NuVision, and premiered early in 2000. The plot mixes romantic comedy and lighthearted variations on crime-thriller conventions into a parody of police corruption, but without the overt denouncement of political parties found in Estrada's film. If anything, the focus on the capital's rampant crime and the police force's complicity with criminals and animosity toward true victims was a jab at the Federal District's leftist government under Cuauhtémoc Cárdenas, who ran for president against Fox in 2000. *Todo el poder*'s commercial success in the new market and *La ley de Herodes*'s media attention and audacious political commentary together inaugurated a trend of more vociferously denunciatory cinema, in fiction and documentary, including Estrada's follow-up films, *Un mundo maravilloso* (*A Wonderful World*, 2006) and *El infierno* (*Hell*, 2010).

Amores perros (1999)

Film critic Carlos Bonfil writes of *Amores perros* that despite its influences from internationally recognized auteur cinema, what is remarkable about its hometown success is "the way in which it turns a national cinema that for decades was holed up in a complacent self-consumption

into something that is interesting, believable, and attractive to increasingly demanding viewers from different social classes" (2000). The film follows new tendencies in international cinema, with its notable "velocity," and a refusal to explain characters or orient the spectator within contexts, favoring scene openers in medias res and the use of the camera to highlight seemingly extraneous actions, props, and setting details (Sánchez 2002, 262–63). The dialogues and pacing of the film (characters mumbling to each other in slang, or screaming obscenities during a high-speed chase) contrasts with the theatrically enunciated banter of the romantic comedies (Solórzano 2007, 63–64). Yet, as many have pointed out, for all of its edgy camerawork and startling plot twists, *Amores perros* does not forgo the long-running cinematic tradition of semitragic melodrama in its themes, including the melancholic tones of Gustavo Santaolalla's score and the pop/*emo* hits that made up the soundtrack. Like *El callejón de los milagros*, its characters' interactions create a mesh of tangled destinies—this time covering the whole city, ignoring class boundaries—as their lives literally collide in the car crash scene that adjoins the film's three separate stories.

The widely consumed soundtrack and the marketing campaign were part of the same model of film production imported by Valdelievre and Ehrenberg a few years earlier, in this case under the aegis of Altavista Films. Following up on the successful launch of *Todo el poder*, Altavista pushed its own image and that of its film by stressing innovation, evidenced in the use of new talent, new business models, and new aesthetic parameters, all tailored to the needs of the new spectator. As media buzzwords, "innovation" and "newness" coupled well with the political campaigns of the same period, in which Fox gathered a broad coalition of supporters under the rubric of "change," all of these terms in ideological alignment with the policy push from state-run to private business and from national to global market appeal.

The film became a national ego boost when it won Critics' Week in Cannes in the spring of 2000, going on to premiere in Mexico just weeks before the presidential elections in June 2000 and eventually pulling in Mex$98 million in 24 weeks. The drastic increase in nonproduction spending can be seen in that Altavista launched the film with approximately the same number of copies and the same amount of publicity as its summer blockbuster competition, John Woo's *Mission Impossible 2*, for which Tom Cruise was rumored to have received US$100 million, the budget of at least 50 average Mexican films (Tovar 2000b). *Amores perros* was bought by 15 countries for distribution and was further sanctified with a nomination for the Best Foreign Film Oscar. Though it lost to Ang Lee's

Wo hu cang long (*Crouching Tiger, Hidden Dragon*, 2000), it beat veteran filmmaker Maryse Sistach's *Perfume de violetas* for the Ariel for best film, the award given by the Academia Mexicana de Artes y Ciencias Cinematográficas (AMACC). At the same time, the reviews were mixed among Mexico's most-read critics, many rebuking it for sensationalistic violence and finding it to be condemning of its characters. Its advocates recognize a level of complexity in the film, a poetic juxtaposition of image, sound, and narrative (well dissected by Paul Julian Smith in his eponymous book). Most credit Iñárritu's remarkable creative career: as a DJ and radio producer in his early twenties, working as creative director of an advertising agency, and founding production company Zeta Films before reaching 30, all of which put him very much in touch with the sensorial desires of his young audience. The film's commercial implications did not impede the recognition of its aesthetic and political importance in Havana, Cuba, at the 2000 film festival, where its "original and innovative treatment" of the theme of urban violence in Latin America won it the Premio Glauber Rocha, which is dedicated to "stimulating productions throughout the subcontinent that express 'with high amounts of rigor and authenticity' the social reality of Latin America" ("Conquista la cinta mexicana" 2000). Before its box-office explosion, Iñárritu saw his film as an "alternative" in Mexican cinema, and, like Rocha himself, spoke of wanting to "de-banalize" violence with this work and to show the opposite of what is seen in US films (Díaz Rodríguez 2000). Whether he achieved this goal or simply paved the way for a new level of desensitization is under debate, and many still see the film's treatment of class issues as open to ambiguous readings. For example, the middle story—playing out a growing anxiety among Mexico's elite that the urban violence displayed in the other two stories is literally creeping up through the floorboards of the city's penthouses—is both a repetition of lighter treatments of the theme (as in *Todo el poder*) and a direct response to the romantic comedies' evasion of the topic: "[The episode about Daniel and Valeria] could be the worst nightmare of any of the characters of *Sexo, pudor y lágrimas*" (García Tsao 2000).

Y tu mamá también (2001)

Y tu mamá también premiered in June 2001, one year after *Amores perros* and the PAN had upset the country's cultural and political stases. From production to exhibition, the film built up an extensive list of publicity-worthy elements: a hot international cast, private

funding from a new production company, a dialogue built on up-to-date youth slang, undertones of political change and social inequality, explicit sex, a surprise ending, and a censorship controversy. Returning from a premiere at the Cannes Film Festival in 2001, the film took in Mex$95 million after just eight weeks. It went on in 2002 to win the Independent Spirit Award for Best Foreign Film and Best Picture from the Los Angeles Film Critics. Like Iñárritu, Cuarón secured private funding from the upstart company Producciones Anhelo, which was underwritten by millionaire Jorge Vergara of Omnilife and prided itself on the complete artistic freedom of its directors.

Sánchez sees *Y tu mamá también* as a continuation of the *comedia light* formula that Cuarón started with *Sólo con tu pareja*: it foregrounds the wealthy and beautiful against a backdrop of colorful peasants and traditional fishermen, all as a pretext to stir up discussions of sexuality. However, what Cuarón achieves with *this* story of sexual coming-of-age is to complicate character types while extracting them from the clichés of the materialistic consumer world of other romantic comedies. The road-trip genre allows them to escape the urban terrain, which typically outnumbers depictions of provincial life in contemporary cinema. Although the protagonists' interaction with the social reality of the rural setting is limited, the director underscores these moments by interrupting the diegesis with the voice-over of an omniscient narrator, drawing attention to the absence of such scenes in most recent filmic representations of Mexican daily life, and on some level, calling out the spectator's fascination with the folkloric. As in *Amores perros*, two key narrative ruptures concern car accidents, also with momentary socioeconomic "destiny-crossings," but without the visual sensationalism of the violence. The shock value in *Y tu mamá también* comes at the end, when the heterosexual tension that drives most of the story comes to fruition in a homoerotic scene between the protagonists. The ending's scandalous secret gave the film a postpremiere marketing angle and a good hook for organic, word-of-mouth promotion. Cuarón's objection when SEGOB's Dirección General de Radio, Televisión y Cinematografía (Bureau of Radio, Television, and Film, RTC) gave it a restricted *C* rating (adult content), calling it a form of censorship, generated more intrigue for the film, while the restriction itself limited the audience. The voice-over narration ends with the film's epilogue, framing the story with a political allegory and the loss-of-innocence theme, equating the end of the PRI's regime with the end of the protagonists' friendship. Politics, sex, controversy, and one of the largest marketing budgets in Mexican

cinema at the time were able to push it into the top five of all-time highest-grossing national films in the domestic market.

El crimen del padre Amaro (2002)

Mexico's second most-attended film to date, *El crimen del padre Amaro*, began its theatrical circulation in August 2002, shortly after the pope's visit to Mexico, and enjoyed an unprecedented amount of media attention thanks to protests and threats of boycotts from conservative groups and denouncement from the Catholic Church. The scandal around the film's content—including abortion, priests breaking celibacy vows, cats taking communion, and drug traffickers funding church hospitals—was eventually lost in the controversy itself, when outspoken members of Mexico's pro-life group Provida filed a suit against the government official who approved the film, inciting a State-versus-Church debate.

Like *El callejón de los milagros*, *El crimen del padre Amaro* was adapted from novel to screen and updated to a contemporary setting by Vicente Leñero, and the script, cast, and sets were standard fare for domestic productions. But the anticlerical premise (a priest has an affair with a young woman, who dies after an illegal abortion) and the use of two popular young actors (García Bernal's first major role following *Y tu mamá también*) was already enough to guarantee a substantial audience, a threat to the religious organizations that denounced the film. The pointedly "blasphemous" scenes fueled the controversy, although many who opposed the film admitted to not having seen it (see chapter 3). As a vehicle for Talancón's breakthrough role in cinema and the third consecutive hit with García Bernal, this romantic and tragic melodrama confirmed star figures, production values, and certain plot lines as key elements for commercial success, while the controversy that helped break box-office records gave a strong push to the trend of spinning censorship to generate publicity.

The Trajectory of the New Romantic Comedy

If Cuarón's two Mexican productions are milestones for the development of the romantic-comedy formula, they are also significant indicators of the change in depictions of sexuality in mainstream cinema, and the continual recycling of the theme to draw different age demographics and adapt to new generations of viewers. Two films, *La primera noche* (*The First Night*, 1998) and its sequel *La*

segunda noche (*The Second Night*, 2000), both directed by Alejandro Gamboa and produced by Televisa's production unit Televicine, used the winning combination of romantic comedy and youth audience to explore the theme of a teenager's first sexual experience, similar to the US *American Pie* series, eventually concluding the trilogy with *La última noche* (*The Last Night*, 2003). The box-office returns of the first two caught the attention of US producers and distributors, triggering Disney/Buenavista International's creation of Mexican offices, Miravista, to produce the film *Ladies' Night* (2003), a higher-budget and more-sophisticated take on the same theme. It also inspired Warner Mexico, who coproduced *La segunda noche*, to make *Efectos secundarios* (*Side Effects*, 2006), directed by theater director and *Ladies' Night* scriptwriter Issa López.

Efectos secundarios, funded by Warner, Videocine, and FIDECINE, was released with an unusually large number of copies for its time—358—and brought in Mex\$7.6 million in its first weekend. The story focuses on a group of friends on the verge of turning 30 years old who attend a high-school reunion and relive the anxieties and insecurities of their youth. Representing a generation of self-absorbed, aimless, and materialistic characters, *Efectos secundarios* attempts to offer a comic allegory of Mexico's loss of identity since its economic opening. But while earlier takes on this theme, as in *Cilantro y perejil*, employed conservative values (heterosexual marriage) to explore midlife crisis and sexuality, an ideological evolution can be seen in other films. Beginning with *Sexo, pudor y lágrimas*, the unspoken dilemma of a film that sets up mirroring symmetries of happy and unhappy couples is that coupledom itself is still the ultimate goal, a reality that pushes Demián Bichir's eternal-bachelor character from alienation to suicide (Bonfil 1999a). *Efectos secundarios*, *Ladies' Night*, and other films of the mid-2000s, such as the drama *Así del precipicio* (*On the Edge*, Teresa Suárez, 2006), while still depending on love and sexuality for character motivation, demonstrate a certain amount of assimilation of new values into their stories: today's thirtysomethings don't have to be married, many are not, and some have bigger issues to deal with, most often a major identity crisis.

If heterosexual bachelorhood has become an acceptable status quo, mainstream representation of alternative sexualities remains in a tension between token incorporation to diversify audience reach and a mild condemnation to reaffirm a film's conservative values while boosting interest through taboo topics. *Y tu mamá también* can be credited with making homosexuality a permissible topic, if superficially addressed, within contemporary youth films.[3] Box-office

contemporaries *Así del precipicio* and *Niñas mal* (*Charm School*, Fernando Sariñana, 2007), a youth-oriented comedy cowritten by Carolina Rivera and Issa López, both focus on groups of post–high school women and each includes a lesbian character in a supporting but narratively marginalized role. López's next directorial project, *Casi divas* (*Almost Divas*, 2008) places a transsexual character with equal footing among a group of aspiring actresses who must emphasize their feminine attributes to compete for a lead role in a *telenovela*. Although the character does not win the competition, the ending suggests that her ability to perform gender will lead to a successful television career. López's stories are most notable for adapting the concerns of women in contemporary urban Mexico to the commercial conventions of its contemporary cinema; this holds true for *Casi divas*, a story rife with stereotypes and narrative clichés that nonetheless achieves a certain deconstruction of gender identity, and national identity, in an entirely mainstream film.

Expanding Audiences: Animation, Genre Films, and Period Pieces

With dual access to state support for commercial cinema through FIDECINE and the tax credit EFICINE 226, the late 2000s saw a wave of films seeking to maximize audience reach. The two primary routes were animation and genre films. Aware of the great profit potential of the all-ages audience, the trend in animation began when studio Huevocartoon's *Una película de huevos* (*An Egg Movie*,[4] Rodolfo and Gabriel Riva Palacio) broke box-office records by drawing more than four million spectators. The same creators followed up in 2009 with the sequel, *Otra película de huevos y un pollo* (*Another Movie with Eggs and a Chicken*), which drew more than three million. In 2008, Animex Estudios released *La leyenda de la nahuala* (*The Legend of the Nahuala*, Ricardo Arnaiz), which adapted Mexican cultural legends to an animated children's ghost story. The same formula was used for the sequel, *La leyenda de la Llorona* (*The Legend of La Llorona*, 2011), also written by Arnaiz but produced by Ánima Estudios and directed by Alberto Rodríguez. In 2009, the same director–producer team had released the marginally successful *AAA la película: sin límite de tiempo* (*AAA the Movie: No Time Limit*), presenting Mexican masked wrestling-league icons as the comic-book superheroes that they impersonate. In 2010, Ánima Estudios paired with Warner Brothers to create *Don Gato y su pandilla* (*Top Cat and His Gang*, Alberto Mar, 2011), an original

Spanish-language feature version of the Hanna-Barbera cartoon series from the 1960s. Warner released *Don Gato y su pandilla* with nearly five hundred copies, including some in digital 3D; it became the highest-grossing film of 2011 and made it onto the list of top-ten box-office hits of the decade.

Early in 2007, new production house Lemon Films released *Kilómetro 31* (Rigoberto Castañeda, 2006). Its horror conventions, digital effects, and adaptation of Mexican folk tales brought it close behind *Una película de huevos* in box-office sales, with 3.5 million viewers. Director Julio César Estrada's haunted-house story *Cañitas* (2006) received theatrical release shortly thereafter, followed later that year by *Hasta el viento tiene miedo* (*Even the Wind Is Afraid*, Gustavo Moheno, 2006). Both the latter and Estrada's next film, *El libro de piedra* (*The Book of Stone*, 2009) were adaptations of Mexican horror films released in 1968 that later became cult classics. While Lemon Films went on to test ground with other untapped genre markets, such as suspense thrillers and action films, a number of filmmakers expressed interest in fantasy genres. In 2010, *De día y de noche* (*By Day and by Night*, Alejandro Molina) and *2033* (Francisco Laresgoiti) were released, two of the few science fiction films in the two decades since Guillermo del Toro's *Cronos* (1990); the same year also brought another horror film to audiences, Jorge Michel Grau's story of a family of cannibals living in Mexico City, *Somos lo que hay* (*We Are What We Are*).

Despite the exploration of new genres, mainstream screwball comedies also drew large crowds at the end of the decade: in 2008, *Rudo y Cursi* surpassed three million in attendance by reuniting García Bernal and Luna on-screen for the first time since *Y tu mamá también*. In 2010, the leading film, with just under three million spectators, was *No eres tú, soy yo* (*It's Not You, It's Me*, Alejandro Springall), a remake of an Argentine romantic comedy starring television comedian Eugenio Derbez. In 2011, Lemon Films launched indie/cult director Beto Gómez's most commercially successful film to date, *Salvando a Soldado Pérez*, a narco spoof of *Saving Private Ryan* that drew just over two million spectators. Later that year, the dark Christmas comedy *Pastorela* (Emilio Portes, 2011) reached nearly one million spectators.

One film that seemed to defy all predictable patterns of commercialization was *El estudiante* (*The Student*, Roberto Girault, 2009), under the creative development of writer/producer Gastón Pavlovich. With very little investment in publicity, the film stayed eight weeks in theaters and reached almost a million spectators, according to the filmmakers, based on "word-of-mouth" promotion. The story

follows an elderly man who returns to study at the university and offer sage advice to his new, young friends on how to handle difficult life issues. The University of Guanajuato setting links the city's famous Cervantino arts festival to the script's thematic use of Don Quixote. A subplot follows a female character who becomes pregnant by a married professor and, with almost no discussion of the sexual harassment issue, chooses to keep the child. Aside from the Cervantes theme, it was apropos to set the film in a state where abortion is cause for imprisonment, and congruent with Pavlovich's stated desire to return conservative values to contemporary Mexican cinema. The filmmaker considers this project a response to *El crimen del padre Amaro*, which profoundly offended him; *El estudiante* "allowed him to show the other Mexico that still exists, the one grounded on the values of respect, education, good manners, and family unity" (Olvera González 2010).

Alongside *Rudo y Cursi*, Altavista Films' *Arráncame la vida* (Roberto Sneider) was one of the biggest hits of 2008. In this film adaptation of the 1985 novel by Ángeles Mastretta, Catalina Guzmán (Talancón) marries a Mexican general (Giménez Cacho) who becomes governor of Puebla and a hopeful for presidential candidacy. Set in Puebla and Mexico City of the late 1930s and early 1940s, the cost of reconstructing this era in sets and costumes made it one of the most costly Mexican films to date, with a budget of approximately US$6.5 million. Its box-office success (with 2.4 million spectators, ranking it tenth in top national films of the decade) likely added affirmation to the state's plan to allocate funds toward the production and distribution of a program of films to commemorate the centennial of the Revolution and the bicentennial of Mexico's independence, which would premiere weekly during the months of late 2010. Funding was primarily awarded to high-budget period pieces by established directors, including Felipe Cazals's *Chicogrande*, Jorge Fons's *El atentado* (*The Attempt Dossier*) Antonio Serrano's *Hidalgo, la historia jamás contada* (*Hidalgo, the Untold Story*) and Francisco Athié's *El baile de San Juan*. (*The San Juan Ball*)[5] Included in the celebratory program but varying the formula were Luis Estrada's *El infierno*, a parody of these very 2010 festivities set in Mexico's contemporary drug cartel culture; Carlos Kuri's animated film *Héroes verdaderos* (*True Heroes*); and Canana Films' *Revolución*, a compilation of ten short films by young directors and set in varying time periods. Outside of the commemorative program, two other historical dramas from recent years, *Desierto adentro* (*The Desert Within*, Rodrigo Pla, 2008) and *Los últimos cristeros* (*The Last Christeros*, Matías Meyer, 2011), have taken up controversial topics by

setting films during the Cristero War of the 1920s. An adaptation of the same theme, almost concurrent with the latter but antithetical in tone, was produced for English-language and US-Latino audiences in *For Greater Glory: The True Story of the Cristiada* (Dean Wright, 2012), starring Andy García and Eva Longoria.

The *Other* Audience

In the metropolitan areas of Mexico where multiplex theaters have been concentrated, the exclusion of a large segment of the population from consuming cinema in theaters is not solely economic. The deregulation of ticket prices in the mid-1990s coincided with an increase in violent crime, the combined effect of mass urbanization, economic crisis, and a frail justice system. The concerns over public safety during this time period added a sociotopographical perspective on this divide by taking the social activity of going to the movies out of public space and into the privately patrolled sanctuary of the shopping mall. *Todo el poder* and *Amores perros*, among the first films to target the more affluent audience, were already incorporating this concern into their narrative by showing the penetration of violent crime into upper-class spaces. Within a few years, other films would depict the multiplex itself as one of the seemingly secure, private spaces to be affected by crime: *Manos libres* (*Hands Free*, José Buil, 2005) narrates a young girl getting kidnapped while going to a movie and *Asalto al cine* (*The Cinema Hold-Up*, Iria Gómez Concheiro, 2011) depicts a gang of four teenagers from a working-class neighborhood who hold up a movie theater.

The topographical distinction between the public and private urban spaces creates an imagined reinforcement of economic boundaries that is consistent with neoliberalism's need for class stratification. The exclusion of the lower classes from these spaces and from market participation is, like in other inflated markets, held in place by a black market that makes lower-quality goods available at 25 to 50 percent of the price: DVD piracy. The price is even more accessible in that it allows for multiple viewers and repeat viewings, and also cuts out additional costs, such as transportation.

> Mexico has the perfect breeding grounds for the successful develop of an audiovisual black market; on the one hand, there are the existing socioeconomic conditions for a broad market exclusion, and on the other hand, a corrupt judicial system with plenty of loopholes. (Gómez García 2005, 265)

Legal and economic policies together create a bind for the consumer with their contradictory permissive actions and condemning rhetoric. Although the MPAA is vocally against piracy, this alternative market allows multiplex ticket prices to remain high without much resistance. Mexico's law enforcement tolerates piracy to the same extent that it tolerates the vast sector of informal commerce on the streets of the cities, as it is a source of income for a large segment of the population, a band-aid solution for unemployment issues. At the same time, antipiracy campaigns—on television, in theaters, on billboards, and on labels—constantly announce the act as illegal, keeping those who cannot afford cinema on the margins of the law and of cultural consumption, reinscribing them in same category of criminality that justifies their exclusion from consumer spaces. An example of an antipiracy ad running in 2007, shown in theaters along with trailers, begins with a working-class single mother returning home exhausted after work and bringing a recently purchased pirate DVD for the family to watch; when the mother chastises her son for not studying, he responds that he bought the answers to the exam and argues that it is not cheating, because he *paid for them*. The studious and scrupulous daughter implies that the mother's act of buying a pirate DVD set an example for her brother's actions, declaring the purchased exam, "Just like your movie." In another ad, a group of preteen girls gangs up on a friend, telling her that the fact that her father buys her cheap, illegal films indicates the lesser quality of his love for her.

Despite being part of informal commerce, black-market sales in Mexico are elaborately structured around hierarchies of suppliers and vendors, with commissions taken at various levels of management from distributors to street merchants, and include bribe payments to government officials, such as customs agents. In the case of film piracy, the source of prerelease access to films is generally not addressed in official discourse, though the newness of the technology lends itself to a myth of an underground network of computer hackers and electronic transnational smuggling. The case of *El laberinto del fauno*'s processing for its Mexican release in October 2006 revealed a much more embarrassing reality for the Mexican government. The first copy of the film to enter Mexico from postproduction in Spain was a watermarked print that went directly to the RTC offices to receive its audience-restriction rating and then to the SEP's copyright offices. When the watermark appeared in the pirated DVDs on the streets of Mexico City, *El laberinto*'s producers traced the leak, ironically, to the copyright offices, which the SEP adamantly denied ("Niega SEP piratear" 2006).

Mexico's exhibitors are the first to point out that in countries without piracy problems commercial DVD sales often make up half of a film's income; while piracy may indeed hinder a domestic film's chance of recouping investments, it is also a useful scapegoat for taking the focus off exhibition conflicts, including box-office repartitions. And because the purchase of pirated DVDs cannot be factored into a film's reported audience, the buyer's purchase does not count in the free market's so-called democracy of taste, despite the fact that the available choices are dependent on mainstream programming. Piracy also highlights the exclusionary practices on the level of theatrical programming: it is an alternative outlet for domestic films that are bumped from the theater lineups. Even though it detracts from financial returns, some filmmakers recognize the value of this market in the publicity and distribution of the film—as with Luis Mandoki's documentary series on Andrés Manuel López Obrador. Nonetheless, the symbolic capital in piracy exchange is precisely in its underground status, getting desirable films for lower prices as they premiere in theaters, if not before, and in that sense consumer choice is still largely linked to blockbuster releases, including those from Hollywood.

Mexico's New Producers Find the New Market

When veteran film producers and educators were asked in the 1990s what their most urgent advice would be for the rising generation of filmmakers, the response was fairly consistent: that the filmmaking process *must* be professionalized. This has been initiated within film education, at the CCC and at Centro Universitario de Estudios Cinematográficos (University Center for Film Studies, CUEC), where an effort has been made to move away from the notion that a first-time filmmaker must take on the roles of directing, writing, producing, shooting, and editing at once. The film schools have sought to broaden students' career options by offering specializations that nurture individual skills and talents and strengthen the level of professionalization in those areas when graduates go on to work in the industry.

The role of the producer has also been made more central within the industry, often using established producers like Bertha Navarro and Jorge Sánchez as models to illustrate a position of leadership on par with that of the director, but with different responsibilities. Navarro herself sees the producer as essential in acting as an intermediary between the creative and commercial aspects of the film, reconciling the demands of the artists with those of the financial backers

to arrive at something also desirable to audiences. Navarro sees the commercial appeal demanded by investors as necessary in as far as creating a national audience, one that will support noncommercial cinema as well (Casas 2005, 103).

Mexico's more seasoned producers are adept at negotiating these two sides of filmmaking, and also for assessing the risks and benefits of artistic innovation in cinema. Whereas IMCINE's two funds categorically divide films into subsidized art projects and profit-rendering investments, individual producers such as Navarro, Valdelievre, or Miravista's Inna Payán are willing to take on artistic films if there is enough personal passion for the project, both theirs and that of the director. *Sexo, pudor y lágrimas* producer Valdelievre invested in Eimbcke's *Temporada de patos* because he liked the story itself and also appreciated that the director was a perfectionist who had a clear vision of how a minimalist style would allow his project to not exceed the capabilities of his somewhat novice filmmaking skills (Valdelievre, personal communication, June 2007). Payán felt "gratification" working on *Ladies' Night*, a film she considers to be high quality in its production, and at the same time appealing to a wide audience. She also took on *Historias del desencanto* (*Stories of Disenchantment*, Alejandro Valle, 2005), an extremely personal, ambitious, and esoteric project, because she admired the director's vision and passion. Payán places her faith in "people," trusting the individual talent and motivation behind the film to create a connection with the audience (Payán, personal communication, June 2007). Both Valdelievre and Payán, while recognizing a distinction between their commercial and artistic projects, do not have a clear definition of either, and like most private producers, consider "quality" to be the common denominator in all of their projects. An evasive term, "quality" as defined by both producers seems to imply a combination of the artistic talent and fastidiousness of an individual.

This combination of ambition and clarity of vision is notable in the work of the younger generation of producers. Two young companies that exemplify this, with staffs and crews generally in their twenties and thirties, are Lemon Films and Canana Films. Lemon, started by heirs to the Azcárraga/Televisa fortune Billy and Fernando Rovzar, produced the film *Matando cabos* (*Killing Cabos*) in 2004, a relatively well-received dark comedy with kitschy references to popular genres, such as Mexican wrestling films and film noir. Lemon's next release, the horror film *Kilómetro 31*, had a deep budget for marketing and special effects that were key in its box-office numbers. The reintroduction of the horror genre, not common among contemporary

Mexican productions because of the competition with high-budget Hollywood special effects, is an example of one of Lemon's primary goals: to revive popular genres that are considered unachievable under Mexican budget and technical restraints, with the intent of allowing the descriptor "Mexican" to reflect a film's national origin, rather than be a pejorative genre label that for audiences typically connotes melodrama. For Lemon, this comprises both the company's mission and its method for stabilizing a profitable, nonsubsidized production house in Mexico—a feat achieved by few. However, the same exasperation with application of "Mexicanness" as a filmic category is used as the ironic title of a film coproduced by Canana Films, *Drama/Mex* (Gerardo Naranjo, 2006), which in fact revives and reappropriates the tradition of melodramatic realism for a young, irreverent, but cinematically sophisticated audience. Canana was started with the celebrity status and financial backing of actors Luna and García Bernal and maintains a concern for social issues and regionally diverse representation that is absent from Lemon's ambitions. Canana's most visible project, aside from their collaborations with Naranjo, is Ambulante Gira de Documentales, a festival of documentary films that circulates throughout the country, promoting social and educational concerns. The festival's itinerate nature follows Canana's mission to promote stories that reflect Mexico's geographical, socioeconomic, and cultural diversity.

Much of the younger generation of producers came into their careers when marketing was already a high priority and many have added to the more traditional practices with new approaches to youth marketing, especially for the urban demographics. The content of the film can sometimes be sufficient to generate organic publicity, as seen in the struggle over ratings and censorship. Conventional methods such as billboards, theater and television trailers as well as the use of actors in press interviews are considered the most dependable, although the marketing era coincides with an increase in Internet advertising, promotional websites, and forums connected to well-known sites (such as esmas.com) to target youth audience. In more recent years, social networks such as Facebook and Twitter have become mainstays for distributors promoting new releases. Recognizing a limited access to Internet[6] as well as the saturation of media images, some campaigns have experimented with more tactile or accessible mediums to reach their audience, and to push the limits of the expected. For example, Lemon's macabre mannequins of dead children—attached to the cardboard stands used within the cineplexes—are credited with much of the film's attention (see figure 2.1). Stickering or tagging telephone

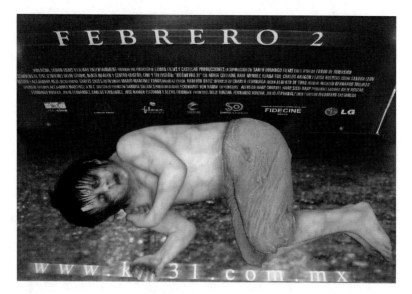

Figure 2.1 Lemon Films' macabre marketing for *Kilómetro 31*. Courtesy of Lemon Films.

poles, graffiti stenciling the exterior of buildings, or papering the walls around construction sites mimic the guerrilla advertising techniques of urban artists and musicians. *Drama/Mex*'s stencil graffiti and papering, combined with its dark slogans "Your misery is my happiness," "I hope you die," and "Do you think I care?" (see figure 2.2), targeted the cynical twentysomethings who would identify with its characters. At the same time, offsetting production and publicity costs via product placement is also on the rise, thanks to corporate interest in the new audience; product brands have made cameos in a variety of different genres, including a WonderBra billboard in *Sexo, pudor y lágrimas*, Corona beer in *Matando cabos*, and Microsoft XBox in *Temporada de patos*.

While the importing of new production models, the attempt to diversify the genre offerings, and the updating of visual styles all fall within the rubric of globalized media, there has been a notable effort to customize these changes to the tastes of national audiences and to maintain the tradition of a national audiovisual culture. García Canclini's 1993 essay on the future of cinema expresses a concern that the film market worldwide is shrinking in response to a surge in home entertainment, and yet notes that losing the audience's point of identification in the face of globalization is not necessarily an issue. He

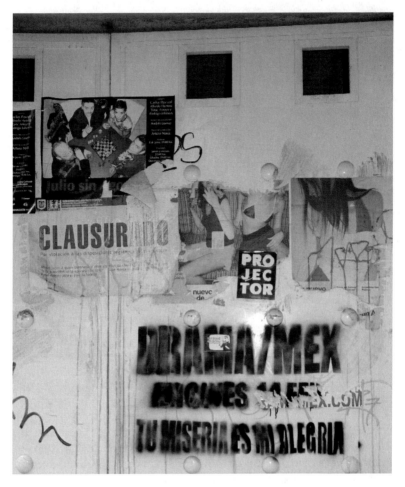

Figure 2.2 *Drama/Mex*'s guerrilla advertising, with the slogan "Your misery is my happiness." Courtesy of author.

describes a wave of "reterritorialization" and local community building in response to "deterritorialization," and predicts that these new identities can be accurately depicted in the complexity of the characters, situations, and geographies of recent cinema (1997, 256). From an investor's standpoint, Valdelievre confirms this theory, insisting that "there will always be a local market for local cinema" (personal communication, June 2007). Nonetheless, some media voices have recently begun to doubt the supposed savvy of the new spectator when analyzing which films truly reach a wide audience, as with the guaranteed

triumph of series like René Cardona Jr.'s eight *La risa en vacaciones* movies throughout the better part of the 1990s, or of María Elena Velasco's "La India María" comedies. Looking at 2006 box-office numbers, Solórzano compares the moderate success of the political satire of PAN politicians in Luis Estrada's *Un mundo maravilloso* to the off-the-charts success of narrative simplicity and potty humor in *Una película de huevos*. She concludes that although *albur* (humor based on light sexual double entendre) and politics seem to be the last infallible connections with the Mexican audience, "[when offered] the two depictions, Mexico chooses drawings of eggs over the country's reality" (2007, 65). The same conclusion could be drawn when comparing the top-two biggest Mexican box-office hits in 2010: the macabre satire *El infierno* with two million spectators and the formulaic ridiculousness of the comedy *No eres tú soy yo* with three million. Nonetheless, the success of a Mexican film cannot be removed from the context of its marketing and publicity, and the circumstances of its release. Without taking these elements into account, one runs the risk of affirming free-trade ideology's tendency to confuse choice based on taste with choice based on availability.

Chapter 3

Censorship and Sensationalism: *"el neotremendismo autoritario"*

Despite having been removed from legislative vocabulary as of 1949, film censorship in Mexico is still attempted, and often successful. In tracing out a history of censorship practices in Mexico, the complexity of its systems of power becomes evident. Throughout the century, conservative religious groups have dictated codes of moral decency, but at specific moments religion itself has been banned from cinematic representation. Historically, depictions anything less than eulogistic of the president, the army, or the Virgin of Guadalupe were prohibited (Ugalde 2003); but as Mexico moves toward projecting globally the profile of a progressive democratic nation, it can no longer use policy to openly squelch political dissidence. Instead, it presents the RTC's ratings system—modeled after the US film ratings system—as an impartial method of ranking a film's suitability for public viewing. Although the RTC continues to dictate the defining parameters of explicit violence and pornography, since the 1970s these themes have posed much less of a concern for censors than negative representations of the nation, the upper classes, or the government itself, particularly with regard to corruption and repressive actions against citizens. In twenty-first-century Mexico, different forms of censorship still in practice and constituting both formal and informal policies are carried out by authoritative bodies in definitive, coercive, or passive methods; by filmmakers themselves in the case of self-censorship; or by distributors and exhibitors when commercial concerns are at play.

The relationship between Mexico's film industry and its economic policies is central to understanding the ambiguities of censorship's current status. Mexico's political powers still hold a substantial amount of control over which films get produced and seen, although

in recent years the media and individual filmmakers have been able to spin a number of film censorship cases so as to generate more box-office sales for the film in question; and this practice has not gone unnoticed by exhibitors, for whom controversy has become a commodity. The subtitle of this chapter translates as "authoritarian neosensationalism," a combined reference to Ayala Blanco's labeling of *Amores perros* as "*neotremendismo chafa*" ("cheap neosensationalism") and Lorenzo Meyer's critique of Salinas's policies as "*liberalismo autoritario.*" While Ayala Blanco sees the trend of stylized violence in Mexican cinema as a gimmick to ignite publicity through shock value, Meyer sees free-trade policy in Mexico as an inevitable failure because of the state's inability to break free from its long-held authoritative practices. The paradox of authoritarian neosensationalism, in which films are not only still unofficially censored but also profit from their anticensorship media campaigns, is one of the many contradictions left by the uneven application of economic policy to the film industry within the context of an incomplete political transition. From this example, one can see that the prohibition of censorship is not limited to the authority of the state imposed on cinema, but rather consists of a network of interacting proscriptions and counterproscriptions against expression that operate on multiple levels, from international policy to social norms to individual morality.

In articulating what has changed over the past few decades, it will be important to elaborate a distinction between direct and indirect censorship, the former referring to the traditional notion of cutting scenes from reels before releasing it to the public, or banning the film, which includes destroying or canning and shelving the reels. Reviewing the history of censorship in Mexico elucidates the fact that despite a general shift in recent decades from direct censorship toward the more subtle practices of monitoring cinematic content, even in the early years of the industry indirect censorship and self-censorship existed alongside cinematic "moralizing" campaigns. It is also essential to reevaluate existing categorical terms, such as "economic," "political," or "ideological" censorship, particularly with regard to the interaction of artistic creation and economic policy in contemporary cultural production. This reevaluation will offer a more nuanced understanding of what indirect censorship implies and the breadth of possible interventions to suppress cinematic content that it may include.

As case studies of censorship, *La ley de Herodes* and *El crimen del padre Amaro* are two films that describe corruption and were the object of campaigns to prevent their theatrical release. The first uses satire to point out the corruption of the state; the second—though

also accused of ridiculing authority—uses a serious melodramatic tone to represent the corruption of the Catholic Church. Film critic Luis Tovar's comments on the censoring of *La ley de Herodes*, two years before the release of *El crimen del padre Amaro*, is ironically prescient of the connections between the two cases:

> The attitude of our film authorities really reminded us of the plot of *The Name of the Rose*, the film adaptation of Umberto Eco's novel: Father Jorge hides the Aristotle book that speaks of laughter—and punishes with death he who dares to read it—, because laughter eliminates fear and without fear nobody would need God. (2000a)[1]

The thematic overlap of political and religious authoritarianism links Mexico's censorship history to the current happenings in the audiovisual industry. Each of these films, both by screenwriter Vicente Leñero, follows an antiheroic struggle, with moral integrity at the heart of the story. Each narrative was also juxtaposed with an external, high-profile event that framed the fictional realities within the nation's momentous millennial history, giving the films' controversies more relevance within media coverage beyond of the entertainment industry.

Censorship and Repression

The first—and possibly most critical—point to examine when looking at the current interactions between the control over cinematic production and exhibition and what has historically been referred to as "censorship" is that its repressive forces are not unidirectional. Mexico's media industry is a particularly complex context in which to consider the traditional suppression of ideas and images, given the conditions of its political transition, the contradictions of its "authoritarian liberalism" since the implementation of free-trade policies, and the state's long history of ambiguity regarding the Church's role in education and indoctrination. One can begin to understand the complexity by mapping out a series of restrictions, taboos, or pressures exerted upon policymakers, filmmakers, investors, and consumers as they relate to cinema and the film industry. For example, despite Mexico's long history of presidentialism[2] and authoritative control over the press, including gross atrocities committed against journalists who attempted to expose abuses of power, the country remained largely unnoticed by international human rights groups throughout most of the twentieth century due to a certain amount of protection from the United States (Aguayo 2000, 34). However, with the turbulence of the Salinas

administration and the interest of eager investors in Mexico's future stability prior to NAFTA, the country's policies fell under deeper scrutiny. As the rhetoric of neoliberalism promised to turn Mexico into a prosperous, democratic, "First-World" nation, the contradictions of political practice could be seen in attitudes toward censorship (Meyer 1995, 161; Yudice 1998, 367). While Salinas's rewriting in 1992 of the LFC insisted that during commercial exhibition films "shall not be subject to mutilation, censuring, or edits on the part of the distributor or exhibitor, save with prior authorization by the rights holder," it also mandated that films receive authorization from the RTC prior to exhibition, maintaining SEGOB's control over content.[3]

Under the same legislation, the film industry was opening up to free-trade policy, and yet cinema's valorization as cultural production was important in the rhetoric of national unity. As one scholar points out, "official acts were directed toward stabilizing public opinion by increasing government initiatives to gain supporters," including the government's attempts to "seek the consensus of different social actors and independent filmmakers, supporting their work with funds and incentives in an effort to gain legitimacy" (Saavedra Luna 2007b). This was particularly the case with film censorship, in a time when several previously censored films were released: "The subject of censorship was also present despite the fact that complete freedom of expression was affirmed as part of the political banner, which was seemingly demonstrated with the authorization of films previously considered polemical" (Saavedra Luna 2007a, 35).

In later years, the Vatican's renewed interest in Mexico as a predominantly Catholic population generated an opposing pressure, that is, for Mexico to promote a conservative image to the rest of the world. This movement to recharge the Church's strength dredged up the Revolutionary government's historical repression of religious practices in the 1920s, which itself contradicted the Church's later collaboration with the state in its "moralizing" campaign through cinema. Catholic groups of the 1940s initiated this campaign and formed the principal institutional bodies of cinematic censorship. In the transition—at least in appearances—from authoritative to democratic film policy, the language of the early religiously oriented censorship codes carries over into the institution that now oversees film authorization and ratings, continuing a certain inseparability of religion and politics. These institutional documents established the norms for the most basic and traditional taboo of film censorship: the imposition on individuals (as film spectators) of a prohibition against watching immoral films or modeling their behavior after immoral (or amoral) characters. From the

angle of creation, filmmakers are in constant negotiation with whether to conform to or break with the delimitations of what is considered "representable" in terms of artistic expression, commercial viability, legal implications, or some combination thereof (e.g., how expressions of sexuality might impact RTC ratings, which can drastically reduce a film's box-office sales through age restrictions). At the same time, condemning prohibitive practices under the name "censorship" has the potential to generate attention for a film and turn prohibition into intrigue. A typical marketing slogan used by filmmakers who feel they are the object of censorship is exactly the reversal of the taboos placed on viewing the films: for example, Luis Estrada used *"Por qué no quieren que la veas?"* ("Why don't they want you to see it?") to launch *La ley de Herodes*, inviting potential spectators by way of subtly reproaching an unwitting obedience to conservative practices or conformity with traditional values, enticing them to see the film precisely to experience its taboo content (Estrada 2000).

So, how then does this apparatus of censorship inhibit and what does it produce? Michel Foucault's *History of Sexuality* presents a view of how repression can be read as generative, that is, when institutional power creates an "incitement to discourse" around the repressed idea (such as sex) and subsequently its insertion in multiple spheres of daily life, including medicine, education, religion, psychology, architecture, and so on (Foucault 1990, 18). In Mexico, censorship not only generates controversy, but also fosters the conditions for an insistence on speaking about the taboo, in the media, in legislation's extensive documents elaborating what concepts and images are unacceptable, in the language used by the RTC regarding what qualifies as "adult content" or in its reports on specific films, in education policy, and in the public discussion of the point of debate. Furthermore, if we take into account not just the prohibitions on film content but also the prohibition on censorship within democratic politics, then the works that do circulate are the product of the latter repression. To conclude this chapter, we can see how a more recent wave of films has been produced already anticipating the tension between these two forces, a trend that has created a generative economic force within the market.

A History of Censorship in Mexico

Censorship in Mexico officially started in 1913, under Victoriano Huerta, with the prohibition of any image that contained "attacks on authorities, other people, morality, good manners, peace and public order," or any depiction of unpunished crimes or misconduct

(Ugalde 2003). While there was some lightening of censorship during the second half of the Revolution, it was legally reinstated under Carranza in 1919, with the Reglamento de Censura Cinematográfica (Regulation of Film Censorship), which established SEGOB as the regulating agency. The law focused primarily on imported (e.g., from Hollywood) films' depictions of Mexico but also censored problematic representations of national heroes.

However, two years earlier two significant and oppositional changes occurred that would have residual effects on the political and moral censorship throughout the rest of the century: the new Constitution and the new growth of the Caballeros de Colón (Mexico's Knights of Columbus). The 1917 Constitution, marking an end to both the Revolution and the prior authoritarian reigns, included several articles aimed at secularizing government policy, concerned that the Church had too much power of influence. The anticlerical legislation, including the secularization of public education, put strict limits on religious practices and teachings, creating the tension that would lead to the Cristero War in the late 1920s. According to a series of essays published in the late 1930s by film director Alejandro Galindo, this anticlerical sentiment carried on well after the end of conflict and representations of Catholicism were considered inappropriate in cinema as production entered into its Golden Age:

> In our cinema, one cannot mention God, not even from the lips of a mother, even if the development of the drama requires it; that a person should fall to his or her knees and pray before an image is inconceivable, because one of the censors would immediately destroy that scene, or the whole film itself, the aphorism of pointing it out as "religious propaganda." (2007b, 25)

But this effort by the state to avoid propaganda was undermined by the strength achieved by Catholic groups in regulating cinematic content. The Caballeros de Colón, initiated in Mexico in 1905 but lacking any significant growth during the Revolution, surged in 1917, fueled by the Catholic resistance to the new constitution (Zermeño 1997, 82). This group

> was to carry out, in effect, an essential role in the reorganization of the post-Cristero Church, in particular the moralizing campaigns that would take place between 1930 and 1960: the corps of leaders and authorized censors, at least until the 1970s, would be the Caballeros de Colón. (1997, 81)

The group saw cinema as a new and extremely influential medium of expression and made it their concern not just to warn against immoral or indecent acts in films, but also to promote those films in which moral behavior was well modeled. In 1929, as the state was reorganizing and consolidating secular institutions with the objective of national unity, the group Acción Católica (Catholic Action, AC) was formed in Mexico by the Caballeros de Colón with the "intention of unifying into one organization...all types of Catholicism" (1997, 81). The focus of this group, by way of the Caballeros, "was concentrated on moralizing society, understood as the need to re-Christianize it" (1997, 81). By the mid-1930s, the Caballeros and Acción Católica had gained significant influence over the censorship process and went on in 1934 (at the same time that the Hays Code was being instituted in the United States) to form a third subgroup: "By the beginning of 1934, just as in the United States, the Acción Católica, on the initiative of the Caballeros de Colón, formed the first Commission of Censors" (1997, 80). The group took the name La Legión Mexicana de la Decencia (Mexican Legion of Decency, LMD) and would continue to monitor the moral content of film production into the 1960s (Zermeño 1997, 80–81; Monsiváis 2006). They sent out "*apreciaciones*" (recommendations) in their bulletin advising heads of family as to which films to see (Zermeño 1997, 84). The moralizing campaigns reflect an exaggerated importance placed on the power of the cinematic image to influence the masses, an idea that becomes inverted in the sensitivity of the censor when dictating what should *not* be seen. By the end of the 1940s, the new Código de Producción Cinematográfica (Film Production Code, produced between 1948 and 1953) would go so far as to protect priests from criticism, contradicting earlier anticlerical legislation: "No religion or its clergymen should be the object of comedy. Showing a priest of any religion with any minor human faults is admissible, as long as it puts into relief a constant effort to correct his own behavior" (cited in Zermeño 1997).

Zermeño emphasizes the transformation of both the alliances and the goals of these related Catholic groups over the course of a few decades, from being primarily religiously affiliated and morally concerned, to collaborations with the state, to eventual commercial pursuits. As of 1937, the episcopate declared the LMD "*obra nacional*" (work in service of the nation) and it became the "only [group] authorized to conduct film censorship" (1997, 85). The LMD went on during the presidential terms of Alemán and Adolfo Ruiz Cortines to establish "a major influence on the formation of public and Catholic

opinion, by being able to pressure and directly denounce a film's exhibition before the State Department of Film Censorship" (1997, 85). Just as political and religious censorship seemed to find common ground in establishing these new government agencies, economic factors, too, began to overlap with politics and religion. When the government mandated that a film be viewed in order to obtain permission for exhibition, the screening departments of Mexico's Federal District began to charge a tax of Mex$2 per reel for each "supervised film" (Galindo 2007a, 23). The Church recognized the industry's commercial appeal. In 1948, the archbishop authorized two men, with both strong Catholic backgrounds and experience in business, to become official distributors of 16mm films censored by priests, provided the priest themselves made no financial gain (Zermeño 1997, 86).

In 1949, the words "authorization" and "supervision" officially replaced "censorship" in film policy (Ugalde 2003). And as Mexico moved into the authoritative regimes of the mid-century, it became clear that the moral content of cinema was less important than its portrayal of political or religious figures. Sexually risqué material was still monitored by the LMD, but with problematic themes extending to anything that instigated "social hatred" or class conflict (Ugalde 2003). This applied to films that might blame the upper classes for Mexico's socioeconomic imbalance and the problems of the poor, such as Luis Buñuel's *Los olvidados* (*The Young and the Damned*, 1950), which, in order to be exhibited had to add a voice-over at the beginning of the film to explain that the story referred to an international crisis that was not unique to Mexico. Emilio Fernández's *El impostor*, based on the play by Rodolfo Usigli, could be considered a precursor to *La ley de Herodes*, censored for its critique of the PRI; made in 1956, it was not released until 1960 (Ugalde 2003).

Outside of cinema, the main thrust of political censorship was not necessarily Church influenced, but rather stemmed from the tight control of the press by the presidential office, beginning in the 1950s with Miguel Alemán, and continuing in the 1960s, with Adolfo López Mateos and Gustavo Díaz Ordaz's explicit repression.[4] Censorship did, however, operate largely through commercial control over cinematic representation. According to Ugalde, the media's ostentatious avoidance of political critiques projected the illusion that the country was reaching a state of utopian stability, with "incorruptible police and authorities, as well as speedy, efficient, and egalitarian administration of justice for everyone" (Ugalde 2003). It was the challenge to the idea of incorruptible leaders that kept Julio Bracho's *La sombra del*

Caudillo (1960), said to criticize the army and the president, out of cinemas until 1990. Ugalde comments,

> This false image was the result of an iron-fisted censorship resulting from the Producers–State collusion in which the former did not film subject matters that were problematic or bothersome for authorities and, in exchange, received support for the distribution of their films through the recently nationalized state exhibition chain, Operadora de Teatros, and through the distributors Películas Mexicanas and Películas Nacionales. (Ugalde 2003)

Economic censorship, addressed decades earlier by Galindo, was clearly still in effect, and still not mutually exclusive from political censorship.

The weakening of the Catholic groups in the 1970s seemed to allow for an opening up of content in the cinema (less so in television), breaking new ground with sexual and moral content. In a time of financial crisis in the film industry, sexually exploitative genres like the *fichera* were particularly appealing to producers due to their low cost and the strong audience-draw of their racy content. The rigor of the censorship authorities, be those the president, the Censorship Department, or the RTC (established in 1977), would continue to change, as did the criteria for what these "morals" and "good values" included.

Throughout the latter half of the century, denouncement or suspension of censorship itself became a populist gesture used by some regimes to demonstrate a more progressive side or to highlight a moderate position on a particular issue. This was the case with the *sexenio* of Luis Echeverría, whose exuberant support for communications and cultural production led to the nationalization of a flailing film industry (putting his brother at the helm) and was intended to distract attention from the atrocities committed by the previous administration, in which Echeverría was secretary of the Interior. While overall production numbers crashed in the 1970s, state subvention was high, as was the quality of the films produced and the permissibility of controversial topics. The years of López Portillo saw a complete backtrack, with the appointment of his sister to head the newly formed RTC, which knocked state production down to an all-time low and shot arbitrary censorship back up through the roof. With the advent of neoliberalism under de la Madrid, funding cuts became the primary means of stifling film production, while letting the blame fall on the market itself (Ugalde 2003). Salinas's plan to combine free-trade and national culture seemed to swing the pendulum back toward Echeverría's cultural

liberation, the former being the president who would finally release *La sombra del caudillo*, as well as Fons's *Rojo amanecer*, which had been produced but not released during de la Madrid's term. Despite this public display of freedom of expression, Salinas's legitimacy as president was tenuous following suspicions of electoral fraud, and as a result, "there was a notable increase in censorship"; forbidden topics included anything that brought to mind Salinas's leftist opponent, Cuauhtémoc Cárdenas, including references to former president Lázaro Cárdenas (Ugalde 2003). Salinas's 1992 cinema policy passed into law the film-ratings recommendations that had been established by the RTC in 1989.

According to Ugalde, film production under Zedillo dropped to an average of 16 feature films per year, evidence that "censorship was carried out through financial control" (2003). At the end of this term, which had four different directors of IMCINE, the controversy surrounding *La ley de Herodes* started to surface. At this time, it was clear that the funding restrictions went beyond financial limitations, as when the agency's third director, Eduardo Amerena, declared that he would not fund the production of *"perredistas"* (leftist, referring to PRD) scripts, although he later clarified that he was referring to any film critical of the current administration (Ugalde 2003). Vicente Fox's administration, coming out of what was said to be the first truly democratic elections in Mexican history, was vociferous about transparency of political and corporate actions, and initiated the opening of the national archives to information requests from the general public.[5] Nonetheless, a number of filmmakers during these last two *sexenios* have made claims to indirect censorship, especially the inability to complete or to exhibit their films, often blaming IMCINE. *El crimen del padre Amaro* was the most visibly controversial film, although in this case the state was blamed for funding it and the Church for boycotting it. One of the last films produced under Fox was *El violín*, which struggled to get distribution but was eventually released in 2007. Because of its critique of the army, the filmmakers promoted the film with almost the same slogan used by Estrada: "Find out why they don't want you to see this movie." But others saw this as a ploy by the producers to up the film's sale price, given that distributors were not anxious to invest in a black-and-white film with nonprofessional actors.

Indirect Censorship and Paradigms of Power

Describing the early years of the film industry, Carlos Monsiváis laid out the roles of different censoring agents: "The state looks after the

limits of cinematic expression, producers exercise self-censorship and the Film Commission and the League of Decency approve or disapprove the candor of the movie-theater offerings" (2006). Discussions of censorship in twenty-first-century Mexico seem to pivot on questions of linguistic definitions, debating whether traditional authoritarian practices of controlling expression are still carried out and whether the contemporary context deserves such a harsh label. In response to the 1999 incidents surrounding *La ley de Herodes*, a *New York Times* article quoted Tovar y de Teresa as saying, "Censorship no longer exists in the political lexicon of Mexico" (Preston 1999). Rebutting this official rhetoric, discouraged directors, writers, and producers proclaim that this transition was merely a shift from direct to indirect censorship, the latter being primarily economic in nature. These economic measures include limited funding opportunities, lack of publicity, difficulty in securing distribution, restrictive RTC ratings, and bad positioning of the film within an exhibitor's lineup, imposed by government or corporate agents, including the policymakers who support corporations before artists. But state officials, such as Tovar y de Teresa, and corporate leaders, such as Cinépolis CEO and CANACINE president Alejandro Ramírez, simply lament these as the list of hardships that a film must overcome in Mexico in order to possibly succeed, with no one to blame but the market, the poor quality of domestic productions, or the country's economic difficulties. At the same time, many filmmakers critique their own peers for *self-censorship*, defined as tailoring one's work to meet the approval standards of authorizing or funding agencies, as a passive solution to overcoming these economic roadblocks.

The inefficiency of the categories of censorship makes its discussion that much more nebulous. While current debates use *economic* censorship interchangeably with *indirect* censorship, as a replacement for *political* censorship, the terms cannot be easily separated, given the relationship between business and politics. Furthermore, common uses of the terms tend to conflate means and methods. The distinction becomes ineffectual when considering that political agents may use both economic and legal means to censor a film, and the commercial censorship may be intended either to protect a political relationship (a big-picture economic concern) or to protect investments from the potential loss caused by restrictions or controversy. Other models attempting to elaborate an understanding of censorship distinguish between the stages of production in which a censor may intervene, anywhere from script, to production, to exhibition. These older models tend to point out the internal/external aspect of censorship, being

that in the later stages, those of circulation, restrictions are inevitably placed by agents external to the film's creation.

Following the latter model, indirect censorship can be understood as not following the timeline of traditional direct censorship, which is imposed after a film is produced, when it is seeking official approval for circulation from outside authorities. Rather, the insidious nature of indirect censorship lies in that it can take place throughout the creative process. For example, at any moment a producer can enter an editing room and "recommend" edits that are going to benefit the movie, the investors, or the production company's public appearance. At the same time, a creative decision can be made to include controversial content, either for its commercial appeal or to break ground with political/artistic expression. All of these small potential points of intervention into a film's final product do not describe a clear model of state regulation, but rather a web of interests that are neither purely artistic nor purely political. When considered this way, the term is insufficient to distinguish the acts that seek to limit a film's expression from the social conditions that foster such acts and their benefits.

Christian Metz's theoretical work on censorship sets a categorical scheme, distinguishing three types. Political censorship, or censorship proper, is based on moral standards and is institutional in nature (referring to its external imposition); economic censorship is based on commercial criteria and imposed by the producers as a form of self-censorship and can be considered institutional in a case such as Mexico, in which state and industry overlap; and finally, ideological censorship is imposed by the filmmaker or writer who has internalized the institutional limits on filmmaking (Metz 1974, 236–37). These three forms of censorship fall on a timeline, beginning with ideological, which takes place at the moment a film is conceived of, continuing with economic, and ending with political, at the moment of distribution or exhibition.

Departing from Metz's three-point description, I suggest a more useful visualization of contemporary regulation of filmic content focusing specifically on the suppression of ideas—that is, what is not expressed, as opposed to what is expressed—arranged not as categories but rather as a series of intersecting continuums. These continuums describe independently the *motivation* for suppressing content, the *means*, the *relationship to the creative conception*, and *depth of its ideological embedding*, and together map out the nuanced connections between the internal creative process and the external legal suppression of ideas. The *motivation* for suppressing content falls on a spectrum of

political, artistic/aesthetic, or commercial choices, the emphasis being that none of these is completely exclusive to the other. The spectrum of *means* can range from direct legal action, such as banning a film's exhibition or cutting scenes, or the indirect methods above, many using funding as a way of limiting a film's survival. The relationship that suppression of content has to a film's *creative conception* relates the chronological development of a film's aesthetic choices, as indicated by Metz, from the writing or pitching process to preproduction and fundraising, to shooting, to postproduction, and, finally, circulation. This timeline also incorporates the internal/external spectrum with more subtle distinctions, recognizing that as a film moves toward completion the choices become more external than internal; however, where Metz saw economic/commercial as related only to the middle phase (production), the separation of the continuums recognizes that commercial influence—considered motivation—can intersect at any chronological stage. The internal/external binary, which Metz separated as institutional versus internalized, is further complicated by the last spectrum: the *ideological embedment* can be looked at on a range from subconscious/unquestioned choices to conscious/polemical, with most choices falling somewhere in between. Metz presents the concept of "the Plausible" to ask us to consider to what extent this suppression of content is recognized as such by the suppressor, and to what extent the suppressed content is merely *inconceivable* as an acceptable cinematic image.

The RTC and the Plausible

Metz's ideological—or self-imposed—censorship considers the extent to which filmmakers or writers limit the production of ideas and images to what is "plausible," in the Aristotelian idea of conforming to narrative codes of what is possible, whether in fantasy or realism. Metz's analysis of plausibility is generally concerned with the way in which cinematic genre conventions create conformity of expression (Metz 1974, 238). That is, what is believable can only be determined within the context of genre (e.g., sci-fi, melodrama, social realism, etc.), but this believability can then govern expression from a number of positions. For example, because believability within genres is related to audience expectations, conformity to the genre's conventions is a factor in a film's financial gains and triggers the imposition of economic (self-)censorship by the producers. Furthermore, as I will elaborate below, the way in which narratives present character motivation, unsavory behavior, and consequences of individual choices and

actions can, according to official policy, decide a film's appropriateness for a given audience. For example, while a Mexican television audience may find news coverage of unpunished amoral behavior to be entirely commonplace, the plausibility of fiction is still governed by idealism and moral correctness.

Before a film can be released in Mexico, it must receive a classification from the RTC to decide its appropriate audience. The film is screened by RTC authorities who judge the film's content and apply a rating that will appear in all publicity and points of sale of the film. The ratings (AA, A, B, B-15, C, and D) are parental recommendations, not restrictions, with the exception of C, for ages 18 and over, and D, for pornographic content only. The categories of classification begin with AA, for all audiences but especially young children, and work through the alphabet with maturing age brackets. Although this is a direct, nonnegotiable legal policy, it also falls under the heading of indirect censorship due to its effects on a film's economic success (by literally limiting the audience and by affecting the negotiation of a distribution contract or a filmmaker's potential for securing future investments) and to its regular public reiteration of the limitations on a filmmaker's choice of images.

The restrictions of the RTC and the specifications of the 1992 LFC assume an understanding of the extremes of the spectrum of the ideologically conceivable, from what is universally appealing to what is universally morally outrageous (snuff films, bestiality, etc.), and apply age ranges that gauge the development of the human brain to the ratings' gradations of what is acceptable. For many years, the classifications have been seen as arbitrary, created at the whim of those who work for the RTC, and filmmakers have complained that this designation of appropriate content, especially the imposition of restrictive ratings, is simply a continuation of the moral censorship imposed by the Catholic organizations decades earlier. Yet, like other outcries against censorship, a restrictive rating can be turned around to favor a film's publicity, as when *Y tu mamá también* was released and director Cuarón's denunciation of its C rating as censorship garnered a fair amount of press (Badillo 2001; Franco Reyes 2001). The 1998 LFC's regulation, published just months before *Y tu mamá también* was released, was supposed to address this concern by elaborating the criteria by which an individual working in the RTC could establish his or her findings. The accompanying outline of these standards, which focuses on the introduction of B-15 rating and was published more than a year later, details specifically (1) the degree to which the age groups should be able to discern between reality and fiction or

good and bad characters, and make judgments on the behavior and actions being represented; (2) the explicitness of sex and nudity; and (3) the way in which violence, aggression, or vice (such as drugs) are represented as having negative consequences.

A close examination of the language used in this and previous film legislation shows us that this ratings system, said to be modeled after the US system, is not far from the language of the early Catholic censorship code, itself said to have been adapted from the Hays Code. The Código de Producción Cinematográfica, as analyzed by Zermeño, elaborates the specifications of sexually taboo images, such as "the absence of pants" or "any oscillatory movement of the breasts, such as a swaying movement of the body without moving the feet" (cited in Ugalde 2003). The Código also requires a film to show "indecision and regret" when amoral behavior takes place, and marks unlawful vengeance, political corruption, or positive depictions of drug consumption as censurable (Zermeño 1997, 90–93). Similarly, the newest RTC guidelines divide age groups based on the individual's ability to clearly comprehend amoral behavior. For example, the requirements to receive a B rating (12 years or older) are as follows: "Subject matters related to narcotics or psychotropic substances are treated without displaying their consumption. When the subject of addiction is presented, its negative consequences are shown" (Creel Miranda 2002). For a B-15 (15 years or older) rating, "when nudity is presented, it is sporadic, without close-ups of an actor's genitals and in a non-humiliating context. Addiction and drug consumption can be included, but the illegal consumption of narcotics and psychotropic drugs is minimal, either without encouraging it, or discouraging it," and furthermore "in the case of violence, it is not extreme, and may be linked to implicit sexual conduct, showing the negative consequences of that connection" (Creel Miranda 2002). The language makes clear that in 2002 the power of cinema to morally educate or negatively influence behavior is still of strong concern in these restrictions, but now directed toward formative age groups rather than the lower classes and the spiritually wayward.

J. David Slocum's scholarship on the repression of the film industry in Hollywood is concerned not only with what images are suppressed, but also with the combination of imposed restrictive policy and the *seen* images that work to mutually reinforce certain messages. In discussing films depicting war combat scenes, he uses the idea of *habitus* (not from Bourdieu, but from Norbert Elias's *The Civilizing Process*), which he describes as the "values and dispositions consistently demonstrated through physical action," or the "second

nature" imposed by social interaction over one's instinctual drives, much like Freud's superego (Slocum 2005, 44). Habitus is thus an intersection of policy, filmic content, and its political/historical context. Storylines in war films modeled human behavior as action that was always inscribed within social repercussions, with consequences, and characters were able to triumph by transforming their instinctual reactions to extreme adversity (such as war) into socially acceptable actions. These images, combined with the policy restrictions of the Hays Code, were not simply a reinforcement of power per se, but a modeling of codes of behavioral conduct during a historically specific period in time, that is, wartime. At the end of his article on censorship in Mexico, Zermeño points out that "self-regulation" has been instilled as a result of the decades-long moralizing campaigns by Catholic censorship groups. In this sense, the legal and economic imposition of restrictions combines with religious-based cultural norms in dictating the limits of the Plausible. Though Metz's essay is concerned with genre convention and form,[6] the excess in Mexico of the negative consequences of violence and corruption, primarily within the forms of social realism and satire, might be seen as a working through or negotiation of these limitations on cinematic images in the moment of a changing extrafilmic reality.

La ley de Herodes and the Historical Present

For Mexico's reigning party, what was most disconcerting about Luis Estrada's *La ley de Herodes* was its timing, dangerously close to the 2000 elections, in which both the PAN and the PRD had strong campaigns and threatened to unseat the PRI. The film's advanced preview was to take place in November, during the Festival de Cine Francés in Acapulco. The problems began when the screening was almost canceled due to supposed technical difficulties. The film's principal actors, Damián Alcázar and Leticia Huijara, complained to the press about the cancellation, at which time then IMCINE director Eduardo Amerena began to backpedal, changing the issue to the fact that the film did not have an authorization number from the RTC (meaning that it had not been screened for classification). The RTC responded that the film did indeed have an authorization number, although, in fact, this was not true and it was later revealed that an agent within the office had viewed an early cut and convinced his supervisors to approve it, in order to protect the film (Ugalde 2003). Thanks to the press attention and the outrage of the public, the film did indeed screen in Acapulco.

In early December, the film saw its unofficial theatrical premiere: with almost no publicity in Mexico City papers, it was shown at the Cineteca Nacional and the Centro Nacional de las Artes (both theaters that cater to small, cinephile audiences and located in the same area of the city), with poor-quality copies ("with two pirate copies produced in the state-run [film] laboratories") (Ugalde 2003), and with some showings out of focus (Israde 1999). Film critic Carlos Bonfil remembers that IMCINE decided to screen the film "a month later, in two movie theaters in Mexico, without authorization from the director or from Bandido Films, without a poster, without trailers, with minimal publicity in the newspapers, and with the sole declared intention of proving that in Mexico no type of censorship existed" (Bonfil 1999b). Some of Estrada's supporters say the objective was to present the film in poor conditions with no explanation, in hopes that audiences and critics would be discouraged from watching the entire film or would interpret the bad sound and image as a discredit to the director's competence. But others see the state film agency's actions as even more calculating and interested than they appeared, given that distributors were already offering to buy the film and planning a US$400,000 marketing campaign and two-hundred-screen release, on a launch date which was to be dictated by the distributor and likely would coincide with the pre-election media attention, as turned out to be the case with *Amores perros*. By releasing it as early as possible—without consulting the director and without publicity—IMCINE compromised the distributor's plan.

The film was cut short from the two-week theatrical run that is guaranteed for domestic productions according to LFC (Israde 1999). The follow-up, as reported by *The New York Times*, was that Estrada spoke immediately with CONACULTA president Tovar y de Teresa to renegotiate the rights to his film, purchasing FOPROCINE's stake in the movie for US$900,000. Tovar y de Teresa told the *Times* that the incident was due solely to Amerena's "erratic behavior," for which he was asked to step down from his position at IMCINE (Preston 1999). At the same time, IMCINE's director of production Montiel Pagés resigned, criticizing the state agency for its actions. Finally, in February 2000, *La ley de Herodes* had its official release and eventually brought in Mex$40 million.

The negligence of IMCINE in promoting the film is even more acute when considered in comparison to the record-breaking success of *Sexo, pudor y lágrimas* and *Todo el poder*, which were wrapping up their theatrical runs at the time and had both shown successful outcomes for private producers testing the effects of large-scale marketing campaigns on Mexican audiences. Without controversy, Estrada's

film would likely have followed a similar pattern, given that aside from its direct reference to the PRI—a first in Mexican cinema—neither the story nor the characters were unique. In fact, the film pays homage to its own cinema's history, alluding to the work of Emilio Fernández, Ismael Rodríguez, and Estrada's own father, José, among others.

La ley de Herodes starts out with a familiar story of a stranger arriving from the city to a small town. The town is San Pedro de los Saguaros and the stranger is Juan Vargas (Alcázar), the new mayor, accompanied by his wife (Huijara). As with Fernández's Río escondido (1948), in an era of proposed national progress, the stranger has the good intentions of improving the town through positive leadership, and ushering it into modernity. But Juan Vargas runs up against resistance from the towns-people, not to mention his own frustration when seeing the scarcity of material resources needed to make improvements in this forgotten rural community, plagued by every possible hardship of Mexico's failing infrastructure. But where Fernández's typical hero(ine) would rebel against tradition's obstinacy, Estrada shows us an antiheroic weakness. The plot follows Vargas's character transformation as he is betrayed, mocked, and chastised by his superiors, his constituents, his fellow functionaries, and even his wife. He ends up twisting his position of power, at first to extort funding for public improvements, and then to satisfy his own greed. His fear of being caught leads to a chain of violent acts, increasing in premeditation as he becomes more deeply enmeshed in his own crimes. Like Fernández's María Candelaria (1944), the film's ending includes a lynch mob forming (in this case, to go after the mayor), implying that corrupt politics and archaic judicial practices are mutually perpetuating and are keeping real progress at bay.

When we first meet Vargas, previously a garbage-collection supervisor from the capital, he has been appointed to his new role as interim mayor when (as the film's opening shows) the previous mayor of San Pedro de los Saguaros is lynched by the townspeople in a revolt against his corrupt authoritarian ways. The governor wants to keep the town quiet in the months before the upcoming elections and appoints Vargas because of his stupidity, his blind loyalty to his political party, and his naive honesty. When Vargas asks for money to make improvements in San Pedro, he is laughed at, told that he has to be more resourceful, and encouraged to use a colossal volume of local laws to find ways to fine San Pedro's inhabitants for minor infractions. The town's resistance to paying fines forces the good-intentioned Vargas defensively into exerting his authority, eventually resorting to violence. Exercising power, receiving money in return, and escaping

punishment for his own violent acts is the elixir that turns this zealous civil servant into a corrupt politician.

The more common depiction of corruption in Mexico shows its existence and attributes its prevalence to the rampant crime and the dysfunctionality of the legal infrastructure, illustrating a hierarchy of corruption from institutional to street level, as a top-down model of power. Estrada's satire equates the politician with the everyman, and shows how easily the latter gets pulled into corruption through frustration and impotence. The story details how small moments of fear and humiliation in hierarchical systems lead to acts of violence. In the film, the chain of hierarchy starts with characters that are not even seen on-screen, including the president, and shows how aggression gets passed down the chain, ending with the town drunk or a stray dog. At the same time, it implicates the passive observer, such as Vargas's assistant, Pek, whose silence constitutes an act of omission. The dialogue emphasizes that Vargas rationalizes his decisions and evades a guilty conscience by projecting his impotence onto those below him, as when he kills the town drunk, the only witness to his first murder, and mutters to his victim, "Damn Filimón, look what you made me do!" Just before the film ends, the audience is led to believe that Vargas has been lynched, just at the mayor before him. But for Estrada the history that repeats itself is much more dangerous than a lynching: Vargas ends up a *diputado* (congressman), promoted as a result of his corrupt practices, as another novice mayor arrives in San Pedro. Vargas is last seen preaching the rhetoric of the Revolution, justifying murder and corruption by positing his opponents as "enemies of the Revolution."

But where is the novelty in this depiction of corruption? And how does a film set in 1949 threaten to change political history 50 years later? First, the film makes multiple references to upcoming elections, with Vargas's appointment as mayor being a preelection strategy to keep political unrest out of the press. But beyond that fact, one could argue that the allusion to Fernández's work underscores the historical allegory (implied or imposed) and even prophesies the film's controversy. *Río escondido*, produced during Alemán's *sexenio*, was only released after a disclaimer was added to the beginning of the film saying that "this story is not actually about the Mexico of today, nor has it been our intention to set it there," alluding to *before* the Revolution and protecting Alemán's regime from criticism (Tierney 2007, 145–49). The setting of *Herodes*, undeniably Alemán's regime, creates a multilayered critique of contemporary politics through its history allusion: first, in the simple fact that the story makes explicit reference to the PRI and its party practices; second, extradiegetically,

in being the first film in Mexico's history to openly critique the PRI, which some critics have hailed as "an end to self-censorship" (Lazcano 1999); and finally, these 50 years that serve as the allegorical time machine between PRI in 1949 and PRI in 1999 point precisely to the longevity of the party's rule, a result of corrupt practices. In other words, *Herodes's* satire and historical setting preempted any potential voice-over, as if stating "this story takes place a long time ago, and yet it might as well be the present, given that Mexican politics remains trapped in the 1940s." The most biting level of the film's absurdity is neither satire nor limited to politics: it points a finger at a society, the contemporary spectator, that would let itself be governed by such "laughable" yet darkly violent practices for so many decades.

Despite being seen as a landmark in political expression, the structure of *Herodes*'s external censorship, that is, the attempt to limit its circulation, maps out a complicated web of power dynamics. Estrada was critiqued for his privileged position, being the son of a well-respected filmmaker, which is said to have garnered support for his claims to censorship, particularly in *La jornada* and *Reforma*, the more liberal of the nationally circulating papers. Whether or not his press and industry connections indicate a favoritism not available to other filmmakers, the fact that Estrada had a government official at the RTC lie about the film's status to get it exhibited in Acapulco shows that he is not exempt from rule bending. Ayala Blanco, who saw the film's censorship as otherwise typical practices getting special media attention due to the proximity to the presidential elections, was primarily concerned about the complicity of distributors, how easily they were persuaded not to take on the film when the political concerns became cumbersome (Galicia Miguel 2000).

Freedoms of Expression and Religion:
El crimen del padre Amaro

Unlike Estrada's films, Carlos Carrera's *El crimen del padre Amaro* was nothing to laugh about—at first. However, like Eco's story of the condemnation of comedy, it did speak of and to an audience that no longer fears eternal damnation. And when the religious groups that opposed it pointed out the scenes that most ridiculed Catholicism, and created such illogical media sound bites as the following words of Bishop of Ecatepec Onésimo Cepeda, laughter and anger ensued:

> The film [*El crimen del padre Amaro*] is filth, and for the moment the Catholic Church cannot take offense because we have still not seen

the scenes from said film, but in the moment that we see it we will be offended and will place the utmost pressure on the government and wherever else necessary so that the film be erased from history. (cited in Monsiváis 2002)

The dueling reactions fueled the schism until it became a constitutional concern, a war posed as a conflict of Church and State (but which divided both sides) and the ideal fodder for media hype. In the end, *El crimen del padre Amaro* became the highest-grossing film in the history of Mexican cinema.

El crimen del padre Amaro was lauded in several international festivals, eventually won eight Ariel awards in Mexico, and was nominated for an Oscar, a Goya, and a Golden Globe in the category of Best Foreign Film. The story, loosely based on the 1875 novel by Portuguese author José Maria Eça de Queiroz, is similar to *La ley de Herodes* in that it recounts a mysterious stranger's arrival in a small town with the hopes of saving it. Amaro, the attractive young priest played by Gael García Bernal, at first serves as a minor disruption to the sleepy status quo, but is also a witness to questionable ethics within the parish. Amelia, a teenage catechist (Ana Claudia Talancón), immediately abandons her provincial romance with her journalist boyfriend, Rubén, in pursuit of her forbidden lust for the young priest. Padre Amaro's seemingly naive gaze at the town's goings-on combines with Rubén's investigative inquiries, narrating the unearthing of the parish's numerous layers of misconduct, corruption, and cover-up. Aside from the sexual relations between Amaro and Amelia, which ends in an illegal abortion procedure and consequently with Amelia's death, other scandals include the ongoing love affair between Amaro's superior, Padre Benito, and Amelia's mother; the church's collaboration with a local drug cartel to launder money into the construction of a hospital; the excommunication of another priest, Natalio, for his liberation-theology practices and aiding of local guerrillas; and the bishop's blind eye to all of these conflicts. The story incorporates both topical issues of debate, such as celibacy vows and abortion, and more direct critiques of the church's power and its self-protecting, ambiguous internal ethics.

The controversy surrounding the film's exhibition started with a website, which caught the eye of Jorge Serrano Limón, head of the pro-life organization Cultura de la Vida, a subset of Mexico's Comité Nacional Provida. Serrano's reaction to the film sparked the beginnings of a boycott by the Catholic Church, as well as a flurry of media coverage citing the opinions of artists, politicians, and religious

leaders throughout the country, even before the film had premiered. When the media coverage seemed to be doing little more than generating more ridicule for church leaders, Serrano upped the stakes by taking legal action against the government. On August 12, 2002, a formal suit against Secretary of State Santiago Creel was heard before the Procuraduría General de la República (attorney general), claiming that authorizing the exhibition of the film was a violation of the constitutional protection of freedom of religion. Serrano, who had not seen the film, also filed a suit against IMCINE director Alfredo Joskowicz and the new director of CONACULTA, Sari Bermúdez. In his hearing, PAN Senate leader Diego Fernández de Cevallos argued in favor of Serrano's claim, and was backed by several church leaders who claimed that the film's content was offensive to all Catholics and was an attack on the Virgen de Guadalupe. However, the severity of Serrano's actions and his lack of a strong legal case lost him the backing of other church spokespersons, who insisted both that it was not the role of the church to censor works of art, and furthermore, that the film's representation of religious life should be a wake-up call to its members to think about what types of reforms were needed to keep up with changing times (Granados Chapa 2002).

Presenting the issues at the heart of the film's boycott as a conflict of Church versus State is clearly an oversimplification, not only because Serrano's group was of the conservative extreme within current Catholic political positions, but also because of the historically complicated relationship between Church, State, and censorship. Given the history of anticlericalism in Mexico, this conflict seemed to reopen an existing wound, one that had long since permeated the film industry. It was not difficult for Provida to convince a large segment of the public that the film represented an attack on religious beliefs given the number of decades Mexico had maintained the anticlericalism of its 1917 constitution: the articles were amended just in 1992. Even more recently, just months prior to the film's release, Pope John Paul II had visited Mexico, two years after he officially canonized 25 religious figures for their martyrdom during the Cristero War. On a national level, the pope's visit was a reminder of the bloody power struggle of that war; on an international level, it was a celebratory recognition of Mexico as a predominantly Catholic population (approximately 80% according to the 2000 census), a political move by the Vatican to revitalize ties with its Latin American contingents.

The cry for "Freedom of Religion" was set opposite "Freedom of Speech," which holds its own place as a historical victim of government repression in Mexico, most severely with regard to journalism.

In *The History of Sexuality*, Foucault offers the idea of the "speaker's benefit," in which the speaker who denounces repression takes on a privileged position. Dreyfus and Rabinow write, "In the pose of the universal intellectual who speaks for humanity, the speaker solemnly appeals to the future which, he tells us, will surely be better. The tone of prophecy and promised pleasure neatly mesh" (Dreyfus and Rabinow 1983). That is to say, that a certain rhetorical advantage surrounds the one who speaks of and against repression, and the teleological promise of progress and freedom makes the statements more palatable and less questioned. The Church, in positioning itself as victim or martyr, usurped some of the legitimacy more often given to those arguing for freedom of speech.

But not everyone found new sympathy for Catholics. For Carlos Monsiváis, the pope's visit was in itself another one the media's publicity spectacles, which circulated an illusion of a renewed power to mobilization and influence through the religious masses: "The primary error was isolating a single event (Fifth Papal Visit) and interpretting it as the recovery of political control over consciences" (2002). Political cartoonists also commented on the spectacle of this controversy. Cartoonist Magú published an illustration of a cinema marquee alongside a church steeple with two bishops lamenting, "We no longer have any power…We didn't stop the premiere, nor did they send us any comp tickets." It mocks the ambivalent relationship between prohibitions laid out by the Catholic Church and Padre Amaro's celebrity status and draws attention to the reciprocity of this ambivalence: both the filmmakers and Church would stand to benefit from the public spectacle. Cartoonist Helguera makes an ironic point about the politics of "exhibition" and the hypocrisy of the Church's position given the numerous sexual abuse scandals, showing a bishop exposing himself to a young boy (see figure 3.1); his cartoon won Mexico's National Journalism Award in 2002. Spectacle or not, Church leaders seized the moment to issue warnings to moviegoers. Bishop of Aguascalientes and president of the Episcopal Education Commission, Ramón Godínez declared, "All those who see *The Crime of Father Amaro*, including for morbid curiosity, will incur a sin, because the film denigrates and mocks what is most sacred to the Catholic Church" (cited in Monsiváis 2002). In extreme positions such as these, the performance itself of the story, recording this performance, and watching this performance in a theater are all morally and legally punishable acts, in a conflation of these two codes of conduct. The polemical issues of the fictitious diegesis and the film's status as a work of art were of little concern in this light. In taking their

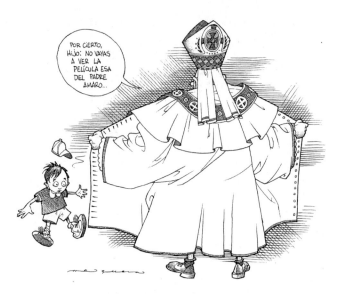

Figure 3.1 "By the way, son, don't go see that Father Amaro movie." Political cartoonist Helguera's "*Qué ver y qué no ver*" ("What to See and What Not to See"), published in *La Jornada*, August 14, 2002. Illustration courtesy of A. Helguera.

stance from that of a recommendation to not see the film, to that of charging the Mexican government with a crime and the Mexican spectator with sin, the film had to be taken out of a context of the imaginary and into terms of concrete violations. Provida accused the state of violating five laws, including Article 3 of the Constitution, that the state cannot show religious bias or favoritism, and Article 18 of the RLFC, that films with explicit nonfictitious sex, violence, or crime (as with a snuff film), would not be authorized for exhibition ("Divide Amaro" 2002). That said, it is important to mention that the two main scenes that were cited as blasphemous were first, when communion wafers are fed to a cat, and second, when Amaro wraps the shroud used to dress the church's statue of the Virgen de Guadalupe around Amelia, as a playful impersonation of the virgin and as a type of holy foreplay to their sexual intercourse. Given that no true crimes or sex acts were performed in making the film, these two scenes might be seen as the evidence of violation of the antisnuff laws, only if the criminal act is replaced by the sinful act.

The film's subject matter, including all of the controversial content that *cannot* be described as an explicitly filmed sin, is undeniably open to ambiguous readings. The conventional standards of the RTC classified the film as B-15, indicating that even from the cautionary

perspective of this state agency, the issues are complex in their presentation, but that an average viewer from adolescence onward would be able to make sound judgments on the complexity of the moral dilemmas or questionable behavior of the characters. However, that is not to say that the film offers a clear instruction on personal ethics beyond laying out the minimal amount of gray area in issues that are presented as Manichean in politics and religious instruction. Amelia's death can be an argument for pro-life (condemning abortion) or pro-choice (condemning illegal abortion). Benito's laundering of drug money to build a children's hospital also toys with the spectator's sympathies.

Rather than reading one of Leñero's scripts as a critique of State and the other of Church, they together tell us of the ethical deadlock of a failed state legal system based on the Church's failed moral infrastructure. *El crimen del padre Amaro*'s true subject matter can be taken as a struggle with moral dilemmas and inner faith, and a critique of the general apathy of the society, as citizen or parishioner. Like several of Carrera's other stories, it speaks to the paralysis, apathy, and silences of loneliness and doubt, often in the main characters: characters are filled with conflict, but void of conviction. Adorned with all of the music, plot devices, and photographic conventions of a melodrama, Amaro's subdued demeanor in the face of tragedy and injustice is even more embossed. Both Juan Vargas in *Herodes* and Father Amaro begin as heroes who will stand up and speak truth to power, but weakness and a desire to protect themselves make them both complicit and resigned to silence. The power of both films, the seed of their threat to authority, is that they challenge(d) so many spectators to not do the same.

Part II

The Aesthetics of Transition

Chapter 4

Hyperrealism and Violence: Fatal Aesthetics

Ayala Blanco's poetic description of the predominant aesthetic trend in Mexican cinema a half-decade into the new millennium is replete with double entendres and indicates how one of the most successful films of this period, *Amores perros*, had set the standard for cinema to be charged with carnal lust and animal savagery:

> From the grandiloquence to the grandiosity of Mexican cinema. To the image and similarity among its prescriptive titles, the grandiloquence of humanistic films both bestiaphilic and bestiary, irrupting, pouncing on each other from the first image, attacking without respite, barking and biting, falling apart before expressing themselves; they scratch violently without the help of any sense of rationality and tear themselves apart in editing in order to get pieced back together. (2004)[1]

This new cinema, on the one hand, uses universally provocative themes to keep the narrative at the pace of a fast, fragmented editing, while on the other hand offers a naturalistic ideology to make sense of what critic Rafael Aviña calls a "barbaric Mexico," a trope that seemed to be dominating the fin de siècle national imaginary. Twenty-first-century Mexico's narrative cinema has become completely saturated with images of wanton bloodshed, varying in the extent to which they politicize, satirize, stylize, romanticize, or fetishize violence, both formally and thematically. Violence pervades on a number of levels, including but not limited to the fictional performance of violent acts, the manipulation of the photographic image itself (as noted in the opening citation), the subjectification of the spectator through cinematic interpellation,

and the ideological implications of the commercialization of violence in the media industry.

This chapter considers the *sexenios* of Zedillo and Fox as key in the analysis of contemporary cinematic violence for what they incurred historically: times of economic crisis, mass urbanization, and increased crime; the opening of free-trade policies that impacted both the film industry specifically and nationwide socioeconomic conditions in general; the open denunciation of social conditions and government corruption in the wake NAFTA and the scandals of Salinas's presidency; these administrations' treatment of political insurgence with both military force and media propaganda; and the overall changes throughout the 1990s in globalization- and technology-driven aesthetics. The cinema produced in this period transformed hypperrealist, stylized violence into a formulaic subgenre in Mexico, similar to the exhausted reproduction of *ranchera*, *cabaretera*, and *fichera* films in earlier eras. A number of the films produced with support from EFICINE 226 were already moving away from hypperrealist aesthetics toward more commercial adaptations of the same structural and thematic depictions of violence introduced throughout the previous decade.

When Calderón took office in 2006, under questionable election results, his use of military force against protesters in the Oaxaca teachers' strike set the tone for the government's approach to civil disobedience. This was followed by a six-year war against drug cartels, with an estimated 60 thousand fatalities. By 2012, grotesque and seemingly senseless violence overtook communities and cities throughout the nation at levels far beyond the urban delinquency of the 1990s. The irruption of violence in public spaces and the subsequent media coverage, in some instances controlled by cartels, reproduced more macabre images than any films to that point. Mexico's reality surpassed its cinema.

Articulating Violence and Representing Crime

In audiovisual media, the representation of violence can manifest in the visual elements and performances, as well as on formal and artistic levels; violence can be maintained thematically, with genre conventions and elements of narrative structures that can depict violence explicitly or implicitly; and finally, it can be presented ideologically. "Violence" as a term broadly encompasses the various ways in which one agent uses force to assert power over another, as well as the attempt to resist that force, from the level of the political to

minute daily interactions. Scholarship on social violence has used different categorical terms to distinguish the various scales of violence's impact and the materiality of its assertion. Terms such as "quotidian," "structural," "institutional," and "symbolic" violence establish a difference between individual acts of violence (what are most commonly understood to be violent crimes, often bodily inflicted) and the webs of criminal activity that exist on an institutional level (such as corruption) but have a residual effect on the social conditions that tend to foster crime and violent behavior, as well as a psychological impact on the public sector's ability to encounter a sense of order in government institutions, such as legal justice or public safety.

The categories and their relationships reflect an effective, if simplistic, conceptual model of the causes and effects of violent acts, a paradigm that is manipulated frequently within the discourses of Mexico's cultural production. Historically, Mexican cinema's most common thematic and narrative representations of violence focused on revolutionary warfare and rebellion, acts of violence in the name of vengeance, the oppressive living conditions of the lower classes, and violence against women. More recently, in the face of both economic crisis and a certain media opening allowing more direct critique of government institutions, urban crime and corruption have become predominant representational themes. Filmmakers have become experts in modeling through fictional anecdotes the symbiosis of institutional and quotidian violence, revealing corruption as both cause and effect of poverty, and both corruption and poverty as a states of extreme desperation and disillusionment with any national or local system of legal justice or protection. The narrative structure of these anecdotes is very often circular, or spiraling, offering violent crime and death as the characters' only viable exit from their socioeconomic predicaments. At the same time, in recent aesthetic shifts, the stylization of violence manipulates the image itself through editing and photography to offer sensorial appeal while also recreating certain emotional and visceral characteristics of physical violence. When these stylistic conventions for heightened cinematic pleasure become the tools for depicting a thematic correlation of crime and poverty and a fatalistic narrative, they have the potential to perpetuate various forms of symbolic violence, such as the naturalization of racism, classism, or what Claudio Lomnitz calls "the depreciation of life" (2003).

In Mexico, the film industry itself is a key arena of the "cultural terrain" mentioned by Miller and Yudice in which a struggle to wield political and social power plays out through policy, production, and consumption. As explored in previous chapters, recent film legislation

has resulted in limiting the lower classes' access to cinema in public spaces, while film content has shifted its representations and ideas to more affluent audiences and antipiracy trailers openly condemn the economically excluded for their desire to participate as spectators. A level of symbolic violence also persists in the tension between cultural, artistic, and commercial interests, and between public and private control of production. Artistic innovation often seeks to rupture reified ideas and renegotiate our understanding of conservative or antiquated social values or models of representation, while commercially driven cinema tends toward appropriating proven formulas and language for the sake of financial profit, often reinscribing existing social orders, whether ideologically through content or economically through media consumption itself. Throughout the process of production and exhibition, censorship acts as a repressive force to limit cinematic expression that might undermine hegemonic power or encourage the mobilization of a counterhegemonic force.

In simple terms, one can define *crime* as an act or omission understood as unlawful, but it is most commonly a reference to those aggressive offenses that bring immediate bodily harm to others and are represented with increased abundance in Mexican cinema: rape, assault, or murder. However, it is imperative to note that interpretations of criminal acts are certainly not fixed. In fact, as it commonly circulates in Mexican cultural production, the very notion of crime, in a sense of supralegality, is as polyvalent as the images that might represent it: it is the last resort of the oppressed, an act of heroic rebellion that challenges an authoritarian regime, an inevitability of *mexicanidad*, a moment of savage survivalism, a symptom of abuse of power, an act of vengeance or of taking justice into one's own hands in the absence of reliable legal institutions, a culturally embedded eye-for-an-eye creed, and so on. At the same time, the notion of lawlessness, or outlaw, can shift its connotation depending on the position of the accuser: on the one hand, a revolutionary, on the other, a corrupt government. In historical allegory, violence can be hermeneutically either heroic or barbaric, and passivity, peaceful or resigned. In recent Mexican history, the revolutionary ideals that served as the rhetorical justification of a civil war and seven decades of single-party rule, have been diminished by years of disillusionment and the government's increasingly visible illegitimacy, and yet the most vocal dissidents are still held in check by the stigma of being lawless vigilantes. And after more than a century of the state's paradoxical—even hypocritical—articulations of a position on violence, revenge, *zapatismo*, vigilantism, retaliation, or repression, one can see

how these ambivalent articulations might fuel the reproduction of a series of violent images with necessarily ambivalent readings.

The Media and Other Public Displays of Violence

Bartra asks, "What powerful force compelled the government to open up toward a democratic transition? What managed to convince and captivate such a large part of civil society and intellectuals? What was it that filled Mexican society with dark humors and tensions?" (2002). The cynicism that at the end of the last century was characteristic of cultural expression in Mexico—what Bartra refers to as infectious "*humores negros*"[2]—film critic Rafael Aviña sees as "that social bitterness that is the legacy of *salinismo*" (2004, 119). This negativity and bleakness had a particular manifestation within the cinema of the era. Dark portrayals of violence exist throughout Mexican film history, but the political events during and subsequent to Salinas's administration and the economic crises that had an irreversible impact on the social sector mark a new era, in which violence—in all of its forms—saturated the mass media. Beginning with key events of the 1980s, we can trace transformations in experienced and representational violence over the following decades, nationally and in the urban sphere of the capital.

With Mexico City being the center of film production, the changes to the metropolis became a major focus of its cinema in the 1980s. The economic crisis of 1982—three devaluations of the *peso*—was followed by drastic cuts in state spending on public programs when de la Madrid came into office. This, combined with a shift from Import Substitution Industrialization to neoliberal economic policies and an attempt at bureaucratic reform, brought a drastic decline in the general population's financial well-being and public safety. Per capita income dropped 25 percent, the value of workers' wages was cut in half, and inflation for basic food items was between 250 and 750 percent (Lomnitz 2003, 50–51). At the same time, de la Madrid's strategy for reducing police corruption included firing over three thousand Mexico City police officers, which both cut the effectiveness of the police force and also landed a large group of unemployed, corrupt ex-cops in overt criminal activities (Lomnitz 2003, 58–59). Already experiencing an increase in crime due to mass urbanization, Mexico City was contending with urban deterioration and a shortage of basic resources due to spending cuts, increased poverty, fewer police officers, and a rise in organized crime when a devastating earthquake destroyed much of the city in 1985. This near-apocalyptic scenario became the backdrop for a number of films produced in the late 1980s and early 1990s.

On a national scale, another transformation was taking place regarding censorship and freedom of the press. Despite decades of evidence of human rights abuse, until the early 1990s neither the national nor the international press was openly critical of Mexico's government. According to Sergio Aguayo, Mexico was able to keep its turmoil below the radar of international attention based on a tacit understanding with US leaders to maintain a quiet, secure southern buffer in exchange for relative economic and social stability (2000, 34). However, the accusations of electoral fraud during the 1988 elections brought a new wave of dissident voices into the media, such as Canal 6 de Julio. In the last year of the *sexenio*, precisely in conjunction with the initiation of NAFTA and serving to further destabilize the legitimacy of the ruling party, the EZLN staged an uprising. While the EZLN's statements to the government and media were asking primarily for the unity and support of the Mexican people and the recognition of the legitimate civil rights of the indigenous communities of Chiapas and of other states, the direct accusations toward Salinas as an illegitimate leader resonated loudly and initiated the circulation of equally critical voices. Later, Ernesto Zedillo and the paramilitary forces' repression of the movement would bring many Mexicans to recognize a civil war in the southeast region of the country. The primary tools of this uprising were its use of armed force and the name of Emiliano Zapata to reappropriate from the PRI the symbolism that had served to validate their authoritarianism for half a century: the image of revolutionary insurgents and an armed struggle for democracy. This physical and ideological siege was coupled with strategically directed communication with national and international journalists. Within the first weeks of the conflict, exchanges via media broadcast between Salinas (suggesting that the EZLN was a group of outlaws) and Subcomandante Marcos (asking who, indeed, were the true agents and victims of several centuries of injustice) would ignite a nationwide reevaluation of such reified dichotomies as violence/ passivity, law/criminality, and self-defense/self-preservation. The movement spoke directly against the lawlessness of a corrupt government that used this same notion of violence as its legitimizing rhetoric, underscoring existing mistrust of authority and creating a well-publicized performance on acting out against injustice. Salinas's term ended with a number of high-profile scandals in which he and his family were implicated, such as the assassinations of Luis Donaldo Colosio and José Francisco Ruiz Massieu. For many Mexicans, these events removed any remaining ambiguity from the question of who was the true criminal and along with the further economic instability

after yet another devaluation of the *peso* in 1994, they allowed political scandal, corruption, and the critique of Mexico's leadership to become a daily occurrence by the mid-1990s, including an acceptable topic for cinema and *telenovelas*.

But this was not the only display of violence in the media. Throughout the decade, the two television stations that dominated the news media and had an unapologetic allegiance to the ruling party "felt no need to restrain from their exposés of urban crime and scandal, the way they had in the past"; they were quick to play up this type of criminal activity, which could indeed be pinned on the popular classes, and as of 1997 on Mexico City's leftist leadership (Lomnitz 2003, 60). This also held true for the type of cinema that was to be produced by the private sector in the late 1990s. Aviña writes,

> The image of the capital as a corrupt, violent, and lawless city has been one of the most well-worn topics for the new cinema under private initiative. However, the narrative aims, which attempt to denounce the reins of urban violence, have only served to spew classist manifestos and moralistic scoldings. (2004, 120)

A prime example is Altavista Films' prototype for production and market reach in the new exhibition system, *Todo el poder*, a parody of Mexico City's rampant crime and police corruption, which the same producer followed with *Amores perros*.

The new image-conscious, advertising-influenced aesthetic values pushed into the market by producers such as Altavista coincides with a broader cultural revalorization of aestheticized violence. For example, in print newspapers, the *nota roja* section is a foundational medium for circulation of violent narratives and images in Mexican culture. As a subgenre of journalistic writing, the *nota roja* has been key in investigating the gorier side of criminal activity, and, on some level, letting violence itself prevail over questions of class or political interests. Despite its low intellectual status, its value is periodically elevated by the cultural elite. In 2006, a 90-year retrospective in the newspaper *El universal* dedicated several pages to celebrating the origins of the news genre and commented on the breadth of possible incidents that might appear, letting incidents of human transgression upstage editorials on international or domestic concerns. It covered

> all in society that transgressed the law, its persecution, and its punishment; that is, crimes that were bloody, accidental, premeditated, "clean", white collar, of passion, and anything imaginable; arrests,

investigations, judicial processes and penal legislation, prison systems, and other sentences and sanctions, in addition to natural catastrophes, health hazards, suicides, and public safety. In sum, a whole catalogue of the tragedies that could afflict a person. (Joyner 2006)

This same aesthetic revalorization of violence occurred in 1990s, when the international art world began to promote the work of crime photographer Enrique Metinides in coffee-table style art books and retrospective photographic exhibits in Europe and the United States, touting him as an artist who "found humanity in catastrophe" (Searle 2003). John Kraniauskas's analysis of *Amores perros* sees Metinides's sublime vision of death as evidence of the type of aesthetic appeal in violence endemic to audiovisual production in Mexico of this period (2006, 15). One essay on Metinides likens his style to Buñuel's fictional portrayals of the city (Rea and Veledíaz 2006), but another points out that it is precisely the *reality* documented in his perfectly framed crime scenes that creates the voyeuristic pull:

> Unlike enjoying a landscape or a painting, unlike a gore film—inserted into the realm of fiction—[observing] the vicissitudes of misfortune provoke[s] a type of aesthetic experience woven from the anxieties of moral order, from the suspicion of having crossed over threshold of misconduct. Elements that, added to the aggravating factors of mystery, contribute as much to the intensity of their effect as to the aura of transgression, of perversity, that inevitably go[es] along with [it]. (Amara 2006)

As this chapter will further elaborate, the documentary-style approaches to cinema beginning in the same period suggest an indexical relationship to Mexico's violent reality, constructing in film the same "halo of transgression, of perversity" that appropriately accompanies its most violent moments.

Contemporary Cinema's Barbaric Antecedents

A large part of Rafael Aviña's historiography of Mexican film genres examines "*el México bárbaro*," and enumerates the filmic precedents to contemporary representations of violence (2004, 119). Both domestic and political violence have been present in Mexican cinema since the early films of the Revolution and throughout the Golden Age, but certain shifts in the mid-century brought changes in geographic references, from rural to urban. Fernando de Fuentes's Revolutionary trilogy set a standard for showing how violence ravaged the countryside during wartime, and several films of Emilio Fernández showed

lynching as a typical provincial recourse to justice in villages where modernity had not yet managed to reform the masses with the rational legal practices of civilization. Themes of betrayal, revenge, sin, and redemption propelled the melodramas of this period. The theme of the modern city's corruptive vices can been seen as early as Mexico's first sound film, *Santa* (Antonio Moreno, 1932), and carries on throughout the *cabaretera* films of the next decades. The bank heist of Enrique Rosas's *El automóvil gris* (1919) can be thought of as the beginning of the suspense thriller and one of the earliest references to urban crime.

But while the city stood in as an ever-present reference to the costs of modernization, it was not until Buñuel's *Los olvidados* (1950) that the extreme consequences of urban poverty and deprivation are brought to the screen in an effort to shock and condemn what might be comparable to contemporary depictions. Buñuel's Mexican oeuvre, beginning in 1946, marks an aesthetic rupture from Golden Age cinema and the end of this industrial era of film production. Both film and literature of this time show the deterioration of the various iconographic portraitures of the idealized mestizo family that had been perpetuated by visual arts movements throughout the first four decades of the twentieth century. The use of graphic violence in narratives of inescapable tragedy continues into the 1970s with the auteurist films of Arturo Ripstein—who developed his filmmaking career under Buñuel's tutelage—and is subsequently passed on to later generations, as with Jorge Fons's *El callejón de los Milagros*.

Popular commercial genres such as masked wrestler films, low-budget horror and science-fiction films, and drug-cartel border films have depended largely on violence, but primarily as a pretext for action sequences. The work of director Guillermo del Toro, beginning with *La invención de Cronos* (*Cronos*, 1993), offers a thematic link between the earlier Mexican hybrid genres of sci-fi and terror and the violence of Mexico's contemporary realism. Del Toro's fascination with insects and morbid faerie tales is revealed in his depiction of child characters. Recruited to Hollywood to lend his macabre vision to US productions, del Toro saw his treatment of death as a reflection of his cultural background, something not done in Hollywood. Responding to the many comments in the media on a scene in *Mimic* in which two young children die, he stated,

I think First World cultures tend to homogenize religion and make it more remote. For example, kids in America don't know they're going to die, whereas in South America if you tell a fable about a kid going into a dangerous place, the kid invariably dies. It's about teaching children that if you cross certain lines of safety, you die. (Sorvino 1997)

The more critically successful films of del Toro have been the Spanish coproductions *El espinazo del diablo* (*The Devil's Backbone*, 2001) and *El laberinto del fauno*, both involving young children and using the backdrop of the Spanish Civil War and Franco's tyranny to weave the drama of political unrest into surreal horror fantasies, allowing for metaphorical readings of his films regarding the role of escapism in cultures of intense tragedy.

The more direct commentaries on crime and corruption that emerge in the late 1980s vary between comic and melodramatic narrative. With a negotiation of moral dilemmas being key to melodramatic plots, a wide variety of "lawless" themes fill this role, almost all against an urban backdrop: acts of rape, assault, kidnapping, or murder; concepts such as corruption, political violence, domestic conflict, revenge, racism, or classism; and varying agents such as homeless youth, journalists, detectives, police, wealthy business men, prostitutes, or bureaucrats. Though all seem to be fixated on the saturation of violence in the urban sphere and the interconnectedness of individual and institutional perpetuators of crime, most of the dramatic films tend to exist on an axis of two spectrums: a narrative continuum between melodramatic (resolvable) and tragic (finite, story-truncating) acts and an aesthetic continuum between a minimalist yet explicit depiction of violent acts and the stylized, fast-paced editing used to heighten suspense and emotional reactions.

The Wheel of Fortune: The Narrative Structure of Fatalism

Fatalism, in its traditional literary and philosophical meanings, connotes the same contradictions of fate itself, both the defeatism of a predestined future and the notion of "luck," that is, that a turn of improbable positive events exists, such as winning the lottery. The Dutch word "lot," meaning "fate" or "fortune," is the etymological root of "lottery," whose current definition and practice can be traced to the fifteen-century systems in Burgundy and Flanders of raising money for public works or poverty programs. Thus, the fact that lotteries themselves are paradoxically a system of voluntary yet also coercive taxation on the lower classes is just one example of how "fortune," "luck," and "destiny" are inherent in the logic of political economies. The ideology behind neoliberalism that presents late capitalism as a historical inevitability, equates individual consumerism (alleged economic freedom) with democracy, and thus naturalizes socioeconomic inequality is another example. Political theorist Paolo Freire laments,

"The immobilizing fatalist ideology that motivates neoliberal discourse runs rampant in the world. With airs of postmodernity, it insists on convincing us that there is nothing we can do to change the social reality, which—historically and culturally—ends up being or turning 'almost natural'" (1997). Neoliberalism's economic Darwinism masks the true side effects of trade liberalization, such as unemployment, decreased government spending on social programs, lower wages, and unprotected working conditions, the same factors that benefit the large corporations that influence policy making.

Lomnitz makes the point that despite irreverent representations of death throughout Mexico's cultural history, the fatalism expressed in contemporary society was not simply naturalized through national mythologies. During the crisis of the 1980s, urbanites expressed that fatalistic apathy was a mechanism for coping with the hazards of daily life, from working conditions and transportation to pollution and personal safety from crime (García Canclini and Rosas Mantecón, as cited in Lomnitz 2003, 54). For Lomnitz, this was compounded by the technocratic leadership's clear depreciation of the lives of the lower classes, evidenced in decreased services for the poor, neglect for basic infrastructural maintenance, and a general inability to articulate a hopeful future for the majority of the population (2003, 62–66). At the same time, technocrats sought to heighten the visibility of extreme need "in order to justify even the most meager form of state beneficence," which generated "a sort of aesthetics of the presentation of *necesidad* that developed in state assistance" (2003, 63).

Precisely in the era of Mexico's transition into neoliberal policy, there begins a cinematic trend in dramatic realism that presents the fatalism of tragic narratives in the context of urban poverty. Although this work is considered a rupture from previous generations, there is evident influence of the 1970s filmmakers of the first wave of "nuevo cine mexicano"; Felipe Cazals (*Canoa, El apando, Bajo la metralla*) and Arturo Ripstein (*Reina de la noche, Profundo carmesí*) set new precedents, respectively, in sanguinary realism and in representing morose characters in insular, melancholic ambience. Younger film-makers applied a heavily dramatic style to a renewed fascination with urban violence and social deterioration, engendering a subgenre of films about the plight of solitary characters, condemned to classically tragic destinies against the backdrop of a vilified Mexico City, with the moralizing plots of *Santa* and the shock value of *Los olvidados*. The conservative elite's moralizing attitude toward the lower classes surfaces repeatedly in cinema's thematic linking of violence and vice.

Aviña points to Gabriel Retes's *La ciudad al desnudo* (*The Naked City*, 1989) as the beginning the contemporary wave of explicitly violent urban dramas. In the film, a young unemployed couple and their new baby are forced to move to an undesirable neighborhood and end up as victims of rape and assault at the hands of their drunken, belligerent neighbors. Though Retes was critiqued for the excessive, unprovoked, and unproblematized bloodshed and sexual assault, some defended the script, saying that it was an unapologetic depiction of the times, one that audiences and critics were hesitant to accept (Ayala Blanco 1989, 76; Barriga Chávez 1989; Coria 1989). The weaknesses of Retes's and other similar scripts lies in the dependence on a recurring violence to drive an otherwise horizontal plot, as well as in the facile manner in which the vices considered characteristic of city life are lumped together into a chaos of cause and effect, hastily linking poverty to prostitution to sexual deviance to drug addiction to assault and robbery to murder, and so on, often with an added dose of loneliness, desperation, and guilt propelling each or all of these acts. Oscar Blancarte's *Dulces compañías* (*Sweet Company*, 1996) tells the story of a young male prostitute, picked up first by a woman and then by a man living in the same apartment years later, who after extensive verbal exchanges murders both of his clients. The story divides its time evenly between the two situations, in both cases giving the young man ample time to expound the details of his childhood of neglect and abuse, which lead him to this pathological state. The emphasis on the protagonist's monologue turns the apartment into a theatrical stage, with the only movement—physically or narratively—being the climactic murders of the two stories. The film offers no hint of resolution or psychological transformation in the lives of any of the three characters aside from escalating fear and rage, and ultimately paints a terrifying image of the consequences of sexual commerce.

Typical of the tragic subgenre is the perspective of a young protagonist, such as Blancarte's prostitute, from a broken home and forced prematurely into an antiheroic psychological journey. Francisco Athié's *Lolo* (1993) might be seen as a precursor to later films, such as Maryse Sistach's *Perfume de violetas* and Gerardo Tort's *De la calle* (*Streeters*, 2001), all of which take from *Los olvidados* the topic of youth surveying the decadence of the industrial city.[3] Distinguishable from the *Santa*-inspired *cabaretera* films in which the brothel represents a degenerate domestic space infected by but protected from life on the streets, these contemporary films show their wayward heroes as navigators of an eroding urban sphere, attempting to dominate it through various actions such as befriending street gangs, infiltrating

the underworld, finding work in the informal sector, meeting up under freeway overpasses, hiding in alleys, squatting in abandoned buildings, and sleeping on benches or in underground tunnels. The journey across a decrepit landscape allows the camera to show audiences the failing infrastructures of the Mexican metropolis while the young characters run up against the human agents of this system, the corrupt or ineffectual authority figures (parents, teachers, police officers, etc.) who only appear to be more deeply entrenched in the nightmare. The underdog characters of these films become tragic heroes, victims of the social order that they attempt to transgress; regardless of the ethical implications of their actions, their own death or the death of their loved ones ultimately reinscribes them in a chimerical punitive order that is held above the inoperative legal infrastructure.

The inescapability of death or of one's life circumstances is reiterated by visual leitmotifs of circularity and entrapment, and by a heavy-handed symbolism of luck, destiny, or foretold fortunes. The opening scene of *De la calle*, a story about homeless youth in Mexico City, which uses the same as nonprofessional actors, shows the main characters breaking into a deserted carnival at night and starting up the Ferris wheel: in Mexican Spanish, *la rueda de la fortuna* ("the wheel of fortune"). The image of three desolate characters—Rufino, Xóchitl, and Cero—riding in circles until daybreak draws out the narrative structure of the film. In the final scene, the characters end where they started, with Xóchitl sitting in the Ferris wheel witnessing Rufino's bloody death on the ground. The symbolism of life as a rolling wheel of (mis)fortune is underscored when a lunatic prophet recognizes Rufino and warns him, in nonsensical scripture citing, of his cursed future.

Similarly, Sistach's *Perfume de violetas* carries the subtitle *"nadie te oye"* and contends that for the troubled contemporary adolescents the characters around them are personifications of malice, selfishness, or indifference, particularly the hypocritical adults who refuse to hear or see their pain. In a hopeful beginning, Yessica and Miriam meet and base a friendship on their struggle against the hardships of growing up in Santo Domingo, an underprivileged Mexico City neighborhood. Yet, the story subtly foreshadows its ending midway through. The sequence in which the girls' relationship begins to go sour opens with an establishing shot of a Ferris wheel at the local market, using rock lyrics in the soundtrack to draw it to the foreground: *"en la rueda de la fortuna, mueren, nacen"* ("on the Ferris wheel, they die, they live"). That the two girls are imprisoned within the cruel fate of their sociogeographic circumstances is repeated with visual cues including

Yessica being trapped on the narrow streets of her neighborhood when
a bus blocks her path, both girls being locked inside the gates of their
middle school, or Yessica climbing through a window or by stealing
a key in order to get into Miriam's house, the only domestic safety in
the film.

Two other films that depict youth struggling in vain to escape their
socially designated destinies are *Amar te duele* (*Love Hurts*, Fernando
Sariñana, 2002) and *Piedras verdes* (*Green Stones*, Ángel Flores Torres,
2001), both of which use a more thematic than symbolic approach, but
at the same time add a more mystical than realistic tone, which lends
itself to the stylized visual effects. *Amar te duele* finds "star-crossed
lovers" in contemporary Mexico, exchanging the medieval feuding
families for a typical class conflict of the SUV-driving private school
fresas (snobs) versus the *nacos* (lower-class simpletons) who sell clothes
in a market stall. Caught in the middle are the rich Renata and the
poor Ulises, whose paths cross in the commercial no-man's land of
the shopping mall. Perhaps inspired by the youth appeal of the 1996
adaptation with Leonardo DiCaprio and Claire Danes, *Romeo + Juliet*
(Baz Luhrmann),[4] in this version Ulises's ambition of becoming a
comic-book illustrator adds an outer-space fantasy twist to the theme
of "separate worlds," represented with animated editing effects such
as a four-way split screen resembling a comic-book layout.

In *Piedras verdes*, the disorienting jump cuts and the surrealism of
scenes that begin in one apartment and continue in another without
a visible cut cohere the recurring themes mysticism, drug use, and
hallucination throughout the main character's looping, circular des-
tiny. The opening sequences show Mariana's biological mother's fatal
accident at a rural train station, her father fleeing the scene, and the
surgical removal of a baby from the mother's pregnant cadaver; it then
jumps forward 18 years to show Mariana's difficulties living with her
wealthy adoptive family in Mexico City and her relationship with a
drug-dealer boyfriend, Carlos. Mariana's impulsive decisions are ini-
tially portrayed as a combined influence of urban nefariousness, bad
luck, and drug addiction but are developed through the course of
the narrative as part of her inevitable path to the desert, to the site
of her premature birth, her father's current residence, and her moth-
er's death. "The film not only portrays its characters as trapped in a
vicious, dead-end cycle but also manages to draw the spectator into
their emotionally confused state" (Podalsky 2008, 152). The story
ends with Mariana's completion of this "fatal" circle when she relives
her mother's accident in the same train station while being chased by
Carlos. *Amar te duele* and *Piedras verdes* focus primarily on the plight

of young affluent characters who, after rejecting the peer pressures of drugs, alcohol, materialism, and conservative values, are condemned to tragic endings. The cosmic interpretation of predestiny is underscored for the youth audience with music-television-style visuals, a commercial implication explored in the following section.

Like *Piedras verdes*, other films of similar narrative patterns trace the escape to a simple rural life and the more authentic Mexican lifestyle of the Golden Age cinema. *De ida y vuelta* (*There and Back*, Salvador Aguirre, 2000) and *Noticias lejanas* (*Distant News*, Ricardo Benet, 2004) present characters who were born into rural poverty, and in both films the city offers the allure of a chance to change their destiny. Yet in both stories, the city only brings a corruption of their idyllic life, contaminating the rural space with aggression, if not showing that the corruption of materialism has already infected the rural landscape. In all three films, the characters end up returning to the countryside as carriers of the city's viral destruction, harming either themselves or their loved ones, and suggesting that geographically there is no longer a landscape in Mexico that is free from the violence of industrialization.

In *Lolo*, *Piedras verdes*, and *De la calle*, among others, the death of the character whose point of view drives the story truncates the narrative structure and leaves the film without a denouement beyond an imagined afterlife or possible redemption through death. The paradox of this prevalence of tragic realism in Mexican cinema is that despite the condemnation of its protagonists, it offers a type of double subversion by combining a social critique of violence with a narrative arc counter to classic Hollywood: with the exception of the noir postmortem narration of films like *Sunset Boulevard* (Billy Wilder, 1950), in classic cinematic narrative the death of a principal character generally provides a psychological development of another character, through whose perspective the film gains closure. Similar to del Toro's attitude toward children and death, the aforementioned films refuse to let narrative conventions dictate who dies, or who dies when. However, the lack of dramatic resolution in these tragedies undercuts their critical perspective by reinforcing a Sisyphean vision of societal transformation or socioeconomic ascension.

While the narrative dependence on visceral violence remains a constant throughout the dramatic cinema of the past two decades, what changes is the spectrum of aestheticization. If the films of the 1980s and early 1990s were entirely dependent on the actor's ability to dramatically relive the character's trauma, the films of the late 1990s and early 2000s present the same themes, but with new emphasis on

cinematography, editing, pacing, and art design. *Lolo* and *De la calle*, two films with a number of aspects of their production in common, exemplify this spectrum with their similar narrative structures and depictions of escalating violence, but contrasting aesthetics; stylistically they bookend a decade of these fatalistic urban tragedies.

Fatal Aesthetics and Realism

From an idea in your head and a camera in your hand,...to the steady-cam, the camera that surfs over reality.

—Ivana Bentes (2002)

Having grown up in the era of important continental cinematic movements of the 1960s, Brazilian director Walter Salles credits his own generation of Latin American directors with creating new ways of representing the social problems occurring throughout the region, so as to bring this crisis to the attention of the audiences throughout the world.[5] Most known for *Central do Brasil* (*Central Station*, 1998) and *Diarios de motocicleta* (*The Motorcycle Diaries*, 2004), Salles has referred to his own work as well as *Amores perros* and *Cidade de Deus* (*City of God*, 2002)—the latter of which he coproduced—as films that achieve an innovative visual style using certain techniques of documentary filmmaking to show the conditions of poverty and underdevelopment in Latin America in a more vérité light, and credits their enormous success with this new vision. Film scholar Ivana Bentes, cited in the above epigraph, is critical of this perspective on the recent surge of blockbuster Latin American films, which have in common their use of "a post-MTV language, a neo-realism based on high-level adrenaline discharges, multiple reactions per second created by the editing, and total immersion in the images" (2002, 192). Bentes's critique focuses primarily on *Cidade de Deus*, but like Salles, includes *Amores perros* in this category. Her concern is twofold: first, that the supposedly true-to-life protagonists of these violent tales are being represented from a distance as caught up in tumultuous circumstances, but without participation in their depiction, and without any broader social context that would theorize the role of other social classes in perpetuating the crime and the conditions of poverty; second, that the pleasure for the movie-going classes in viewing these aestheticized, adrenalin-infused images of violence and poverty contradicts the ethical imperatives set forth by Glauber Rocha four decades earlier in his essay *Estética da Fome* (1965). Bentes's concerns

pose the question of how much of this new style is innovation and how much is media globalization.

A certain danger indeed exists in equating "documentary-style" cinematography with realism, given that this form has become almost ubiquitous in television production. However, the "post-MTV" moniker deserves elaboration beyond Bentes's notion of a "camera that surfs over reality." Although the fast editing, jumpy camera movements, and general disorientation of the spectator is often used in music-video montage in the 1990s—a visual counterpart well suited to contemporary music—the entertainment-oriented music-video format is less a culprit in engendering the aestheticization of realism than the television genres of roughly the same time period, such as MTV's *The Real World* and Fox's *Cops*, two reality television shows released in 1989, or the later dramas like *NYPD Blue* (1993) and *ER* (1994). These internationally broadcast television series have been in part responsible for addicting the mainstream audiovisual public to high drama mixed with traumatizing editing and camera work. At the same time, an increased catering to independent and art-house audiences in higher-budget film and television productions, including music television, has brought photographic experimentation into the mainstream, including color saturation, grainy resolutions, lighting contrast, shallow focus, and unusual framing (such as extreme close-ups). In that sense, the post-MTV cinematic language as it refers to aestheticized violence can be defined as follows: (1) a general tendency toward shorter duration of shot and less linear montage syntax—often said to appeal to the shorter attention span of contemporary audiences, (2) a combination of camera movements and editing techniques in dramatic sequences that is meant to provoke a disorienting, frantic effect and that attempts to simulate high-anxiety experiences, and (3) a heavier emphasis on the photographic effects, which distinguishes itself first from the traditional character/dialogue-focused cinematography and second from the low-frills style of social realism. Lastly, a renewed emphasis on soundtracks in the past decade reiterates the parallels with music television indicated by Bentes and also reveals these productions to be pieces of larger commercial-media ventures.

The 1990s in Mexico and internationally saw a series of historical changes that impacted the media-arts industry as a whole. Overall, the importance of the photographic image skyrocketed at this time, thanks to the boom in the multimedia industry, the explosion of image editing software, and an overabundance of graphic design students bridging

artistic and professional spheres, the infiltration of advertising into every unfilled physical or virtual crevice visible to humans, the artistic creativity seen in the independent film industry through improvements in digital technology, the spillover of indie and world cinema into television through cable coproductions, and the influence of digital technology and computer animation in cinematic special effects. In Mexico, these same movements combined with the professionalization of nondirectorial positions such as editors and cinematographers, and the recognition of films, actors, directors, screenwriters, photographers, and so on, in the international festival circuit, the US Academy Awards, and the Mexican Academy Awards (Arieles). In particular, this decade watched several Mexican cinematographers (Rodrigo Prieto, Emmanuel Lubezki, Guillermo Navarro, and Xavier Pérez-Grobet) achieve national recognition and then move into Hollywood and international careers, along with their director colleagues.

And while the attention to photography, lighting, and art design in the films of Mexico's new-millennium renaissance may be an aestheticization of traditional Latin American social realism, we ought to note that *Amores perros* circulated commercially in the same months as *The Matrix* (Andy and Lana Wachowski, 1999) and *Crouching Tiger, Hidden Dragon*, whose surreal, digitally enhanced slow-motion fight scenes were the decade's paragons of stylized violence. The contrast in content and style with films like *Amores perros*, *Y tu mamá también*, *El crimen del padre Amaro*, and *La Ley de Herodes* shows that Mexican cinema of this time was still primarily concerned with domestic political and social issues and realist approaches to representation and closer in production standards to US independent cinema than to Hollywood.

Neo-quasirealism: *Amores perros* and *De la calle*

Amores perros's jarring documentary-style camera work, the dramatic use of color and lighting in its photography, and its nonsequential triptych plot are all reminiscent of US independent cinema (see chapter 5). Critics have compared the film's narrative style of combining three concurrent stories and centering them on a tragic incident—in this case, a car accident—to the work of director Quentin Tarantino in films such as *Pulp Fiction* (1994), and have likened its bloody opening scene to Tarantino's *Reservoir Dogs* (1992); additionally, the director himself sees an influence of one of indie film's forefathers, John Cassavettes, as well as that of internationally renowned directors Lars Van Trier and Wong Kar-Wai (Smith 2003a, 30). Distinguishing

it from Tarantino's cinematic irreverence, *Amores perros*'s stylization is not ironic, but quite the contrary. The various stories, like many of its contemporary works, depict different symptoms of the crisis in Mexico's urban social sphere in the late 1990s (poverty, crime, domestic abuse, teen pregnancy, gambling, animal cruelty, materialism, infidelity, alienation, and so on) and everything in the film's visual and aural style is intended to intensify the violence of these moments. Cinematographer Rodrigo Prieto used a bleach-bypass developing process to increase contrast and graininess and various lighting techniques to emphasize the color schemes of the stories, including artificial lighting in exterior shots and a varied film stock in the middle story to mark Mexico's contrasting social strata (Smith 2003a, 77–79). In essence, the "reality" of *Amores perros* is heavily constructed, and yet it is notably effective at fusing cinema's essential elements: high-quality acting, photography, and writing, each of which carries part of the weight of the realism. These elements are fortified by a remarkable sense of timing regarding the sound effects, music, and editing, both within the individual stories and in their interplay. Although the director has referred to the audiovisual complexity of the film and the graphic intensity of its content as a two-and-a-half-hour "scream,"[6] like Tarantino's films, it also has entertainment value. While many international critics praised the film for its technical achievements on a small budget for Hollywood standards and its ability to address social problems in a cinematically effective way, Ayala Blanco refers to the film as "neotremendismo chafa" (cheap neosensationalism). His term recognizes the same visual excess that links Iñárritu to Tarantino, but sees it as a product of commercial trends in cultural production, no better than any other film that uses the lowest forms of cinematic appeal (sex, violence, and corruption), capitalist approaches (soundtrack, marketing campaign, and hype), and pseudovanguardist plot devices to create an inconclusive and pessimistic, if sexy, representation of urban Mexico (Ayala Blanco 2001, 482–86). Iñárritu's background in advertising and as a radio DJ is often referenced as a major component of the director's creative vision. In the same elements that Ayala Blanco called neosensationalist, Kraniauskas saw a level of self-conscious spectacle, labeling the film a "leftist technical methodology and a right-wing narrative ethic," equal to a "conservative modernist work," calling the style "urban neo-naturalism" (2006, 12).

A more neutral term used by some critics, "hyperrealism," bridges the political and the spectacular sides of the film. Violence is certainly crucial to the message of *Amores perros*, as evidenced by the myriad

appearances of blood, wounds, and both animal and human cadavers, but these images hold multiple layers of metaphor. The representation of carnage as quotidian stresses the hardships of the characters and the choices they make, and yet the leitmotif of fractured mirrors and glasses raises questions of self-image and vanity in all of the stories, with all of the main characters experiencing *visually* their violent psychological transformations (Smith 2003a, 77–79). The sharpness and the contrast in the photography bring out certain details that are intended to emphasize the conditions within which the characters live, particularly in the first and last segments. One critic's comment on the similarities between *Amores perros* and *Y tu mamá también* was,

> In the area of visual language, they boast "ugly" spaces with the parameters for ugliness of an interior design catalogue. The cherry on top is usually a hyper-stylized photography that equates a boxing ring, the dressing room of a strip club, a street at daybreak, and the interior of an (old) car, and, as a result of the distance between the subject and its treatment, it turns a movie about the damned into an essay on damneditude. (Solórzano 2007, 64)

A possible reading of the integration of form and content is that the photography reflects upon capitalism's correlation between visual appeal and money in contemporary society by aestheticizing poverty and by throwing crippling mortality in the face of those who exploit both wealth and beauty. Prieto's cinematography draws attention to human surfaces, such as the texture of dirty hair, dirt under fingernails, ungroomed facial hair, wrinkles, scars, oily complexions, smears of blood, and torn T-shirts, all things which mainstream media photography most often attempts to tone down with makeup or airbrushing. These details are placed against carefully selected backgrounds, such as the intense greens of the dogfighting spaces or the tiles on the exterior of Octavio and Ramiro's house, composing an integral image that pulls the sublime from some of Mexico City's otherwise banal, decadent, or tawdry spaces, and those who inhabit them.

Despite its homage to image, *Amores perros*'s manipulation of cinematography and montage is subdued compared to comparable stories of the same or later time period. An example of a film with similar aspirations regarding its depiction of the urban sphere is Gerardo Tort's *De la calle* (based on a play by dramaturge Jesús González Dávila and adapted by Marina Stavenhagen, director of IMCINE under Felipe Calderón). As previously mentioned, *De la calle* has several links to Athié's *Lolo*, including that the latter's lead actor,

Roberto Sosa, played the role of Rufino in both the stage version and an earlier film version of *De la calle* directed by Nicolás Echeverría. In making the 2001 version, more than 12 years after Tort had read Dávila's original script, he cast Luis Fernando Peña (Ulises in *Amar te duele*), who would become an updated Rufino for the film and a new Roberto Sosa for the industry (Fernández 2001). What *De la calle*'s Rufino and *Lolo*'s title character have in common includes their brooding way of negotiating the spaces and crowds of their impoverished settings, of struggling to survive despite the presence of negligent mothers, corrupt and abusive police, and the pressure of drugs, vandalism, and thievery among their peers. Both Rufino and Lolo want to flee the city, get pulled somewhat unwilling into theft, get tangled up in murders, and never manage to escape their predicaments. The point of comparing these near-identical stories, both originally social critiques of Mexico City in the 1980s, is that one was produced at the end of the 1980s and the other at the end of the 1990s, and a decade of difference exists in their visual tones.

Rufino's story centers around his relationship with his best friend Cero and his girlfriend Xóchitl, both of whom spend most of their time on the streets, like Rufino, doing odd jobs and occasionally sleeping on old mattresses with other kids in underground tunnels. Rufino has a mother, but is not welcome in her home because of the volatile temper of her lover, a corrupt police officer named Ochoa. Rufino sells drugs that he steals from Ochoa in hopes of getting together enough money to leave the city for the coast, and take Xóchitl and her young son with him. But Rufino gets sidetracked when he learns some information about his estranged father, a former *luchador* who might still be in the city. Rufino also gets double-crossed by Cero, who is passing information to Ochoa, but not before several violent incidents occur, one of which involves his father. The plot follows Rufino through a series of urban landmines comprised of explosive tempers and the destructiveness of youthful indifference. His trials intensify through-out the film, as does his obsession with finding his father; during this time his role transforms from that of passive accomplice to victim of violence to its principal agent. The *crime* that begins the film—drug dealing, street fighting, and police brutality—is depicted as a code of the streets, that is, with rules based on self-preservation rather than on a sense of common morality. However, the acts that end the film critique this lawlessness by showing their agents as truly malicious and vindictive, thriving off of their own sadistic thirst: Ochoa finds Xóchitl in the park and rapes her just to prove his power over Rufino; several of Rufino's friends light a fire in an abandoned van and burn

alive the homeless man inside it; and Rufino's father, who turns out to be a homeless alcoholic transvestite living under a bridge, rapes his own son without knowing his identity.

De la calle's photography is similar to *Amores perros* in its high contrast, its dark interiors with overexposed exteriors, and its shadowy night spaces. Its style is heavily marked by the movement of a handheld camera, which, in early scenes follows Rufino through the market where he works carrying meat from the distributors to the butchers. Arms smeared with blood from the meat and literally carrying death on his shoulders in the form of a beef carcass that appears to weigh more than he does, Rufino wends through the market stalls with a certain confidence that reflects mastery over street life, and the camera is able to trace these movements intimately. Much like the dogfighting scenes in *Amores perros*, the camera seeks to transmit the characters' interaction with their own mortality through dominance over the claustrophobia of the man-made architecture that encages them and over the beasts that they themselves encage, handling a live dog like an explosive toy on the end of a rope and a blood-drenched dead dog (or a side of beef) like a sack of garbage. The handheld camera adds another dimension of movement to their gait and their gestures as they move between these micro and macro confinements.

From the market and still burdened by the meat, Rufino steps outside to a back alley where his street-dwelling peers (played by a cast of homeless children taken into an acting workshop for the making of the film) get high on toxic inhalants and mock a delusional homeless man who cites scripture and will be the omen of Rufino's future. The walls outside the market appear to have been stripped of old posters, leaving a multicolored striped background; the ground is carpeted with discarded leafy greens from the market; tall stalks of other bound green plants line the walls; and a green dump truck is parked of to left. This set is intended to give the impression of being ankle deep in a green forest of garbage, but the shallow focus blurs and softens the colors as it foregrounds the dirt-covered prophet and the bloodstained Rufino, both dressed in grey and brown. The verdigris look of copper patina is a constant in other spaces in the film—including walls, garbage cans, and lights—showing the city's architecture as antiqued and drawing out its decay, anachronisms, and nostalgia. At the same time, the characters' faces and clothes are the browns and yellows of a sepia photograph, creating a contrast that highlights the "soiled" look of the characters but still complements the thematic color scheme. The cinematography's greens and aquas convey coherence and an attractive, visually soothing tone to dulcify

the spectators' consumption of the script's series of macabre moments and camera's agitating movements.

The symbolism of the film's ending proffers a reading steeped in Catholic values of martyrdom and suffering due to the heavy-handed emphasis on the disintegration of the family unit and the consequent social and moral destruction. Stavenhagen's script spirals through Rufino's urban journey, interjecting occasionally his hallucinations of lying in the arms of the Virgin Mary, a surrogate for the absence of his real mother's affection. This journey closes as Xóchitl and her son board the same Ferris wheel from the film's opening scenes; a fire-breathing friend, who had advised Rufino on how to track down the mysterious *luchador*, asks innocently, "Did you find what you were looking for?" marking an ending to the foiled search for a father figure, and drawing attention to the spectator's privileged information: he has just been raped by his biological father and has killed his stepfather. Seeking revenge for Cero's betrayal, Rufino confronts him in the fair, but is stabbed by Cero before their fight gets very far. Xóchitl screams from her seat on the Ferris wheel as she watches Rufino fall to the ground. We see Rufino from a long aerial shot, as if from Xóchitl's perspective, then a close-up of Rufino breathing his last breaths, bleeding; the cross around his neck, centered in the shadowy frame, suggests a postdiegesis denouement of postmortem salvation. The final image is of the spinning Ferris wheel.

Although this film repeats many of the themes that made *Los olividados* a scandal in 1950, a critical reading of *De la calle* would argue that the gesture of making a visually attractive, ultraviolent film corresponds ideologically to the film's narrative structure of condemning the poor and disenfranchised to a *destiny* of more poverty, violence, and premature death. The collaboration between director, screenwriter, and playwright is a mix of already ambivalent personal and political attitudes toward fiction, cinema, and realism. In the film's press book, all three were cited as wanting to tell a difficult story, one of loss that shows the lives of people that are often marginal to the entertainment industry. González Dávila recognizes that his dramas both disturb and provoke the spectator, but with the hopes of moving him or her emotionally. Tort and Stavenhagen not only see some repetition of Buñuel's artistic avant-garde in their film, but also take up the engaged practices of neorealism and New Latin American cinema, using primarily nonprofessional actors and documentary photography. And yet in the film's publicity, the filmmakers depoliticize the film insisting that it is not about denunciation, but rather simply telling a "love story" in which the social reality is visible

as the backdrop ("Filman los dramas" 2000). When discussing the problems of the film industry and what his film attempts to do, Tort insists that cinema is a luxury problem compared to poverty, and that art's role in social change is limited (García 2002). While they worked with a large group of homeless children in Mexico City's historical center, the filmmakers recognized the limitations of their involvement in the lives of these children and noted that the children's participation as actors was inconsistent, given the problems of drug use and the extreme conditions of their lives. Tort was also hesitant to openly condemn these conditions, but seems to see them as something worthy of conversation: "I see the phenomenon of children living in the street as a phenomenon, not as a problem; it's a popular topic, but at the same time, no one wants to talk about these things" ("Filman los dramas" 2000).

Hyperrealism, Stylization, and Point of View

In reference to cinema, *hyperrealism* may be understood as a combination of its two definitions: first, something exaggerated compared to reality, a hyperbole of natural perception; and second, an artistic work that is extremely *realistic* in its details, that is, approximating reality better than other works or mediums. Hyperrealism refers to certain photographs' ability to evoke a sensation of "more real than real" in their recreation of visual perception. Cinema's sound and movement offer additional layers of sensory and psychological experience to the visual. But traditional narrative cinema also condenses time and juxtaposes images with a syntax that allows the spectator to comprehend the time warps and experience a temporally concentrated reality without questioning it. The stylization of recent cinema uses editing and camera angles to push the limits of this grammar, replicating the media-saturated *hyperreality* of the cosmopolitan experience; it also uses the aperture and focus of the lens to create a tension around photography's ability to capture details, a *texturization* of the image that can make it more realistic, more stylized, or both.

If we recognize the continuums of representation that Gilles Deleuze sees as introduced by Italian neorealism, one between the banal and the extreme, the other between objectivity and subjectivity, then we might also borrow the idea that the presentation of images in the works of the movement's more marginal directors (namely Antonioni and Fellini) successfully collapses these continuums (1989, 6–7). Latin America's post-MTV hyperrealism seems to embody a similar collapsing of the continuums in both its photography and camera movements.

The photographic texturization of films like *Amores perros* presents details in such a way as to make a blood smear banal while intensifying a drop of sweat. The folding of subjectivity and objectivity can be elaborated in much more depth, both in the visual rhythm of the film and in the relationship between the camera and the characters that creates the point of view of the narration. Like Deleuze, Edward Branigan sees objectivity and subjectivity as fluctuating and interdependent, at play in the construction of point of view, and directly linked to stylization. "'Subject' and 'object' are not fixed terms, but indicative of a relationship between two elements" (1984, 2). In constructing a point of view, the camera aligns the viewer with a perspective, which is generally linked to the "subjective" position of a character, narrator, or author. But traditional visual language for point of view "can be disrupted by the filmmaker in order to disorient and shock him or her into new patterns of perception" (1984, 6). For Branigan, the way in which a director's formal techniques are used to break from other films (of the same genre, time period, or of his/her own body of work) is the definition of stylization, and the ultimate subjectivity of a film (1984, 48). "The extreme subjectivity is that of the author, his or her attitude toward the world as disclosed in the work... The author's attitude, in the end, becomes the 'moral' of the story" (1984, 8). This "attitude towards the world" can refer to the filmmaker's lived reality as well as to the characters' world, including a link between the two, such as social realism.

Stylization also reflects the attitude of the filmmaker toward the spectator's experience and creates a "psychic distanciation" in the identification process. "The psychical distance is a separation between beholder and artwork caused by both the 'distancing-power' of the individual and by the 'nature' of the artwork" (Branigan 1984, 8).[7] Documentary and fiction cinema differ through the spectator's phenomenologically distinct reconstructions of time, based on the varying components of performativity and "live" action. Both documentary and fiction are processes of registering what is actually present and of creating, for the viewer, an artificial memory through this reconstruction; but the distinction between these categories exists in that they operate with different cinematic grammars and ethics, with different a priori semiotics. With the documentary image, there is a stronger confidence in the "real" origin of the object, and more importantly, in the actions of subjects/characters. In the examined examples of "doc-style" cinematography inserted into fictional stories for the sake of realism, the mark of documentary authenticity is offset by the discontinuous editing's challenging syntax. The fragmentation most often exaggerates

the rapid pace of a film, on the one hand supplementing the social urgency of its content, and on the other, undermining the "realness" of the image by constantly rupturing and repositioning the spectator's relationship to it. This objective/subjective rift, as stylization, is the spectacle that turns realism into hyperrealism. In reproducing the disorientation of violence—and the privileging of irrational over rational—it becomes suitable for the violence it depicts. Ayala Blanco sees this deliberately brusque style of editing, a violence done to the image itself, as the formal counterpart to recent cinema's ideological component, that is, the sexualization of violence that equates impulsive action with bestial lust, found in much of Mexico's post-*Amores perros* cinema. His playful double entendre alludes at once to animalistic copulation and contemporary editing-room practices: *desgarran al montarse para ayuntarse* (1984, 15).[8]

The narrative point of view constructed by the handheld camera offers another mixing of objectivity and subjectivity. The practical aspect of the handheld is its mobility, its agility in following characters into intimate spaces, pursuing them as they change pace. This mobility constructs a 360-degree filmic space, making it "more real" than a traditional fiction-film set. In the films mentioned, the amplification of diegetic space is most visible when the protagonists traverse urban ground, making their psychological transformation emphatic through physical movement, such as Rufino's heroic journey to find his father and Octavio's erratic behavior (as when he stabs Jarocho after the last dogfight). A side effect of the handheld camera's mobility is an additional vertical movement, the "shaky" effect, particularly visible as the pacing is stepped-up. The documentary aesthetic, encoded with heightened realism, here implies an intimate relationship between viewer and protagonist, but only through recognizing an extrafilmic third party, such as a camera operator. The camera's shakiness calls attention to the space *behind* it, to the gaze that follows the protagonist. The narrative perspective is therefore constantly in flux, shifting between the first person of protagonist and an omniscient but not totally invisible narrator/cinematographer.

According to Branigan, "(the concept of) character is a construction of the text, not *a priori* and autonomous" and it "exists to serve and to mask unconscious forces as they are played out in a drama which implicates the viewer" (1984, 12). The combination of the ways in which a character's values and desires are revealed through dialogue, narration, and actions, with how the character's lived space is constructed by the camera is what creates the viewer's understanding of what is knowable, or what is accessible to identification and what is

not. The character's privacy is a construction of the text and the voy-euristic gaze (the viewer's violation of that privacy) is contingent upon it. The handheld camera creates a language of both *voyeurism*—with its privileged proximity to the characters—and of *urgency*—with a visual likening to news footage. Voyeurism and urgency together push the cinematic *desire* of the image—the desire to see and to know—a tension between what exists within the frame and what is absent. What is not seen must be constructed mentally in congruence with what is seen. When violence is framed, this desire to see becomes perverse, as the spectator is asked to reconstruct the details of depravity, to ask for more, as with the photos of Enrique Metinides.

The Fate of Mexican Cinema:
Ruptures and Continuations

Aviña dedicates a whole chapter of his book to "La suerte en el cine mexicano," officially designating *luck* a recurring theme. *Sístole diás-tole* (Carlos Cuarón, 1997), *Azar* (*Chance*, Oliver Castro, 2000), and *El valor de la amistad* (*The Value of Friendship*, José Luis Aguilar, 2000) are three shorts films—among several produced by IMCINE in the late 1990s with funding from the Lotería Nacional para la Asistencia Pública—that succinctly articulate the theme of escaping a low-income destiny, all pivoting on winning the lottery. Similarly, a brief, cynically humorous exchange of dialogue in Luis Estrada's critique of the false stability of the Fox era, *Un mundo maravilloso*, finds the stem of the naturalization of fatalism in Mexico's conserva-tive political ideologies. The wife of a politician asks her husband if he thinks that poor people *want* to live as they do and he responds that in a poll conducted by his staff, when asked *why do you think you are poor?*, "40 percent of those polled said that it was 'God's will,' another 30 percent said 'because that's how life goes,' 20 percent said 'bad luck,' and only 10 percent blamed us [politicians]." This emerges as one of the more poignant messages of Estrada's film: the primary role of the politician is to perpetuate to the underprivileged that their socioeconomic standing is insuperable, through myths of supersti-tious or religious predeterminism.

In the first months of 2007, during the bureaucratic transition into Felipe Calderón's administration, film and television actor Eric del Castillo sought to be appointed as the new director of IMCINE. With Stavenhagen and Sariñana as two other rumored candidates, one of del Castillo's proposals in revitalizing the industry was to make more upbeat stories with triumphant characters and happier endings.

"Why do they focus only social menaces (*'lacras'*)?" commented del Castillo in an interview. "We're already plenty familiar with them, dammit, we all know already what it means to be a lesbian, what a drug trafficker or junkie is" (Carreño 2007). The danger in del Castillo's statement to the press is that despite the prejudice and conservative values made clear by his choice of words—putting lesbians, addicts, and drug cartels in the same pejorative category—it still holds a level of truth in paraphrasing the almost univocal message of recent Mexican cinema, regardless of political and ideological leanings. His complaint regarding the oversaturation of representations of violence and vice in Mexican cinema has a growing alliance among filmmakers, such as the young producers who are pushing the forgotten genres of horror, sci-fi, and suspense in order to return "Mexican film" to a label of origin rather than genre. In making his problematic comment, del Castillo was undoubtedly referring to a widely publicized film released at the time, *Así del precipicio*, which does indeed equate drug use, drug dealing, lesbianism, and sexual addiction, presenting all as the woes of twenty-first-century urban femininity, particularly within Mexico's cosmopolitan elite. Because contemporary television programs are relentless in showing the fantasy lifestyles of extreme wealth, it is easy for cinema to show so-called grit and label it socially conscious, especially when the visual language of realism is so accessible to mainstream viewer regardless of content. But if films such as this, marketed as progressive in their representation of alternative lifestyles and sexualities, a supposed attempt to change antiquated notions of Mexican identity, are in fact as categorically condemning as the rest of Mexico's violent tragedies and reiterate the pejorative stereotypes, whose reality are they really representing?

The boost of investment in commercial cinema following EFICINE 226 brought a number of high-action films still focused on criminal activity, but steering away from the social content of hyperrealism and employing even more exaggerated effects, such as slow motion and more explicit, graphic violence. At the same time, a thematically similar but structurally opposite trend was developing, and received particular attention at international festivals. Films by Carlos Reygadas such as *Japón* (2002) and *Batalla en el cielo* (*Battle in Heaven*, 2005); Amat Escalante's *Sangre* (*Blood*, 2005) and *Los bastardos* (*The Bastards*, 2008); and Benet's *Noticias lejanas* give us a much more peripheral perspective on contemporary Mexico, focusing on the geographic and psychological alienation of its characters. These productions, while still employing documentary-style techniques, including handheld cameras, opt for minimalism over stylization and use long

takes with little action rather than hyperrealism's accelerated editing. The critique of societal violence persists, yet the narratives focus on characters' intense psychological alienation and the internalization of anguish. Slow pacing underscores the relentlessness of existential suffering within their efforts to pass the time each day, often in an oppressive and repetitive space, whether limited by confining urban space or rural isolation. Where *Japón* and *Noticias lejanas* use the topography of a rural landscape (and the film titles) to physically construct the protagonists' social isolation, *Batalla en el cielo* and *Sangre* set the density of the crowds, cars, and concrete of the city in contrast to the protagonists' minimal social interactions in this environment. Where earlier cinema presents external urban violence as a vortex that inevitably pulls the characters into participating, these recent films stress the silence of emotional pain, not only with minimalist dialogues, but also in the characters' refusal to lash out in resistance. In most cases, violence or death eventually irrupts into the narrative, either from or against the characters, but is framed with the same banality as the routines that precede and follow. (Self-)repressed sexuality is a recurring theme, linked to the persistence of puritanical social norms into the twenty-first century despite superficial displays of tolerance. A number of films in the latter half of the 2000s adapt the theme of alienation to a variety of narratives and settings, as in *Desierto adentro, Lake Tahoe* (Fernando Eimbcke, 2008), *Dos abrazos* (*Two Embraces,* Enrique Begne, 2007), and *Párpados azules* (*Blue Eyelids,* Ernesto Contreras, 2007). However, unlike the unforgiving denouements of Reygadas and his cohort, several of the more recent films offer a shred of hopefulness in allowing human contact to break down the walls of melancholic isolation. Similar to how Estrada's *Un mundo maravilloso* critiques the Fox administration's facade of having solved the multiple crises of the 1990s, all of these films suggest that despite the apparent return to normalcy after the cinematic and political spectacles of 2000, the dysfunction of Mexico's social sphere had yet to be addressed.

Chapter 5

Independence and Innovation: Indie Film and the Youth Market

"Odd things always happen when the power goes out," comments writer/director Fernando Eimbcke, reflecting with nostalgia on the moment that inspired his screenplay. A power outage is a moment of experiential simplicity, one that becomes the central rite of passage into adulthood in the film *Temporada de patos*. "I remember when I was younger, we were in the living room watching television and all of a sudden we were sitting there in the dark, silent, with nowhere to go. So we started to talk and tell stories. It turned into a really special experience" (cited in press kit, 2004). The film's publicity materials, creating playful intrigue with the idea of what one can do to pass the time during a blackout ("*cuando se corta la luz*"), invites viewers to ponder the question that launches the storyline: Has the media conditioned today's youth to see life in the twenty-first century as *boring* without electricity? This underlies another quandary, one that many filmmakers producing films outside of Hollywood are forced to ask: Is cinema too boring without special effects, flashy locations, or studio sets? Can an enjoyable film be shot with only available light? Can it be produced without *power*?

The principal focus of this chapter is to compare and contrast the notions of *independent cinema* in Mexico and the United States. A principal distinction is that while US independent —or "indie"—film seeks artistic distinction from Hollywood studios' formulaic narratives and visual conventions, Mexico's independent films are those made without government subvention. These cinemas offer two different models of cultural production, but which overlap in various ways, whether through direct collaboration between filmmakers, through a

simple aesthetic influence of one over the other, or as a result of the two industries producing cinema with similar budgets, for similar audiences, and with a similar political positioning, that is, peripheral to mainstream global media production.

Both US indie filmmakers and private producers in Mexico make claims that a level of artistic freedom is allowed by their independence and that this freedom is key to cinematic innovation. But in these two cases, the relationship of financial support to innovation varies. In general, indie cinema's low budgets dictate the limitations on cinematic form and these limitations force filmmakers to develop nontraditional storytelling techniques that still hold the attention of audiences. At the same time, these new styles, when successful, have been co-opted by major studios looking to profit from the market value of fresh ideas and aesthetics. In Mexico, however, the cinematic successes under the new economic system have come primarily from privately funded production companies, with much larger budgets than the average state-coproduced or entirely independent films. For this reason, when outlining developing trends in Mexican cinema, it is important to distinguish between films with private corporate financing and independent films made without this support and with little or no help from the state. At the same time, many of the higher-budget privately funded films as well as some coproductions with IMCINE, take aesthetic cues from popular independent and art-house films from the 1980s and 1990s. Furthermore, in terms of international distribution, many of these films fall into the same niche market, regardless of their status in Mexico.

In the transition to a new consumer market for cinema, producers and exhibitors discovered Mexico's youth as one of the strongest, fastest-growing sectors. While profit-minded film production and independent film aesthetics might at first seem antithetical, the films discussed in this chapter demonstrate that the youth market is a key intersection of artistic innovation and consumerism. Eimbcke and several other filmmakers of the same generation—educated during the height of the US indie film boom, but trained in commercial media production—have worked with and around the two industry poles of *state* and *private* to produce Mexico's most creative and successful films of recent years, broaching topics, styles, and sounds that address the young viewer. Films considered in this chapter are intended to illustrate the intersection, in narrative and aesthetic content, of the commercial interests of youth marketing with the artistic innovation sought in recent independent, private, and hybrid productions.

From Independent to Indie to Indiewood

Since the late 1940s and early 1950s—decades before the term became a marketing tool in the early 1990s—filmmakers in the United States were positioning themselves on the outside of the studio system: shooting on location, without sets, with limited film stock, cameras, and equipment. For independent filmmakers, not having the built-in access to distribution that studio films have makes financial risk even greater. Yet working without these contracts and large-scale investments can allow for a level of artistic freedom often not permitted within Hollywood's profit-driven productions, and for many politically engaged filmmakers' creative control is more valuable than financial support. While not all independent cinema is political in nature, taking both production resources and creative expression into account, the sector becomes necessarily a counter-Hollywood cinema, whether in aesthetics, narrative styles, or deliberately ideological distinction.

Geoff King's *American Independent Cinema* maps out the varying factors that can permit a US film the indie classification, including financial resources, narrative style, formal audiovisual devices, and manipulation of genre. And it is in the causal overlap of these factors where the countercultural politics of indie film is best understood: a low budget might equate to the ability to maintain creative control and freedom of expression, but it also results in specific technical limitations, such as in the types and variation of camera shots, number of shooting locations, quality of film processing (until the advent of digital), and so on. The response to these limitations often results in decisions that shape the narrative of low-budget films in similar ways, such as a script set in a single location and favoring dialogue over action. Formal techniques may be used to either draw attention to or mask the discrepancies between this type of production and its high-budget counterpart. This shift away from classical Hollywood language results in various distortions of genre-generated expectations (sometimes self-consciously so), which are themselves strategies of ideological resistance to mainstream cultural production. Because the enjoyment of independent or art cinema may require either a more advanced knowledge of aesthetic language beyond plots and characters, or the recognition of an ironic rejection of high aesthetic or literary standards, its consumption can function as a marker of cultural distinction, sometimes of socioeconomic class (King 2009, 14–15).

As the independent film market has developed since the 1980s, the artistic style and unpredictability of its films has piqued the interests of

audiences and subsequently major studios.[1] This is a result, in part, of the many ways that the industry has grown its exposure and networking opportunities since the early 1980s, including (1) a huge increase in international and independent film festivals and markets, which operate as meeting places for international film buyers, a mix of upstart and celebrity actors and directors, and both the critics and paparazzi that cover the events; (2) television programming from networks such as Sundance Channel and the Independent Film Channel (IFC) gaining popularity as cable became a mainstay of American media consumption, as well as HBO and Showtime beginning their own investments (both in film financing for theatrical releases and cross-market productions made for TV but with film actors); (3) awards events such as the Independent Spirit Awards recognizing films for their artistic and technical achievements relative to their modest means; and (4) the unexpected commercial success of a handful of films, often made by recent film-school graduates, whose ticket sales grossed millions of dollars beyond their original spending and spread the Hollywood rags-to-riches fairy tale beyond the limits of the studios.[2] Films such as *Sex, Lies, and Videotape* (Steven Soderbergh, 1989), *El mariachi* (Robert Rodriguez, 1992), and *The Blair Witch Project* (Daniel Myrick and Eduardo Sánchez, 1999), whose predistribution budgets are rumored at US$1.5 million, US$7,000, and US$22,000, respectively, grossed US$25 million, US$2 million, and US$241 million. Although the art-house film audience that regularly supports this niche market has consistently hovered between 5 and 10 percent of the United States' movie-going audience, the low financial risk on indie films, the intellectual appeal to more affluent audiences, and the cultural prestige they offered the corporate brands of the major media conglomerates made them a valuable commodity. By the late 1990s, almost every major studio had introduced an "independent" production studio into its list of assets, whether by acquisition or redirecting the objectives of an existing subsidiary (King 2004, 80–81).

In the United States, the concept of indie film that developed in the 1980s positioned itself in economic and ideological opposition to blockbuster cinema, limiting the application of the indie label (regulated by awards, festivals, etc.) to low budgets and certain visual and narrative characteristics,[3] therefore making it antithetical to mainstream market domination. However, by the late 1990s, Hollywood was already launching some of its most successful higher-budget versions of independent cinema, creating the hybrid terrain of "indiewood." In fact, a key moment in Hollywood's co-optation of indie cinema was Disney's acquisition of Miramax Films in 1993, which was operated by the

Weinstein brothers until 2005, during which time they distributed Tarantino's megasuccessful *Pulp Fiction*. Using the Disney/Miramax era to delineate the heyday of indiewood production, we see that it coincides with the time period of Mexico's transition into the multiplex system and its pursuit of a new target audience. Films such as *Amores perros* fit well within the aesthetic parameters of indiewood cinema, not just because of the comparison to Tarantino, but also because of the ambiguous position vis-à-vis global media production—the same ambiguity manifested by hyperrealism's mixing of violence and glossy visuals—although made on a budget more akin to US independent than to Hollywood production. Furthermore, Miramax's secret to success with films such as *The Crying Game* (Neil Jordan, 1992) and *Sex, Lies, and Videotape* "was to spend much more heavily than was usual in the independent sector on the marketing and other costs required to support a wider release for selected titles" (King 2009, 94); this very trend is one of the key features of Mexico's new model for production in the late 1990s (Valdelievre, personal communication, June 2007). For a major studio, the niche-focused subsidiary division is a vehicle for bringing new talent into the industry, testing more artistically experimental content, and distributing foreign films, all of which offer prestige on both artistic and cultural levels. These three goals overlapped in several cases involving emerging directors from Latin America precisely at the peak of indiewood's boom. Following its success with the fragmented narrative and gritty themes of Soderbergh's *Traffic* (2000), Universal Pictures' art-house division Focus Features helped bring González Iñárritu to English-language audiences by financing and distributing *21 Grams* in 2002, distributed Salles's *Diarios de motocicleta* (a star vehicle for García Bernal) in 2004, and produced Fernando Meirelles's English-language follow-up to *Cidade de Deus*, *The Constant Gardener* (2005).

In both Mexico and the United States, the aesthetic influences of indie and indiewood cinema have bled into the mainstream via other audiovisual media, such as television programming, advertising, and music videos, especially those targeted at the youth market. Filmmakers working between feature productions in advertising and music television are well attuned to the parameters of hipness, which requires a constant reevaluation of the border between familiarity and visual innovation that makes for maximum sales value. Younger viewers—who are more directly impacted by the swift pace of technological change, more open to less traditional audiovisual language, and in Mexico the primary consumers of both film and television—become guinea pigs for experimentation in marketing,

merchandizing, and aesthetic novelty. At the same time, coming-of-age stories, about sexuality or adolescent struggles, are able to contextualize quirky or even transgressive behavior within universal thematic parameters, which makes many of these stories appropriate to indiewood's hybrid market.

Independent Cinema, Youth Culture, and the Mexican State

For most of its century-plus of cinema, Mexico's industry has comprised a mix of production resources, including private domestic capital, overseas investors (including Hollywood and Europe), and the country's own government (Maciel 1997, 94–96). National production companies and distributors have always been countered by nonstate ventures operated by those who either did not qualify for or did not desire government subvention; some filmmakers' work has been too artistically experimental or politically critical to involve state support, other works' producers focused on fast and cheap commercial productions for mass consumption, as with the *vídeo home* market. The industry's categorical divisions are often oversimplified as *state, commercial,* and *independent* cinemas, and yet the latter two are both often defined in relation to the former. The notion of a cinema independent from state patronage gained particular significance in the 1970s when the private/commercial sector lost some of its major assets to Echeverría's nationalization project and at the same time an ideological conflict arose between a handful of auteurs who were able to make relatively progressive, critical cinema with full support from the state, and those who recognized and objected to Echeverría's post-Tlatelolco opportunism (Montiel Pagés 2010, 54–57). Montiel Pagés notes that "it remains a significant paradox that independent cinema gained its greatest momentum when it set itself in opposition to State cinema...because the latter strengthened and gave life to auteur cinema," referring specifically to Ripstein, Cazals, and Fons (2010, 56). And yet when López Portillo's administration came into power, "the old private sector...came out of hiding and started producing their garbage again...[and] called themselves independent producers...since they were making films without state support" (2010, 56). For Montiel Pagés and other filmmakers struggling to make political and art cinema without subvention, this was "an absolute joke because, in reality, they still controlled the industry...[but] no longer had the Film Reserve [Banco Cinematográfico] to shelter their questionable business practices" (2010, 56–57).

In the 1990s, many first-time filmmakers complained of having been overlooked by IMCINE's traditional-minded script selection and economically conservative favoritism, which was only worsened by national budget cuts, as seen with the drastic drop in production under Zedillo. Thus, when the private sector once again emerged toward the end of the decade, it offered itself as an alternative to state production, touting its support for artistic freedom, while also producing films that critics likened to US independent cinema. Companies such as Producciones Anhelo and Altavista Films focused on recruiting new talent, promoting young directors and actors, and creating films with sights and sounds that appeal to the most visually savvy contemporary audiences.[4] Altavista's parent company CIE capitalizes on the vertical integration of several small chains of media consumption, such as Hard Rock Cafe, film distributor Nuvisión, and various music distributors, which allows the producers to use marketing synergy as a strategy in the theatrical release, including launching the soundtrack CD, several music videos, and live concerts (Smith 2003b, 396). Smith writes that "this professionalism of marketing is not only impossible to achieve through statist bureaucracy. It is also one of the three commercial criteria often held to distinguish and disadvantage national cinemas in comparison with Hollywood" (2003b, 396).

Altavista's self-promotion as a conveyor of new talent and fresh ideas was well aligned with the concept of *change* ("*cambio*") that fueled the campaign behind Fox's electoral victory. Creative freedom was promoted as a benefit to well-funded, nonstate productions, and was generally accepted by those already frustrated with IMCINE. In his research on Altavista and Anhelo, Smith sees Pierre Bourdieu's notion on *habitus* as ideal for theorizing the naturalization of this link between private funding and artistic freedom, seeing the two as intersecting "fields."

> It thus follows that in a new funding environment, new forms of film-making will arise with apparent spontaneity. Altavista and Anhelo see no contradiction between artistic freedom and commercial constraints. This is because the directors with whom the companies collaborate seek the freedom to make films that have good commercial prospects; or, to put it another way, the producers offer funding for films that exhibit the signs of artistic freedom. This is not to deny that the resulting films can be genuinely innovative and hugely enjoyable. It is rather to suggest that that innovation remains necessarily enclosed within the magic circle of *habitus*. (2003b, 399)

This "magic circle" is then key in understanding the comparison between independent filmmaking in the United States and Mexico,

especially in that the conundrum is not exclusive to Mexico. The same capitalist ideology that fuels Hollywood blockbuster production, and its thirst for worldwide market domination (including Mexico's), sees limitations in repeating success formulas. Entrepreneurialism depends on novelty and profits from rapid consumption of disposable trends, which then may be accelerated exponentially in media consumption by changes in technology. The same *innovation* sought in the name of artistic expression in US independent cinema in the 1980s became a commodity for Hollywood in the 1990s; when US film production models were imported into Mexico at the end of the century, innovation was already an assimilated component.

These same contradictions in the meaning and purpose of innovation, especially vis-à-vis media consumption, are present in most nationalistic rhetoric—Mexico's included—that wants to unify through tradition and uses cultural homogeneity to discourage dissident voices, while at the same time promoting technological breakthroughs or industrial advancement in the name of progress. The rhetoric of modernization set in place by the post-Revolutionary state now pushes the importance of audiovisual innovation in contemporary cultural production: an ostentatious display of technological advancement serves to legitimize the state despite the fact that the negative impacts of its economic policy have stunted the possibility of a true rehabilitation of its failed infrastructures, especially in economically depressed areas. What seemed like divergent agendas in Salinas's inclusion of cultural development in his free-trade policy might now in fact be evidence of the successful implementation of neoliberal ideology: the same fear of change that Salinas wanted to assuage was transformed into a desire for change in the political transition of 2000, an ideological shift that was exploited in media consumption through its alleged cinematic renaissance. As Podalsky points out, some recent films actually respond with irony to the government's rhetorical position, using divergent or disjointed narratives to depict Mexico as "out of sync" with the developed world in these areas (2008, 153–54).

Podalsky is explicit in linking this shift to youth culture, in contemporary Mexico and in nations experiencing similar historical transitions:

> It is important to situate recent youth films alongside concurrent public discussions about "the problem of today's youth," which vary regionally but frequently intersected in the Latin American context with issues over the legacies of the past and the significance of neo-liberal economic globalization. (2008, 145)

The connection to youth functions both extrafilmicly, with the targeting of young consumers with Mexico's recent cinema, and also within the films, where representations of youth can stand in for social deviance and marginalization. Podalsky sees the co-optation of Mexican youth culture, particularly openly rebellious urban groups such as gangs, as a tool used by different PRI administrations throughout the second half of the twentieth century—hypocritically simultaneous with its repression of the same groups as a display of power (2008, 146–47). While this may not be novel in Mexican politics, the fruition of this process in cinema was precisely the moment when the PRI lost its power, thanks to a number of factors including but not limited to the PAN's ability to mobilize a certain self-identification of marginality and victimization to create Fox's coalition of groups in favor of regime change. This political tactic fell in step with media's marketing of youth culture in exact temporal conjunction with two other undeniable turning points: when film marketing itself surged as a business strategy and when the recent aesthetic and technological innovations in audiovisual media—themselves inherently pro-change—became consumable by mainstream audiences. The subsuming of a new ideology by media was, in some instances, quite overt, even in fiction. Commenting on the discreet cameo appearance of Producciones Anhelo's millionaire CEO Jorge Vergara in *Y tu mamá también*'s wedding scene, in which he is filmed from behind as Mexico's new president (not yet elected at the time of shooting), Smith notes that "there could be no clearer sign of the change of funding paradigm from public to private than the impersonation of the head of state by a pseudo-presidential chief executive officer" (2003b, 397).

In conjunction with the breakout successes coming from the private sector, over the past decade international film festivals and funding sources have made an enormous contribution to financing and promoting artistic innovation, auteur cinema, and younger talent within industries whose public funders are reluctant to take risks. Filmmakers such as Reygadas, who is now a household name after having premiered a number of films at Cannes as both director and producer, felt marginalized by both the commercial and state sectors in the time when he was making his first films:

In this country there are only two ways to finance films: private groups who are not interested unless you bring in more than a million spectators; and the public institutions in which I have indeed felt, on many occasions, rejected by several members who I believe exclude me because I'm not part of the clique and because I don't fit with their expectations, but that's it. (Musi 2005)

But the prestige of international recognition for many emerging film-makers has played a significant role in changing the state's atti-tude toward nontraditional filmmaking and first-time filmmakers. International prizes and domestic blockbusters have together made cinema a trendy topic among legislators, who are interested in support-ing it through increased budget allocations or stimulus policies; on the more immediate level, IMCINE officials and the individuals who make up selection committees—which include representatives from different industry sectors and institutions—have also been opened up to taking greater risks thanks to the proliferation of artistic successes on the international level.

Hyperreality Bites: *Amores perros* and the MTV Aesthetic

Though undoubtedly commercial in their ambitious marketing and considered by many film scholars to be conservative in their underlying ideology, Anhelo's *Y tu mamá también* and Altavista's *Amores perros* were two markers of a millennial boom and were often compared to the crossover hits of US indie film. Because of the purported "new-ness" of its style and the importance of novelty and change in this politically charged historical moment, *Amores perros* was exalted as an example of the true artistic potential of working outside the state. The most visible changes to Mexico's usual cinema were seen in the editing and photographic styles, as well as the film's narrative structure around three plots that intersect with a deadly car accident. Though not seek-ing the same level of visual intensity or the spectacle of violence, *Y tu mamá también* also "breaks" from traditional narrative conventions by including an intrusive omniscient narrator who freezes the flow of action with his social-critique laden commentaries. Following the release of these films, visual stylization through editing and its link to narrative structures would become solidified in youth-oriented films—using, for example, jump cuts, freeze frames, and temporal overlap through scenes from different angles—becoming a new language for articulating the heavily mediated urban youth experience.

Developing his analysis of how stylistic patterns come out of low-budget filmmaking, King writes that in US indie productions,

> where departures from mainstream convention are found at the formal level, they tend to be in two main directions: either in making greater claims to verisimilitude/realism, or in the use of more complex, styl-ized, expressive, showy or self-conscious forms. (King 2005, 10)

This dichotomy functions to contrast two aesthetic veins: the former (verisimilitude) being slower, more character- and dialogue-driven films that attempt to reflect the pacing of "real life," as with John Cassavetes's films or David Mamet's screenplays; and the latter more along the lines of Tarantino, the Coen Brothers, or David Lynch, all of whom tend to make a show of bending the rules of classic Hollywood narrative coding. A modified definition—or possible complication—of the two categories can accommodate a description of the early films of director Jim Jarmusch, who manages to combine these ideas in making an ironic comic spectacle of slow pacing and banal dialogue. This deadpan style, often referred to as "quirky," becomes the norm of indie comedies in the early 1990s with films like *Clerks* (Kevin Smith, 1994), *Slacker* (Richard Linklater, 1991), and *Bottle Rocket* (Wes Anderson, 1996). King's term for this element in Jarmusch's work is "stylized minimalism," which he contrasts with Tarantino's narratives of "stylized digression" (King 2005, 82).

The aesthetic-narrative trend of films like *Amores perros* is most succinctly described by King's term "stylized digression," a combination of structural deviance from the linearity of the classical Hollywood time-restraint-based plotline with audiovisual excess in other elements of the production, including acting, color and lighting, dialogue, and use of music in the soundtrack. While King himself considers *Amores perros*'s blocked-out segments to be much less subversive than *21 Grams*, he sees both the nonlinear narrative and the similar visual tones as representative of a trend in the standard indie fare of the 1990s (King 2004, 90). And yet, the value it places on photographic form could be traced back even earlier. High-contrast, grainy photography, and shadowy lighting in the first and last stories of the film's triptych plot lend an air of realism to images of deprivation. According to Dolores Tierney, this emphasis on photography and varied film stock to show Mexico's contrasting social strata is similar to *Sex, Lies, and Videotape*. She notes that director Steven Soderbergh "makes use of video and celluloid...using video to represent the emotional authenticity of characters' sexual secrets," and furthermore that "video or faster stock can often suggest heightened realism" compared to Hollywood's "polished realism" (Tierney 2009, 107–8).

As discussed in chapter 4, the texture of this photographic realism joins the rapid pace of the editing, the aggressive intrusiveness of the close-up shot, and the agitation of the handheld camera, to all add a perception of violence in form that spills over into the tone of social denunciation in many recent films. However, the average viewer's

familiarity with these conventions since the growth of cable and music television in Latin America makes the depictions of violence palatable, digestible, and rapidly consumable. The "MTV style" (or "post-MTV style") is often critiqued as a superficial, high-adrenalin glossing over of serious political and social injustices, giving rise to a generation of spectators crippled by short attention spans and addicted to the instant gratification of new communication technology. Yet observing this trend as a result of the influences on its producers, rather than assuming a catering to tastes of its consumers, we might note that many film-school graduates make a living on music-video production before or between features. The video as a format often uses nontraditional narrative approaches of experimental cinema, with a more poetic visual syntax. In the narrative fiction films influenced by the music-video genre,

> space-time continuities are subordinated to 1) the synchronization of music and image; 2) the visualization of lyrics or "message"; and/or 3) the creation of fetching images that incarnate a certain quality associated with the song, artist, or product (e.g., irreverence, nostalgia, hip-ness, etc). (Kaplan in Podalsky 2008, 152)

These characteristics, now utilized as much by advertising as by music television, represent a type of stylization that reflects ambiguously as the product of consumer-oriented culture and as a more accurate representation of the psychological state (of the director or the spectator) of perception in a heavily mediated and fragmented daily existence. In many ways, broadcast and cable television programming has domesticated both the visual experimentation and overt sexuality expressed in the music-video genre, in particular through *telenovelas*, whose messages correct deviant conduct with "good morals," as well as with music-video programs whose VJs act as sophisticated and affluent interlocutors of artistic expression, buffering with their enthusiasm rock's expression of angst and dissatisfaction (Podalsky 2008, 148).

It is also noteworthy that this new style of representation is not limited to visual media. Podalsky has pointed out a parallel between the rock music industry and the film industry insomuch as both offer a simultaneous, if ambivalent, consumption and subversion of dominant culture by their young audiences. Music videos are the site of overlap, both in expression and in terms of the market. The link between the film and recording industries was formalized in the

1980s and 1990s, when music videos conjoined both industries with that of television, reviving individually the audio and visual sides and making film soundtracks a key element in cross-marketing strategies. The repercussions of this convergence are of particular interest to cultural critics, whether examining production or consumption. Podalsky writes,

> In the early 2000s [films] began to take advantage of rock, not just as background music...or a (synergistic) marketing strategy...but as an aesthetic template. In this sense, the music video served as mediator and proposed a new audiovisual regime—one that was more metaphorical than linear, in which the spectacle or the preciousness of the image outweigh any other narrative gesture, and whose guiding principle for editing was rhythm. Little by little these patterns have changed fiction film. (2004)

Nonetheless, it is important to remember that not all experience in music-video production leads to the spectacle of narrative digression or the violence against the image itself. Other highly consumable trends, such as nostalgia and laconic minimalism, have paved their own paths in expressing current interpretations of youth experience.

Temporada de patos: A Day without Power...or Authority

Fernando Eimbcke was formally trained at the CUEC film school and then began his career as a music-video director for Spanish-language performers, such as Plastilina Mosh. Having worked with the support of some of Mexico's established and respected directors (e.g., Cazals, Cuarón), Eimbcke recognizes in his own work the influences of US directors such as Jarmusch and Cassavettes, as well as various international influences. According to the film's producer, Eimbcke opted for a minimalist style in his first feature film based on his self-awareness of being both a perfectionist and a relative neophyte. Knowing beforehand that he would want tight creative control over the final product, Eimbcke made production choices that would keep the shooting and editing within the realm of his skill set (Valdelievre, personal communication, June 2007). Aside from Jarmusch, one filmmaker whose style matched these criteria and also appealed to the director artistically was Japanese auteur Yasujirô Ozu. Ozu's *Tôkyô monogatari* (*Tokyo Story*, 1953) and *Ohayô*

(*Good Morning*, 1959) presented shooting strategies that worked with *Temporada de patos*'s location and addressed in form the themes common to both directors: how families live within the structure of industrialized urban space and how youth experiences it. Bringing together these artistic influences, the film responds to a post-*Amores perros* crisis among many Mexican filmmakers of (1) how to make a film for a domestic audience which (2) competes with Hollywood imports and (3) adheres to nationalistic and pan-Latin American politics of counter-Hollywoodism, while (4) living up to precedents in audiovisual production value, narrative innovation, and political voice established by the stylized social realism. While *Temporada de patos*'s Mexico-specific geographic and cinematic references achieve the first and third goal, the indie-esque minimalism gives it an accessible yet auteur style that made for its critical success and helped it get international distribution.

The four major overlapping factors that King uses in defining indie (budget, narrative structure, audiovisual form, and reference to genre) fuse in *Temporada de patos*'s use of a single location, nonprofessional actors, a character-centered low-key tone, limited camera angles, and long takes (allowing for minimal editing). With a moderate budget of US$700,000, part of which came from IMCINE, the film is a mix of state and private funding. But both narratively and visually, it uses stylized minimalism, like Jarmusch's films, as a conduit for the deadpan humor. Shot on color negative, processed digitally to black-and-white video and then finally blown up again onto 35mm film, it manipulates its photographic realism, just like *Amores perros*, but with a different aim (Ayala Blanco 2006, 124–25).

The script constructs a Sunday in the life of Flama and Moko, two middle-class adolescents who live in the Mexico City's Tlatelolco housing development and have recently outgrown the need for a babysitter. Flama's mother rushes off to a potluck handing him enough cash for pizza and the boys' plans for the afternoon are made explicit with a close-up first of cups being filled to the rim with a liter of Coke each and then of hands plugging in the Xbox. The plot inserts three interruptions into the boys' dream day of mind-numbing virtual bloodbath: their 16-year-old neighbor asks to use their oven to bake a cake, the power goes out (leaving the boys panicking at the thought of losing their favorite pastime), and the pizza deliverer, insisting that he arrived within the 30-minute guaranteed delivery time, refuses to leave without being paid.

The afternoon activities that ensue make *Temporada de patos* an enjoyable, well-written coming-of-age melodrama, and the deadpan

tone is very much in tune with how a 14-year-old in a 2003 metropolis experiences the agonizing tedium of life without videogames. Like Jarmusch's films, the emphasis on boredom is achieved through a deliberate flattening of the traditional narrative arc. This flattening is seen in the pacing of both the editing and the acting as well as in the way that seemingly significant scenes are ended without a climactic conclusion. This type of slow pacing, which King describes as demelodramatizing a story, is often the mark of anti-Hollywood political agenda in its approximation of real-time conversations and events and its refusal to erase the unspectacular from the diegesis (*syuzhet*) (King 2005, 69–71).

The essentials of *Temporada de patos*'s visual and thematic style are established in the opening montage. A number of eight-second fixed frames fade in and out to show the neighborhood from various angles: some offer an element of urban blight through graffiti, traffic, and abandoned industrial buildings, bringing to mind the ominous warnings of industrialization voiced in the opening sequence of *Los olvidados*; others capture the cement monstrosities of the housing development from a low angle, updating the famous Mexican sky filmed by Gabriel Figueroa with Mexico City's smoggy firmament; several shots frame the landscape to emphasize the geometric, man-made forms that will become the grounding artistic style for the story set in the interior of these buildings, and also recall early-century Mexican artists such as Tina Modotti, who documented the industrializing process with abstract, modernist photography. But most visible in this opening sequence is *Tokyo Story*'s "pillow shots," a term used for Ozu's fixed frames of industrial urban exteriors used to link longer, dramatic interior shots (see figure 5.1). The monochrome in this opening draws attention to the lines and right angles of the urban space, while de-emphasizing any visual distractions, or kitschy interpretation, that color might make of the setting (Fernández Almendras 2005). The cinematography creates the mood of barrenness and visual tedium that sets the rhythm of Flama and Moko's slow afternoon without electricity, much less malls or cineplexes. The photography's grayscale brings the exterior of concrete and pollution into the interior of the apartment, the filmmaker himself noting that "once it was filmed, this whole idea of concrete, of a gray city, inserted itself into the apartment...as if the city had invaded the apartment" (Fernández Almendras 2005).

These photographic intertexualities draw in yet another in the use of this particular setting: Fons's *Rojo amanecer*, the 1990 film based largely on Elena Poniatowska's testimonial gatherings after

Figure 5.1 Pillow shot from Ozu's *Good Morning.*

Figure 5.2 The opening montage of *Temporada de patos* includes an exterior shot of the "Niños Héroes" building in the Tlatelolco housing complex.

the student massacre in 1968. Like Eimbcke, Fons used Tlatelolco's apartment buildings both as a low-cost location and to make a powerful reference to Mexico's political history and to the working- and middle-class families that occupy these spaces, with particular

attention to the youth experience. This recognizable location is specified when the camera stops on a sign naming one of the complex's buildings: *Niños Héroes* (see figure 5.2). The historical moment that gives the building its name is an illustration of extreme patriotism and teenage military martyrdom, a staple of Mexico's nationalistic public education.[5] Once inside the apartment, we see the "heroes" of this story are two gangly adolescents whose only ambition is to drink Coca-Cola while staging an ultraviolent Xbox war between George Bush and Osama Bin Laden. The dual historical allusion to 1847 and 1968 turns comical as it underscores the unencumbered lifestyle of contemporary middle-class youth. Here, the Ozu reference is to *Good Morning*, a film about two brothers who want to watch sumo wrestling on television all day are surprised when their parents purchase a TV set (see figure 5.3). In *Temporada de patos* and *Good Morning*, the cubicle television holds the teenage male fantasies about the outside world, which contrast greatly with the cubicle domestic space established by their parents (see figure 5.4).

The techniques for framing many of the scenes—the result of shooting with a stationary camera—place the viewer in many instances within the apartment complex's blocky architecture: characters are seen from inside the wall, the closet, the oven, or the television, or on the other side of a door with a window or peephole. The response to this camera work varies greatly, some critics seeing a claustrophobic view of the apartment, others as amplification of the space. While the fisheye distortion through the windows and peepholes triggers a humorous tone, the other "inside" views reproduce the flat, geometric look that imitates the labyrinthine architecture and reiterates Eimbcke's minimalist vision.

In most cases, the camera was set up in one place to film the sequences as tiny vignettes, which are spliced together by fades to indicate a short time lapse. These rectangular static shots amalgamate with the slow editing to let the film read much like a graphic novel or comic book, although the use of the fixed camera was originally intended as a way for a relatively inexperienced director to work more closely with the young actors: "With a continuous take, we could tell immediately if the scene worked dramatically or not. If we had broken it up, we would have complicated things" (Fernández Almendras 2005). Like the choice of black-and-white over color, the long takes and fixed frames omit the visual distraction of camera movement, letting the viewer absorb the nuances of the dialogue and tone. The fusion of the formal and the thematic reveals the influences of both of the Ozu films, in which the Japanese architecture

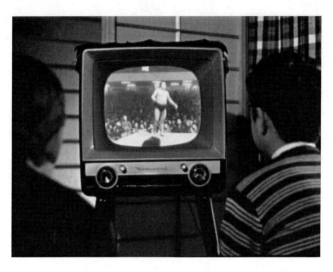

Figure 5.3 In *Good Morning*, brothers are transfixed watching sumo wrestling on television.

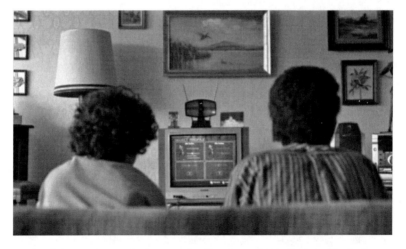

Figure 5.4 In *Temporada de patos*, the "boy heroes" play Bush vs. Bin Laden on the Xbox.

literally and figuratively frames the disintegrating family unit and questions changing middle-class values and consumerism, using the television to repeat the rectangular prism leitmotif (see figures 5.5 and 5.6).

Figure 5.5 Emphasis on architectural framing in *Good Morning* creates repeating rectangular prisms that are concentered in the television inside a box.

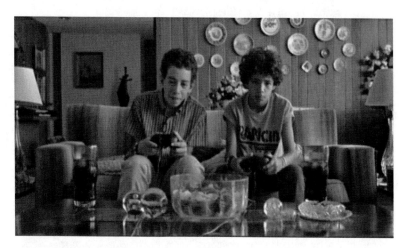

Figure 5.6 Moko and Flama shot from "inside the TV" in *Temporada de patos*. The vertical lines of the aparment's interior are emphasized by the monochrome photography.

A mélange of cinematic references, most of which can be considered marginal to Hollywood, *Temporada de patos* paints an urban landscape very different than the Mexico City of *Amores perros*, and these two films make use of cinematic pleasure and social critique in

very different ways, which can be brought back to King's dichotomy of excess and minimalism in response to Hollywood. *Temporada de patos* was able to draw a broad audience, including the youth audience, and received a strong critical response. While faithful to the comedy genre and Jarmuschian tedium, the film stopped short of making scenes that were so slow, bleak, or long as to create discomfort, which is frequently the case with this style. It uses a coming-of-age formula and a positive but not simplistic ending, which made it appealing to sophisticated younger viewers. Almost paradoxically, it was Eimbcke's music-television background that informed his decision to reject the "MTV style" and attempt to help the young viewer move beyond it:

> At first [filming like that] started maybe as a whim, because everyone was talking about youth, what young people like, that they like a moving camera, dizzying cuts, color, etc... [But] I think that young people are ready for something else. It's cool to move the camera and [use those kind of] cuts, but it's more like television language, more like MTV. I had made music videos in black and white, without cuts, with a single take, and people liked it. I realized that teenagers really were ready for this. (Fernández Almendras 2005)

Nonetheless, in its distribution the film suffered somewhat from the common difficulty in creating a crossover from sophisticated youth viewers (or a slightly older age bracket) to the mainstream teenage audience. King points out that despite the fact that US independent cinema exploded in the 1960s precisely to capture the youth market that had been neglected by Hollywood, current conditions are different and "the move from 'art-house' to teen film more recently is a difficult move (as was the case with *Welcome to the Dollhouse* and *The Blair Witch Project*)" (King 2005, 30–31). Ultimately, Eimbcke's choices came down to an ideological alignment with independent cinema, accepting the fact that his film might not appeal to mainstream youth. Although his concern was still with cinephilic pleasure, he relied on his and the production team's tastes to gauge its potential: "When we were making *Temporada de patos* the only thing we wanted was to make a movie that we would like, that we would really enjoy seeing" (Fernández Almendras 2005).

Niños Antihéroes: Ambivalent Class Critique in *Y tu mamá también* and *Drama/Mex*

Shot beginning in 1999, before the presidential elections, *Y tu mamá también* did not open until June 2001, giving it plenty of gestation time

for marketing campaigns; this resulted in one of the biggest box-office openings in the history of Mexican cinema, grossing US$2.2 million in its first week. Directed by Alfonso Cuarón, the film was produced by private production house Anhelo under the parent company Omnilife, helmed by one of Mexico's wealthiest businessmen, Jorge Vergara. The story follows two Mexican teenage stoners on a road trip to the coast, with an older Spanish woman. Like *Temporada*'s allusion to Mexican patriotism, this unofficial coproduction between Spain and Mexico brings its own dose of nationalism, such as using the last names of the principal characters to reference important figures in the Mexican Revolution (e.g., Zapata, Carranza, Madero) and its independence from Spain (e.g., Iturbide, Morelos). The last name of the boys' seductress, Cortés, is that of the conquistador who invaded Mexico in the sixteenth century, and her foreignness serves as the source of their erotic arousal and also provides the critical eyes through which the spectator can view a landscape all too familiar for the boys.

A number of critics felt that the film constructed a rather conservative perspective, with its superficial incorporation of a folkloric Mexico into its narrative and also because it ends the story by suppressing transgressive behavior with death, conservative values, and nostalgic nationalism (Sánchez 2002; Baer and Long 2004; Noble 2005). And yet, the picturesque aspects are reframed by a voice-over narration's overt critique of uneven development. Cuarón underscores certain seemingly banal moments in the trip using an abrupt, intrusive omniscient narrator, whose voice freezes the diegetic audio track to explain the political and/or social significance of the scene. What runs constant through the seemingly arbitrary commentaries is a foreshadowing of the dramatic conflict of betrayal and the final scene's conclusion that a friendship across class boundaries is ultimately unsustainable (MacLaird 2010, 49–50). The narration also calls attention to the tacit conflict in scenes that serve as backdrops to the main story, implicating the spectator in a perverse fascination with poverty.

> [The film] constructs an allegorical representation of late twentieth-century Mexican society that offers various perspectives from which to advance a critique of social and political problems that have long plagued Mexico. On the other hand, the film's critical perspective is tempered by relying upon stereotyped images of Mexico, which have helped sell the film abroad, and by reinforcing exclusionary gender roles that inform dominant conceptions of the nation. (Baer and Long 2004, 156–57)

The same Brechtian narrative device that critiques class difference and the impact of globalization on Mexico's economy also places the

film within a body of international cinema that uses a self-conscious audiovisual metalanguage to treat existential concerns:

> Similar to the "nutshell sequences" from *Run Lola Run*, in which the action of the film is suspended to display a "slideshow" that presents the future destinies of various minor characters..., the voice-over sequences of *Y tu mamá también* at first suggest a focus on the significance of chance encounters, coincidence, contingency, and even fate...Thus, while it...invokes new [global] cinematic language of contingency, the voice-over in *Y tu mamá también* ultimately insists on the specificity of Mexico's political context at the turn of the twenty-first century. (Baer and Long 2004, 157–58)

The film's conflicted political positioning is enabled by the cinematic conventions of the road-movie genre, pointing to a trait common to several official coproductions that have been flagged as emblematic of this same-but-different treatment of nationhood, with physical journeys across geopolitical terrain often rendering ambiguous visual representations of the nation (see chapter 6). The camera's tourist gaze frames landscape, geographical landmarks, and regional characteristics in the same way that foreign actors mark character development—through difference. Together, the narrative device and the road-trip genre solidify *Y tu mamá también*'s politics: "A combination of conspicuous camerawork and the non-character narrative voice-over works to foreground and thereby dramatize the protagonists' act of (not) looking at the indigenous, *campesino* others" (Noble 2005, 126).

The contradictions of the private/independent label seem to manifest in the mixed attitudes toward a successful democratic election and regime change in 2000, that nonetheless resulted in a more conservative political party with few solutions to Mexico's serious social issues. This ideological uncertainty comes across in the films as well, and can be easily illustrated by the dual meaning of youth, as both subversive rebel and new consumer. Podalsky writes that since the implementation of neoliberal policy in the late 1980s, "youth have served as a symbolic repository for ambivalent feelings about the fall of past Mexican social models in the face of new cultural globalization" (2008, 146). *Y tu mamá también* illustrates this with its shock-value dramatic climax, when the heterosexual tension that propels the road trip concludes in a homosexual encounter between the two male protagonists. This scandalous ending—which also served as an organic marketing strategy—is framed by the narration as a political allegory of "irrevocable change," "loss of innocence," and "the end of a (political)

era." The voice-over narration's critique throughout the film culminates by "emphasizing the failures of the neoliberal model" while also "express[ing] nostalgia for the national-developmentalist state" (Baer and Long 2004, 165).

Historian and film critic Francisco Sánchez does not see *Y tu mamá también*'s treatment of either sex or social stratification as novel within the last two decades of Mexican cinema, but rather traces the explosion of the *comedia light* back to Cuarón's own *Sólo con tu pareja* and attributes the genre's success to its superficial contrast of Mexico's historical richness and its move toward technological advancement. In *Sexo, pudor y lágrimas*, a film that announced the industry's shift toward targeting a more affluent spectator, both drugs and sexual deviance are seen as acceptable vices for upper-class characters and are set against visible consumerism and urban landscapes that show Mexico as cosmopolitan and yet still picturesque (Sánchez 2002, 229). In *Y tu mamá también*, sexual deviance as a component of youth rebellion is an easily digested allegory for political opposition. But the protagonists' choice to "never speak again" about their sexual experience discards the psychological development allowed by their journey as something left behind with the postcard landscape, keeping homosexuality contained within the limits of taboo fantasy for the spectator. As a result, "the film ends up reproducing the misogyny and homophobia that have characterized dominant representations of the nation historically" (Baer and Long 2004, 152).

Drama/Mex was produced at the end of Fox's term but released in early 2007, the first feature released by director Gerardo Naranjo and among the first projects launched by García Bernal and Luna's Canana Films. *Drama/Mex* is not a road movie, but it is set in Acapulco and presents the coastal coastal city as a destination for characters in transit. Its structure comprises two overlapping plots with the same "contingency" of fate represented in other films of the era. One story (of Fernanda and Chano) reveals the hypocrisy of an anguished but ultimately shallow love triangle involving a young woman, her current boyfriend, and her ex-lover. The other story (of Tigrilla and Jaime) finds unlikely companionship through sexual deviance when an inexperienced teenage prostitute meets a suicidal pedophile. Chano works on a cruise line and Fernanda seems to be squatting in her wealthy parents' vacation home. Tigrilla and Jaime come together because they have both run away from their families for different reasons. The upper-class protagonists are not at home in their settings, and move awkwardly among tourists and service workers, obliviously engrossed in their romantic encounters. The

film's temporal structure is deliberately disorienting, with long takes that jump back and forth in time, repeating from different angles the moments where the couples cross paths.

Drama/Mex's title is an ironic tribute to Mexico's rich cinematic traditions, which have been reduced to simplistic categorical and geographic labels for twenty-first-century global audiences. The irony is played up in the film's focus on melodramatic *schadenfreude* in its publicity campaign (see chapter 1). Although the film uses romance and cinematic melodrama as the foundation of its genre codes (though not its narrative structure), it vacillates in how seriously it takes the dramatic circumstances of its characters. As the film begins, Fernanda and Chano bicker, have sex, deceive the other person (Fernanda tells a friend that she never really loved Chano; Chano steals from Fernanda and pretends he wants to marry her), call each other pet names, and ignore each other as they smoke cigarettes (in French *novelle vague* homage). Their love relationship is presented as superficial and narcissistic. The third point of this triangle, Fernanda's current boyfriend, provides comic relief in his immature displays of drunken jealousy and puerile determination. The more serious plot is that of Jaime, a father and husband who arrives in Acapulco with plans to take his own life as an escape from his incestuous lust for his daughter. He encounters Tigrilla, a charmingly precocious teenage girl who has been talked into hustling tourists by her friends, for whom Jaime develops a paternal (if pedophilic) affection. These two love relationships contradict each other in tone, making ambivalent the film's relationship to the genre it references.

The overexposed photography and disorienting camera movements—such as turning on its side—give the film a deliberately unpolished yet stylized look. The handheld camera follows the characters as they move spontaneously without deliberate directions and their dialogues are muffled under ambient sound as they mumble to each other, constructing an artificial authenticity in the recording that transmits the awkwardness of the encounters. The casual acting style replaces the witty banter and explicitly visible character motivation of classic dramas and romances with nonchalance, indifference, and miscommunications, and comes across at once as artistic and amateurish. Solórzano sees this style of realism as arriving late to Mexico and uses Marlon Brando to illustrate a historical turning point in actors' speech that is credited to US independent cinema, something absent in Mexico until recent years: "*Mumble, mutter* and *slur*, three ways of dragging one's tongue that gave credibility to the worlds and characters of US cinema in the mid-1950s, have no equivalent in the majority of Mexican films, even today" (2007, 63). She

blames this precisely on the fact that the nation is so heavily attached to the melodramatic tradition:

> The Mexican cinema that is rooted in realism (most of it) rests on the belief that only words, and not the form of enunciating them or the breath behind a phrase, are enough to achieve the verisimilitude of a performance. Melodrama, the go-to genre for depicting extreme relationships between ordinary people, has borne the brunt of this contradiction. (2007, 63)

Drama/Mex updates the melodramatic acting style, in the way that language is enunciated, similar to what other films, including *Y tu mamá también* and *Amores perros*, are said to have done by incorporating contemporary youth slang into the dialogues. At the same time, a number of other coming-of-age films engage more directly with the idiosyncrasies of human communication, exploring issues of miscommunication and silence through cinematic form.

Sexual Independence and Mediated Communication

King points out gender and transgressive sexualities as one of the subject matters that sustain the ideological vein of indie cinema, alongside films focused on racial minorities, both hoping to debunk Hollywood stereotypes. Feminist, queer, and race-focused cinemas struggle with their positioning in wanting not only to express a marginal social location through nontraditional cinematic form, but also to "normalize" the representations of the groups within media. King sees a certain advantage for queer cinema in this sense, proposing that where the politicization of racial topics is often unavoidable, topics related to sexuality tend to address the subject matter on a more intimate level, presenting the emotional concerns of individuals as issues of identity and individuality, which is already typical of indie film's character-focused minimalism.

> Sexual transgression, generally, is more subject to *commodification* than material that raises questions perceived as more socially intractable and "political." Issues of gender and gender transgression *are* essentially political in nature—entailing differential power relationships and embedded social constructions founded in inequality—but are less often experienced as such. The issues raised by queer cinema tend to be defined primarily as questions of culture and identity—rather than of politics and economy—that lend themselves more easily to niche-marketable quirky, individual-character-centered indie frameworks. (King 2005, 239–40)

Like the aforementioned films that focus on youthful adventures, several films that are aesthetically innovative but without the budgets for large-scale marketing still reach out to young audiences by focusing on coming-of-age topics, particularly the changing norms around sexuality in Mexico. Jesús Mario Lozano's *Así* (*Like So*, 2005) and *Más allá de mí* (*Beyond Me*, 2007), Julián Hernández's *Mil nubes de paz cercan el cielo, amor, jamás acabarás de ser amor* (*A Thousand Clouds of Peace*, 2003) and *El cielo dividido* (*Broken Sky*, 2006), and Iván Ávila's *Adán y Eva, todavía* (*Adam and Eve, Still*, 2004) and *La sangre iluminada* (*Illuminated Blood*, 2007) all use new audiovisual textures and nontraditional constructions of cinematic time and space to explore alternative sexualities. These films, especially the earlier work of their directors, tend to be entirely independent in production and artistically engaged with international art cinema.

Julián Hernández is one of Mexico's most highly praised young directors. His films' explorations of male homosexuality, especially in the context of Mexico City's urban space and repressive social norms, use meticulously constructed audiovisual montages both to convey the poetic sensibilities of the characters and to locate the stories within similar artistic and thematic traditions in film. *Mil nubes de paz* won the prestigious Teddy Award for queer cinema in the 2003 Berlinale and Hernández was recognized as a peer of directors such as Gus Van Sant, Todd Haynes, Derek Jarman, and Pedro Almodóvar.[6] The visual tone is defined by its black-and-white photography, chiaroscuro lighting, and minimalist mise-en-scène that recalls at once Italian neorealism, French new wave, classic film noir, and Mexican Golden Age cinema; its repetition of extreme close-ups of the characters' silent, pensive gazes—often against voice-overs of their own voices; and its fragmented temporal structure that works with the disconnected (also fragmented) sounds and images and constructs much of the action as memory and interior dialogue.

Like *Drama/Mex*, the full title of *Mil nubes de paz* interacts self-consciously with the very convention of film titles, which are often intended as a marketing tool and serve as the buzz word that carries the meaning of the entire film in everyday conversations. Translated into English as "A Thousand Clouds of Peace Encircle the Sky, Love; Your Being Love Will Never End," this cumbersome title (too long to say in one breath) is taken from a Pier Paolo Pasolini poem about his social and legal persecution for his political positions and sexual preferences. Removed from its political context, the phrase is floridly descriptive yet abstract, fragmented and repetitive, much like the film's images. It draws attention to *Mil nubes*'s artful style and its themes of nostalgia

for a past era—formally of cinema and diegetically of music. The characteristics of the title also reflect the way in which Gerardo, his lover, and his friends (fail to) communicate: with either an exchange of silent glances or meticulously redacted dramatic letters, neither of which can express the simplicity of their desire. The disjunction between sound and image indicates that the protagonist is caught inside his own head, poetically narrating his romantic/tragic trajectory. Obsessed with finding Bruno, the lover who abandoned him, Gerardo wanders the streets of Mexico City in a cloud of melancholy that keeps him from engaging successfully with others. He receives sexual advances when asking silently for consoling affection and is offered money from lovers when he only wants a phone number or future date. Like the characters in the film, the title's poetic language is in some ways quite expressive and yet struggles to fully articulate meaning.

A sequence 20 minutes into the film, in the form of a flashback, gives the spectator insight into Gerardo's neurotic fixation on his lost love, while also solidifying the nostalgic photographic gaze that materializes the melancholic tone. The flashback is constructed as such by the insertion of Gerardo into his own memory, but disorients the spectator in the process. From the street at night, the camera pans left across the hand-painted lettering on the window of Café El Popular, framing Bruno sitting in the illuminated interior of the restaurant across the table from someone off screen from the left side of the frame. The off-camera audio of Gerardo's singing voice suggests that he is Bruno's companion, while the lens' focus shifts to penetrate the glass and draw the viewer to a television in the background broadcasting a musical from Mexico's Golden Age cinema. Gerardo's disembodied voice sings along with the diegetic singing from the television while the focus shifts back to Bruno's profile. At the same time, a faint reflection of Gerardo's face appears on the outside of the window, contradicting the sound and suggesting for an instant that he is obsessively watching from the street as Bruno dines with someone else. As the waitress in the background moves toward the table and into focus, her image overtakes Gerardo's reflection and her voice brings the viewer back inside the café. The distance between the two Gerardos—voice and image—cues the recognition of the sequence as memory or fantasy, and yet the following shots center us within this fragment of the narrative, if momentarily. The next two shots of Bruno and Gerardo's still faces contrast with a voice-over of their conversation in the café, alluding to it as the voices of Gerardo's memory, in the form of a dialogue. The framing's extreme close-up impedes the spectator from using environment to locate the story. The next shot is of Gerardo's sister,

who is also a waitress at the café, and brings us back to the interior of
the earlier shot; sound and image match up again in a traditional style,
naming her character and confirming that Gerardo is waiting for her
at a table. And yet his sister's interaction with the two men is limited
to the same extreme close-up framing of her face as she asks them what
they want to order, shifting her eyes from one to the other.

Mil nubes deals on some level with sexual transgression, but more
with the communication issues surrounding sexuality, and the repres-
sive nature of Mexico's conservative values in daily life, which pushes
its inhabitants toward alienation. Where films like *Y tu mamá también*
exploit sexual taboo as a shocking finale to an otherwise conservative
story, *Mil nubes* brings the difficulties of being a young queer male into
a traditional coming-of-age story, but with an appeal to the niche mar-
ket of international art or independent cinema. The techniques used
by the filmmaker reflect the confusion of the main character and trig-
ger the spectator's momentary disorientation. In many ways, this film
is an interesting case to consider the theories of melancholic produc-
tion as it relates to sexual identity. Judith Butler defines gender iden-
tity as an essentially melancholic moment resulting from the trauma
of earliest social taboos, including those of incest and homosexuality.
The traumatic loss results in an internalization of the lost object as
a way of preserving it, which becomes a substitution of "Other" for
"Self." This internalization of the Other marks the moment of the
psychic construction of the ego, that is, an internal splitting that acts
as a regulator of social conduct (1997, 169–70). This aspect of melan-
cholia is made visible in *Mil nubes*, for example, in the aforementioned
café sequence when Gerardo's Self is split in two by the window in his
refusal to give up his memories of Bruno. In coming-of-age stories
such as this, the earliest taboos imposed by the separation from par-
ents are relived in adolescence with the first romantic loss or with any
restriction on one's desire. The double restriction of homosexuality
in the film illustrates that the trauma experienced as lost love and the
trauma of socially imposed restrictions on whom one can love can be
concomitant, if not causally related.

Because the melancholic subject refuses to fully accept what is lost,
an inability to express certainty occurs. Butler writes that

> the melancholic is also "communicative," which suggests that his or
> her speech is neither verdictive nor declarative...but inevitably indi-
> rect and circuitous. What cannot be declared by the melancholic is
> nevertheless what governs melancholic speech—an unspeakability that
> organizes the field of the speakable. (1997, 185–86)

This description of melancholic speech addresses both the disorienting nature of the film's fragmented montage, as well as the expressive yet ambivalent language used by the film's title and its characters. Pasolini's original poem refers to poetry and experienced love as the only two spaces in which the "unspeakable" can truly be expressed, especially in politically repressive societies.[7] Like Pasolini, Hernández's chosen artistic form is the vehicle through which the linguistically incommunicable, the cinematically implausible, and the politically unspeakable come together to express meaning and narrate the trauma of sexual maturation. Lastly, the high level of mediation of this story—in its histrionic dramatic style, conspicuous visual syntax, and nostalgic intertexualities—is in itself a melancholic element in its refusal to fully engage in melodrama's suspension of disbelief, leaving the viewer in a liminal space between fictional and extradiegetic worlds; the making visible of this boundary of mediation, like in the formation of the ego through the internalization of the Other, is a moment of cinematic conscientization.

A similar use of visible mediation to express (homo)sexual maturation in a somewhat melancholic and undeclarative tone is Jesús Mario Lozano's *Así*. Already on the geographical margins of film production for being filmed in Monterrey, *Así* uses a nontraditional language to narrate a university student's entrance into and exit from a bisexual love triangle, a situation of great importance to his identity formation. The script's concept is derived from a piece of trivia that Lozano came across, stating that the average human attention span is only 32 seconds. From this, he tells the story based on a series of 32-seconds scenes, all filming the life of one character at 11:32 p.m. for a period of 90 days. This series of vérité vignettes is interjected with the video poetry of protagonist Iván, who is actively working on establishing his artistic voice as well as his personal sense of self. Iván meets performance artists Mariana and Santiago, who invite him to collaborate on their experimental art and eventually seduce him into a sexual relationship, first with Mariana and then with Santiago. Throughout the film, Iván's role in the couple's artistic and sexual performance seems to be more as an object than a person, and he struggles to gain control over this position and assert his presence.

The theme of "seeing oneself" is explicit in the film, especially in that Iván's video camera is a gift from his blind friend and tutor, Roel. Roel encourages Iván to take advantage of the camera and his own vision in his self-discovery, and yet Roel is given an ability to "see" Iván's true self in that the superficial layer of appearances is

stripped from their relationship by Roel's visual impairment. The film's 32-seconds scenes condense time, calling attention to traditional cinematic narrative's erasure of its own gaps and its privileging of spectacular over-banal moments. As a pseudodocumentation of 90 days, this formative period in Iván's sexual maturity is recreated not by a selection of moments that would impose a moral or intellectual mediation of the story, but through a pattern of repetitive selection that is at once arbitrary and tailored to human spectatorship. The fact that *Así* is in fact fiction means that this artificial "sampling" of Iván's behavior patterns can be read as a self-reflexive mediation of vérité storytelling. Where *Mil nubes*'s attention to audiovisual mediation exists primarily in formal allusions to cinema history and to leitmotifs of psychic splitting, Lozano fuses his own structural experimentation with the video diaries of its internal world, applying the metaphor of self-mediation to the spectator and the character, respectively, through form and content.

Toward or against Hollywood?

The ambivalence in the meaning of *indie* since its entrance into mainstream aesthetics as well as the broad application of the concept of *independent* to Mexican productions complicate the categorical use of the terminology. However, the apparent contradictions are precisely what offer the space in which to understand shifts in Mexico's film market, as both its producers and its audience change. One can view the relationship of aesthetic and narrative innovations (whether truly experimental or a commercially driven imitation of other groundbreaking works) and youth cinema (as representations of rebellion or as target market) in terms of how mediation itself enters into contemporary cinema. Overt mediation seems to narrate youth experience in numerous ways, whether by recreating the new forms of perception that are taking place in urban culture's inundation of information and images, or by allowing cinematic form to illustrate traditional coming-of-age themes, such as alienation, lost love, melancholic angst, self-consciousness, and self-expression. The types of stylization referenced by King, such as digression and minimalism, tend to be vehicles for comedy and irony, and also invite young spectators by rejecting erudite knowledge or conservative artistic traditions and replacing them with a knowledge that is accessible through mass culture. If these types of stylization have roots in US indie cinema of the 1980s and 1990s or in earlier works of internationally renowned art-house directors, the work of recent Mexican cinema has been to

situate this stylization in localized contexts, adding allusions that are less obvious to outsiders.

The strength of the youth market and the young consumers' openness to novelty has permitted some creative leeway among directors, writers, and producers. While some might see aesthetic experimentation as a necessary step in keeping the industry moving forward, others see it as detrimental. In 2005, industry magazine *Variety* reported that

> Daniel Birman, head of production company Alameda Films and co-founder of distrib[utor] Film House, says [the industry's crisis] can't all be blamed on big studio fare. "We have a grave problem: there is too much art product," he says. "We don't compete against the big guys, we compete against each other." (O'Boyle 2005)

According to Birman, the small, quirky, niche-market films dilute the audience for Mexican blockbuster-scale films, and only the latter can compete with US imports. While it is certainly valid that Mexico is capable of producing high-quality cinema with broad appeal for the Spanish-language market, evidenced in the box-office success of films like *Una película de huevos* and *Rudo y Cursi*, the general trend toward higher-budgeted and more commercially oriented cinema that followed the implementation of EFICINE 226 disproved Birman's statement. First, Mexican commercial genres are not automatically more successful among domestic audiences than art cinema, and second, the domination of exhibition by Hollywood studios, is still, in fact, the principal problem. Furthermore, one cannot discount the invigoration of film production in Mexico that came with the successful indiewood and transnational prestige productions of directors such as del Toro and González Iñárritu—neither of whose work can be categorized simply as Mexican Hollywood—or of the international awards to directors like Eimbcke, Reygadas, and Hernández.

This split between artistic/cultural and commercial value within struggling national cinemas begs a contemplation of how to define counter-Hollywood cinema. García Canclini points out, "It must be asked if the predominant cultures—the Western or the national, the state or the private—are capable only of reproducing themselves or also of creating the conditions whereby marginal, heterodox forms of art and culture are manifested and communicated" (García Canclini 1995, 105). In the United States, it is hard to say if the co-optation of indie film's aesthetics, its reduced budgets, and the micropolitics of its niche audiences into Hollywood enterprises is an indicator of

the genre's success or its failure, and if its continuation will be dependent upon increasingly radical content. By the same token, we might also ask if the Spanish-language equivalent of the Harry Potter films would be counter to Hollywood or an assimilation of its ideology. What is certain is that a continued support for creative and thoughtfully developed youth-oriented cinema is urgent, not just in its market potential, but also in engaging Mexico's future filmmakers in the medium, in offering narratives that challenge the ideologies and social norms of prior generations, and in finding the most appropriate means of expression for those narratives.

Chapter 6

Coproduction and Transnationalism: National Cinema in a Global Market

In a 2008 interview with Univision journalist Jorge Ramos, film-maker Guillermo del Toro states, "I've always made foreign cinema, weird [cinema]... I've always made very, very weird cinema... but yes, I do wish I had made more Mexican cinema."[1] The filmmaker identifies with the character Hellboy as being "from two worlds but not accepted by either." *Cronos*, del Toro's first film and the most rooted in his homeland, was a coproduction with the United States set on the US–Mexico border and starring Argentine actor Federico Luppi. Beyond its geography, the location of the film's narrative content—a sci-fi/horror film about a mechanical beetle that exchanges blood for a rejuvenation serum, at the cost of giving its user vampire-like cravings—was marginal to the official national image that CONACULTA was beginning to export. According to del Toro, the film was criticized by high officials in IMCINE and went "without official backing" to Cannes in 1992; there it garnered international clout by winning the Critics' Week award. He explains that despite the success of *Cronos*, his next Spanish-language project, *El espinazo del diablo*, was rejected when it sought state funding. Thus, the filmmaker feels his migratory status was thrust upon him, being unaccepted within his home industry while given various opportunities abroad. In a number of ways, his career trajectory and the works he has directed and produced exemplify the various theoretical models, and the problematics of definition, of transnational filmmaking. *Cronos*'s international awards allowed del Toro to follow the Hollywood émigré tradition, directing the English-language insect-themed sci-fi/horror film *Mimic* (1997). Also in English, he would make the comic book-based *Hellboy* films and *Blade II*, which fully embody high-budget transnational productions,

based on the investing producers, the international casts, and the set locations in Hollywood's overseas studios in Prague (Miller et al. 2005, 153). His most successful Spanish-language films, *El espinazo del diablo* and *El laberinto del fauno*, are set in Spain and as producer he supported projects in Mexico such as *Un embrujo* (*Under a Spell*, Carlos Carrera, 1998), *Asesino en serio* (*I Murder Seriously*, Antonio Urrutia, 2002), and *Rudo y Cursi*; Mexico–Ecuador coproduction *Crónicas* (*Chronicles*, Sebastián Cordero, 2004); and additional projects with Spain, including *El orfanato* (*The Orphanage*, Juan Antonio Bayona, 2007) and *Biutiful* (Alejandro González Iñárritu, 2010).

Miller et al. point out, "Co-production marks an important axis of socio-spatial transformation in the audiovisual industries, a space where border-erasing free-trade economics meets border-defining cultural initiatives under the unstable sign of the nation" (2005, 209). Del Toro is just one of many directors whose career choices and films complicate the use of national origin to categorize productions. This chapter will begin by considering *transnational film studies* as an emerging field in academic scholarship that still works to define its core terminology. The tendency to categorize cinema based on the geopolitical identities of (some but not all of) those who create the films and on (some but not all of) the spaces in which the films are created has become less useful in an era of increased mobility among filmmakers. While cultural categorization highlights the human input into cinematic productions as a way of crediting social environments for artistic inspiration, in reality film productions are based on innumerable factors that include personal creative choices, professional networks, and collective physical and intellectual labor. And yet, films produced under the terms of cultural protectionism, through coproduction treaties or international arts funding, are often expected to take on the burden of representing national imaginaries, citizenship, race, ethnicity, and colonial subjectivities by way of their production choices. This chapter uses examples from Mexico's cinematic collaborations with other nations as an opportunity to explore how international cultural policy attempts to address issues of identity politics within the context of regional trade integration, economic deregulation, transnational migration, and the globalization of labor. It will look at the recent history of coproductions as an increasingly utilized financing model, with particular attention to the relationship between the participating nation-states.

The most prolific program supporting Latin American coproductions is Spain's Programa Ibermedia, which has created a transatlantic network based primarily on shared linguistic heritage. It is no surprise

that the stories and images that have come out of the program are often fraught with clashes between post- and neocolonial ideologies, and, despite filmmakers' desire to expand audiences internationally, often end up reiterating antiquated nationalist discourses or creating alliances based on colonial identity. Other models of transnational filmmaking include funding sources that seek to bypass the national and recognize the talent of young auteurs (the newest del Toros) whose work aligns more closely with international aesthetic trends than with any national discourse; these new funding paradigms nonetheless present a different set of problematic dynamics between center and margin, and between elitist and popular notions of cultural production. This chapter will consider how the United States' relationship as a production partner with Mexico (and with most nations) differs regarding the issues of cultural representation, looking at Hollywood's outsourcing of labor and set locations to Mexico as well as its investment in the new post-NAFTA commercial genres.

Films such as María Novaro's *Sin dejar huella* (Mexico–Spain), Carlos Bolado's *Sólo Dios sabe* (Mexico–Brazil), and Icíar Bollaín's *También la lluvia* (*Even the Rain*, 2010, Spain–Mexico–France)—in which Gael García Bernal *plays* a director shooting a Spanish coproduction in Bolivia—not only represent the concept of transnationalism in their production models, but also deal self-consciously with questions of cultural authenticity in their narratives. The period of time in which Mexico underwent a transformation in its economy and film industry coincides with a global upswing both in concern for the protection of cultural heritage (under the threat of globalization and economic integration) and in coproduction as an advantageous model for film financing. Just as several Mexican films in the early 1990s took up the "Americanization" of Mexican values as a central theme, many coproductions over the past two decades have dealt with issues of transnational cultural identity within their stories: celebrating shared heritage across borders by depicting unexpected personal relationships, marking cultural distinction between the national and the foreign through character traits, or complicating notions of fixed cultural identity through plot twists or narrative irony. As cultural identity wore out its novelty as a cinematic theme, the policies within certain coproduction programs began to change and accommodate more culturally enigmatic works. Considering different examples of these changes, we must also ask what the erasure of issues of cultural heritage, colonial identity, or economic power dynamics from cinematic representation says about more current production trends generated by Hollywood and other transnational funding models.

Transnational Cinema: An Interface between Local and Global

Two central issues in defining transnationalism within film scholarship are first, how films (and filmmakers) are grouped as comparative objects of study in a way that gives relevancy to the comparison (e.g., linguistic connections, cultural similarities, displacement from the same nations or regions) and also recognizes the challenge that the films present to their very groupings; and second, how these post-, trans-, or supranational filmic bodies of work relate to that which is produced firmly within the boundaries of a national industry. Higbee and Lim (2010) lay out three principal trends in transnational film scholarship, including (1) analyses that set up a national/ transnational binary, seeing the transnational as all films pertaining or linked to a particular nation but produced outside its industry or traveling beyond national audiences; (2) analyses that group cinema regionally based on geographical, linguistic, or cultural similarities (examples relevant to this chapter would include Latin American, Iberoamerican, or Spanish-language cinemas); and (3) analyses of "diasporic, exilic, and postcolonial cinemas," which attempt to refute "the western (neocolonial) construct of nation and national culture and, by extension, national cinema as stable and Eurocentric in its ideological norms as well as its narrative and aesthetic formations" (2010, 9–10). Higbee and Lim discard the second approach as being a more regional than transnational focus; and while the first approach is critiqued as eschewing the concerns over power dynamics that the third approach highlights, the third approach is critiqued for its tendency to position diasporic or postcolonial cinema "on the margins of dominant film cultures or the peripheries of industrial practices," and for overlooking "the impact such films might have on mainstream or popular cinema within either a national or transnational context" (2010, 10). As an alternative to all three, the scholars propose a "critical transnationalism" with the goal of producing scholarship that would "interpret more productively the *interface* between global and local, national and transnational" (2010, 10, my emphasis). This approach would take up the critical stance of work done on diasporic/ exilic cinema without underestimating its impact on and interaction with the national cinemas of established industries. The fluidity of this approach, seeing interactions between sites of production and financing rather than categorical definitions, is useful to the goals of this chapter. It is also important to note that the national corpus cannot simply be dismissed in looking at transnational productions, as the

state plays a central role in defining policy, even within supranational treaties, such as Ibermedia or free-trade agreements. Miller points out that "globalization does not offer an end to center-periphery inequalities, competition between states, or macro-decision-making by corporations. Instead this power just cuts the capacity of the state system to control such transactions" (2007, 45).

Looking specifically at Mexico, Luisela Alvaray (2012) makes an important point about the role of local, socially conscious production houses that are working independent of state support while also collaborating internationally. She offers the example of García Bernal and Luna's Canana Films, which maintains the goals of decentralizing and diversifying Mexico's filmic narratives (see chapter 2) through both production and distribution. Alvaray sees these producers as taking on the role of promoting culturally relevant content, and yet purposefully reinterpreting the parameters of defining national culture, for example, with the film *Cochochi* (Israel Cárdenas and Laura Amelia Guzmán, 2008), shot in the northern state of Chihuahua with Raramuri nonprofessional actors (2012, 73–74). She also argues against the assumptions that the wide-reaching Latin American films of the last decade (e.g., *Y tu mamá también*, *Cidade de Deus*) are simply "Hollywood gone south," analyzing them instead as culturally relevant to their place of origin. She calls for the necessity of hybrid production forms. Another example of the interaction between local and global is how the success of directors such as del Toro, González Iñárritu, and Cuarón in large-scale productions overseas has led them to speak out on behalf of cultural protectionism in Mexico.

Transnational Mexican cinema can certainly encompass the works of migratory directors employed in Hollywood or Europe as well as the aspects of US Chicano cinema that address Mexican identity; however, the existence of a Mexican exilic cinema is in no way comparable to that of nations currently under totalitarian regimes, where the production of a film that contests the state is almost always dependent on the filmmaker's emigration. In fact, Mexico's film industry throughout the twentieth century included the active participation of foreign filmmakers and members of certain diasporic communities (particularly Lebanese), and more recent films produced in Mexico have often depicted immigrants (e.g., the anarchist who fled Spain's Civil War) or immigrant communities (e.g., Turkish and European Jewish families in *Novia que te vea* [*Like a Bride*, Guita Schyfter, 1994]) as a way of conveying diversity and political or religious tolerance and of emphasizing cultural contrasts. However, the majority of these immigrant stories depict middle-class European families and

focus on cultural assimilation. The former category, of the Spaniard in Mexico, becomes even more prevalent in the 1990s, when coproductions with Spain increased. While on the level of production collaborations with Spain may challenge the Mexican state's patrimonial role and the film's geographical categorization may complicate national origin, the challenge comes by way of an ambivalent relationship between the cultural product and the colonial origins of the nation itself, or by a product that represents to some a co-optation by neoimperial economic forces. For that reason, a concern for postcolonial power structures is essential when looking at heritage productions and treaty coproductions in Latin America, especially those that incorporate cultural elements into their narratives (termed "natural" coproductions). In Mexican commercial cinema, despite the representation of urban culture as cosmopolitan, diverse, and open to foreigners, there are few depictions of indigenous communities and those that exist tend toward historical representations (reinforcing the early twentieth-century *indigenismo* discourse) or ironic (as explored in later sections). Few are made in such a way as to represent earnestly the cultural and ideological diversity that is already endemic to the national territory.

Spanish-Language Coproductions and Cultural Protectionism

It is true, perhaps we [Spaniards] are trying to redeem ourselves for historical debts we owe to the region [of Latin America].
—Programa Ibermedia administrator Víctor Sánchez
(cited in Falicov 2007)

Cinematic coproduction refers to the collaboration between two or more agencies in the process of financing and producing a film. *International* coproduction can include any film with producers based in different countries, but frequently refers to productions in which funding comes from two or more national film institutes or trusts, offering a shared financial risk and with expectations of a broader audience. In the late 1980s and early 1990s, a number of state audiovisual institutions signed bilateral treaties as a way of making clear what aspects of each nation's film legislation these productions would adhere to. The policies within these agreements often aim to guarantee that cultural input from both funding nations are included in any given production. Actors, directors, production units, and locations carry varying weight in fulfilling heritage standards.

These types of productions are known as technical-artistic coproductions, as opposed to financial coproductions (which under some conditions can also meet treaty requirements). In fiction films, meeting the requirements to receive funding for a treaty coproduction can involve making changes in a script to accommodate casting stipulations, which are based on the legal citizenship of the actors. (Actors who hold dual citizenships in Spain and Latin America are wild cards for fulfilling requirements.) Thus, treaty coproductions take on the onus of representing, both symbolically and performatively, the cultural heritage of two or more nations. While meeting heritage standards can depend largely on nondiegetic elements, such as technical crew and location of postproduction, adapting the narrative content is sometimes necessary to negotiate a cultural balance. This often results in a simplification of national identity, with easily distinguishable indicators (such as accents or historical events) becoming the primary definition of characters and settings, or in plots that bring said characters up against a particular nation's topographical, infrastructural, or cultural idiosyncrasies. A script that has already incorporated multinational locations and/or casting opportunities into the narrative at the time of financing is referred to as a natural coproduction.

Coproduction as a practice, along with international casting, was a part of Latin American cinema throughout most of the twentieth century, and helped to build the Spanish-language market during the first decades of sound cinema with its transnational appeal. One of the principal examples is Mexican cinema's consolidation of the Spanish-language market during WWII, which includes collaborations with Spain, Cuba, and Argentina (López 1994, 10). Beginning in the mid-1980s, Spain's film institute Instituto de la Cinematografía y de las Artes Audiovisuales (ICAA), its agencies for aiding international development,[2] and Televisión Española (TVE) were all geared toward supporting the development of the audiovisual industries in Latin America, increasing aid and investment, and allowing coproductions to qualify for state subsidies (Hoefert de Turégano 2004, 17). In 1989, delegates from 13 Iberoamerican film institutes, including IMCINE, came together as the international committee Conferencia de Autoridades Cinematográficas de Iberoamérica (Conference of Iberoamerican Film Authorities, CACI) and signed an agreement in which the participants agreed to

- support, through cinema, initiatives to develop the cultures of the region's communities;
- harmonize the film and audiovisual policies of the member states;

- resolve issues surrounding production, distribution, and exhibition of the region's cinema;
- preserve and promote filmic productions of the member states; and
- broaden the market for filmic productions in any form of distribution, by way of adopting in all of the nations of the region standards that support the growth and continuation of a common film market.[3]

As a step toward these goals, the members also signed the Acuerdo Latinoamericano de Coproducción Cinematográfica, an accord that has continued to regulate coproduction between most Latin American nations. In a 1997 summit of Iberoamerican heads of state, CACI was authorized to administer Programa Ibermedia, which pools contributions from its members and, through a selection process, awards funding in four categories (training, development, distribution, and coproduction) to filmmakers in its member nations. While Spain is the principal contributor to this fund—and holds a certain leverage as the administrator—Ibermedia's members comprise 19 Spanish-speaking Latin American nations, Brazil, and Portugal.

At the time when Ibermedia's funding began, Spain's role as the primary investor in Latin American cinema was seen as ambiguous, and questioned as paternalistic, if not imperialistic. Spain is the second largest investor in Latin America after the United States, and the block set up at the Iberoamerican Summit was intended to challenge Hollywood's dominance of the global film market by creating collaborative production and new chains of distribution between countries. Teresa Hoefert de Turégano writes that Spain's relationship with Latin American film industries "is dominated by the implicit recognition of mutual needs, which appears to have an equilibrating effect among these economically and politically unequal partners and yet is framed in an imperial triangle with the United States" (2004, 15). But she questions the stakes that Spain's major telecommunications companies, who merged their satellite television platforms into Canal+ (Digital+ until 2011), held in producing Spanish-language content; she suggests that the willingness in the 1990s of television networks (then TVE and Canal+ España) to coproduce Latin American audiovisual projects was part of their parent companies' neoimperialist strategies to dominate the Spanish-speaking telecom market, including Internet and pay-TV (2004, 19–21). However, Tamara Falicov's research specifically on Ibermedia finds that as a contributing party

and the administrative seat, Spain operates at a loss, getting back roughly US$1.00 for every US$1.60–US$1.70 that Latin American nations receive in funding. While she sees Spain as benefiting in the prestige that these coproductions bring in their international awards, as well as the lower production costs of shooting on location in Latin America, she does not discount entirely the role that the colonial legacy plays in this dynamic. For example, contributions to the Ibermedia fund, 50 percent of the total, are provided by AECID as part of its foreign policy to "maintain good relations with other countries, including former colonies" (2007, 27–28). And according to the words of the Ibermedia administrator in this section's epigraph, Spain's investment in fostering Latin American audiovisual content with strict cultural-protectionist policies is a process of reparation rather than an attempt to exploit the market.

Whether or not they are treaty approved or involve public funding, many Spain–Mexico coproductions have taken up the technical–artistic formula as a way of involving Spanish talent and therefore improving chances of distribution in Spain, which for Latin American filmmakers can serve as "a gateway to Europe," specifically its film market (Falicov 2007, 24). Where Hoefort de Turégano sees tendencies in pre-Ibermedia coproductions to exoticize Latin American culture and landscapes, Falicov and others have found a subsequent tendency to pull from a handful of recurring stereotypes of the Spanish foreigner (e.g., the anarchist in exile, the tourist, the racist, and the wealthy entrepreneur) as a foil for protagonists who represent autochthonous Latin American identities (Smith 2003b, 398; Hind 2004, 99–109; Falicov 2007, 24–26). While *Amores perros, Y tu mamá también*, and *El crimen del padre Amaro* are some of the most frequently analyzed examples, lesser-known titles include *Por la libre* (*Dust to Dust*, Juan Carlos de Llaca, 2000), in which two grandsons honor their Spanish grandfather's dying wish, only to discover he had a secret family in Acapulco; *El sueño del caimán* (*The Dream of the Alligator*, Beto Gómez, 2001), in which a young Spaniard leaves his mother and grandmother behind in Spain to seek out his estranged bank-robber father in Mexico; *Nicotina* (*Nicotine*, Hugo Rodríguez, 2003), in which Diego Luna plays a young Mexican hacker suffering from a fetishizing obsession with his attractive Spanish neighbor; and *Cosas insignificantes* (*Insignificant Things*, Andrea Martínez, 2007) in which a young woman introduces her son to his father, a Spanish doctor, after the boy is diagnosed with cancer. The latter two received coproduction support from Ibermedia.

Sin dejar huella: The Economics of
Cultural Identity

María Novaro's fourth narrative feature, *Sin dejar huella*, was pro-
duced by Altavista Films the same year as *Amores perros* but released
a year later. To meet the requirements of its Ibermedia-supported
coproduction between Mexico's Altavista and Tabasco Films and
Spain's TVE, Vía Digital, and Tornasol Films, its leads include Spanish
actress Aitana Sanchéz-Gijón and Mexican actress Tiaré Scanda.
Moving in locations from the US–Mexico border to the architectural
ruins of the conquered Mayan civilization on the Yucatan Peninsula,
this road movie inserts the aforementioned "imperial triangle" into
the film's diegesis. Aurelia (Scanda) is a young mother from Ciudad
Juárez who steals money and drugs from her *narco* boyfriend, leaving
him and her *maquiladora* job behind to go make a new life as a wait-
ress in Cancún. Marilú (Sánchez-Gijón) introduces herself to Aurelia
as "Ana" when they meet at a roadside restaurant and asks Aurelia if
she can ride with her to Cancún. Marilú has recently been arrested by
a perversely obsessive and racist Mexican official during her attempt
to smuggle fake pre-Columbian artifacts into the United States, but is
let go in order for the police to follow the trail to her supplier. Neither
woman realizes that the other is also being pursued by armed men.

As these two sympathetic criminals travel toward their destination,
the topography transforms from the industrial Ciudad Juárez and
dry deserts to lush foliage, arriving at white-sand beaches, *cenotes*,
and mangrove forests. The framing also shifts as the trip progresses
southwest, from simple informational views, such as establishing shots
and interiors, to contemplative and emotive landscapes framed by car
windows, windshields, and rearview mirrors, and accompanied by
music. The soundtrack changes along with the images to match musi-
cal traditions with their geographical origins, including *narcocorridos*
and *norteña* in the north, *son jarocho* as they pass through Veracruz,
and eventually Caribbean salsa. Rather than present the film as lin-
guistically uniform for a pan-Iberoamerican audience, a progressive
contrast develops within the dialogue that follows the transregional
journey: beginning with jokes about Marilú's Castillian accent, con-
tinuing with Aurelia's *norteño* accent used to underscore her naive
remarks, and ending with conversations in Yucatec Maya.

If at first the foreigner in *Sin dejar huella* functions similarly to *Y tu
mamá también* in placing a tourist's gaze on the images framed from
the car, the typical indicators of national identity—and identity in
general—are repeatedly undone and then further destabilized as the

story develops. The viewer knows from early in the film that Marilú's accent is misleading, that she holds Mexican citizenship, having been born there. Yet at the moment when this information is revealed, she is being accused of identity fraud for carrying a number of passports with false names, and even Aurelia calls her Ana throughout the entire movie. Based on her physical appearance, Marilú masquerades as a sophisticated and wealthy European, and yet Aurelia soon learns that her companion has no money or change of clothes and is running from the law. A transformation of the "foreign" status also shifts between the two women. As Aurelia leaves the northern region she is familiar with, she observes the landscape with awe and curiosity, whereas Marilú moves into a comfort zone as she enters the Mayan territory where the artifacts she sells are produced. And while Marilú's knowledge of a Mayan language, pre-Columbian art, and Yucatecan geography might threaten to undermine the supposed authenticity of Aurelia's Mexican working-class identity, the fact that Marilú and her local supplier/replicator exploit that culture by falsifying it reminds us of the former's role as an "impostor." In fact, on one level Marilú's work can be likened to the Spanish telecommunications companies' neocolonial exploitation of exoticism presented as a business alliance that works against the United States and in favor of localized Latin American cultural production. Nonetheless, the story places the characters into a relationship that inverts the dynamic of Mexico's economic dependency of Spain, as Marilú is broke and Aurelia must lend her money and buy her food.

Along with its playful approach to Mexico's colonial heritage, *Sin dejar huella* offers a strong critique of NAFTA's impact on Mexico, of trade liberalization in general, and of the newly elected President Fox's penchant for privatization. In an early scene, Aurelia watches a news report on the femicide in Ciudad Juárez, primarily targeting young women working in the *maquiladora* industry on the border. She flees in fear of both this situation and her boyfriend's involvement in drug trade, another business fueled by US consumption. Rather than finding a more idyllic life in Cancún, she ends up working in a franchise theme restaurant for tourists, whose decor is a commercial, plastic, and hybrid version of Caribbean and Mayan culture. Marilú's story offers further critiques: the business of making impressions of Mayan temple glyphs and selling replicas to US museums mocks the proposal that NAFTA would make Mexican culture an exportable commodity. Additionally, the reference to a museum at the ruins operated by the Instituto Nacional de Historia y Antropología (INAH, the organization behind Mexico's famous anthropology museum) takes

a jab at the Mexican state's cultural policies that see the preservation of ancient artifacts for tourism and the circulation of popular art in North American and European exhibits as sufficient in protecting indigenous cultures. In the last shot of the film, a Pemex (Petróleos Mexicanos) sign seen earlier in the film is replaced by one reading "Exxell" (an invented merging of Shell and Exxon), prophesying the privatization of Mexico's national oil company as the capstone on the state's long process of selling off its assets to US and multinational corporations. This film's irreverent conclusion might be that the debate over whether coproduction with Spain reproduces the legacies of the Conquest or creates a transatlantic cultural identity is moot given the new structures of global economic power going into the twenty-first century.

Sólo Dios sabe: Latin America on Its Own

The issue of the stereotype of the Spaniard is an interesting reversal of the visibility politics of the late 1980s and early 1990s related to Hollywood's (under/mis)representations of racial and ethnic identities, particularly with relationship to Latin American narratives. Controversies include Bille August casting his literary adaptation of Allende's *La casa de los espíritus* (*The House of the Spirits*, 1993) with only US/Hollywood star-system, non-Latin American actors; Spaniard Antonio Banderas receiving lead roles as Cuban revolutionary Che Guevara, Mexican outlaw Zorro, a Cuban mambo singer, or a high-budget version of El Mariachi; and actress Laura San Giacomo being cast as Frida Kahlo in Luis Valdez's original biopic, which was never produced due to the negative press. These examples fueled a wider debate surrounding the performability of race, ethnicity, and nationality, which coincided with tangential discussions at the time around underemployment of minorities in the media industry, affirmative action, and the protection of culture within regional trade agreements. That is to say that the cultural protectionism written into coproduction policy such as Ibermedia was intended precisely to combat the circulation of Latin American stories with only European and North American actors. Ironically, the use of citizenship as the determining factor in casting policies fails to address the question of underrepresentation of racial minorities and addresses neither the political nor the performative sides of the debate. These policies, in elevating the debate on media diversity to a transnational level, evade the cultural and ethnic conflicts that are particular to different nations and regions. In effect, the films that use the European

foreigner to highlight Latin American natives depict the latter using the same homogenized tropes of national identity that artists have been struggling to break free of for more than a century.

Carlos Bolado's Mexico–Brazil coproduction *Sólo Dios sabe* received support from Programa Ibermedia at a moment when the number of required coproducing nations was reduced from three to two, and therefore does not incorporate Spanish locations or actors. However, the parallels the film draws between its two Latin American locations might be seen as responding inadvertently to both historical imperialism and official notions of national identity. From its inception, *Sólo Dios sabe* was planned as a transcontinental project, as a collaboration between Bolado and Brazilian producer Sara Silveira. The two secured funding from Ibermedia, IMCINE, Brazil's Petrobras cultural funding, and several private producers in both countries. This natural coproduction actually took many years to cohere its binational elements and is quite a realistic example of how the economics of global financing in this high-cost medium are inextricable from the aesthetic and narrative results.

Following bilingual Spanish–Portuguese opening credits, the story begins with a border crossing, from San Diego into Tijuana. After losing her passport, Brazilian art student Dolores (Alice Braga) is unable to reenter the United States and is directed by border agents to the embassy in Mexico City. A young Mexican journalist, Damián (Diego Luna), is infatuated with Dolores after seeing her in a nightclub and offers her a ride to the capital. The road trip provides a chance for their romance to bloom while the cinematography showcases the landscapes of northwest Mexico and Baja California with panoramic shots, pit stops at quaint motels and eateries, and a religious festival in a Purépecha town near the base of the Paricutín volcano in the state of Michoacán. The couple's arrival in Mexico City is a stepping-stone, from which the story quickly leaps (by plane) to São Paulo, Brazil. The latter half of the film shows Dolores's confrontation with mortality and her exploration of spirituality as she learns about the rites of her late grandmother's religion, Candomblé. This leads to a second trip, from São Paulo to a more rural and idyllic Northeast, on a lushly verdant coastal Bahía, with both ocean and running creeks, a landscape to contrast Mexico's desertic northern states.

The film's binational qualities surface on several different planes, which can be mapped out as (1) the filmmaker's personal connections and his international professional network of actors and producers;[4] (2) the transnational circulation of capital through the state and private bodies that provided financing, including the treaty policies; and

(3) the characters and locations explored within the diegesis as geographical and cultural markers. The links between these planes—between personal, professional, and artistic interests, or between global economics and filmic storytelling convention—are what nuance the film's reading and make it difficult to see any production choice as solely artistic, commercial, or policy related. For example, Luna was in mind for this role from before the script was written, as he and Bolado both wanted to tell a story of what it meant to be an orphan. Braga was later chosen for her likeness to the late Cuban performance/visual artist Ana Mendieta, whose name and work are woven into this story through Braga's character. Furthermore, the script called for shooting in both countries, and thus incorporated production units in both places. Bolado notes that while Ibermedia's funding award was based on approving the original script and production plan, private investors such as Miravista (Disney) had a much larger presence throughout production and ultimately more influence over the final product (Personal communication, December 2007).

The film's thematic emphasis on biological bloodlines, geopolitical origins, animist religious practices, and Earthworks artists (such as Mendieta) all naturalize the relationship between cultural/racial identity and geographic location, the latter made palpable by the photography's emphasis on the topography of its locations, whether urban or rural. Bolado's interest in environmental art is worked into the film's aesthetic by way of the road movie's scenic stopovers and through the likening of these artistic practices to religious rituals. Bolado comments,

> The film explores manifestations of the spiritual and religious impulse, which is also the beginning of art. I have always been interested in primitive religions, and I tried to make specific symbols of Catholicism and Candomblé resonate, in a way that I hope comes across as respectful. Oxum, the *orixá* (like an angel or goddess) of fresh water that becomes a guiding force in Dolores' life, is present throughout the film.

Bolado's prior research on Afro-Cuban religious syncretism overlaps with the artistic inspiration from artists such as Mendieta, as well as his contemporaries Erika Harrsch and Tatiana Parcero. The focus of Mendieta, Harrsch, and Parcero on the female body is not handled in the film as blatantly political, but rather as another site of convergence (in reproduction) between biological and cultural identities. Land (nature, landscape, cartographies) and bodies are explored

through their similarities and through their mutual imprints on one another. Mendieta's work is mimicked explicitly when Damián traces Dolores's figure in the sand after a conversation about the artist, and more subtly when Dolores's face presses up against the window during sex in Damián's car.[5] Dolores's dream sequences throughout the film take place at the river where her Candomblé initiation occurred and where she spent time with her grandmother as a child. A grainy film stock cues the images as both flashbacks and premonitions, and home-video camerawork marks them as visual documentation of Dolores's youth. Floating flowers reference rites of devotion to Oxum, while the images of Dolores's body in the river fuse the homage to Mendieta's photographic work with a canonical European work, John Everett Millais's *Ophelia*, both of which are prescient of the film's tragic ending.

The continental leap midway through the movie triggers the change in genre, from romance to tragedy. The narrative structure then further emphasizes the parallels between these two Latin American cultures. The couple's life together, a continuation of their earlier voyage, is modeled as a temporal trajectory (using traveling as a theme and clocks as a leitmotif), and the film's narrative traces where their two paths coincide. This trajectory is split in two by the transition between North and South America, and by parallel events and images, a structural and thematic doubling that joins form with content. Another leitmotif, the mirror or reflection, repeatedly shows Dolores and Damián contemplating their own inverted "self" as the two of them become a pair, watching their own images while also looking indirectly at their partner.

This pairing of a binational couple is framed by mirroring events that interrupt their journey, such as indigenous and African religious rituals. Several elements of these events call our attention back to the debates around coproduction's construction of cultural identities, here cultural groups celebrated by national discourse but marginalized by the historic economic realities of racial stratification. Both are religious ceremonies that emphasize the syncretism that occurred as a response to the spiritual conquest of Iberian Christianity over African and indigenous belief systems. The comparison, while suggesting an anticolonial solidarity, is between practices that have already, for many decades, been incorporated into nationalistic discourses and iconographies.

In both the romantic and tragic storylines, the characters work through their own relationships to religion, presented first as superstitious rituals with holy water, impromptu altars, and buying holy

cards, and later as critical life decisions hinging upon the couple's relative valorization of destiny and free will. Dolores's Candomblé practices are compared to Damián's ritualistic Catholicism, and eventually, both have their connections to these practices legitimized through biological/geographical origin. At the festival in Michoacán, Damián is greeted in Purépecha by a local and immediately comments that the man reminds him of his father, giving him an imagined indigenous bloodline.[6] Later, Dolores discovers a part of her identity concealed by her mother, that she is the great-granddaughter of an Afro-Bahian high priestess of Candomblé. Dolores's biological lineage is used to explain her new attraction to these religious practices, while her mother's disregard for them is a result of her desire to "pass" as European.

The cultural parallels are not limited to the traditional. Contemporary pop culture enters the film via the soundtrack, an element of marketing that is essential to the promotion production model and inevitably joins media-consumer reality with the internal world of the film. Brazil's *mangue beat* musician Otto teamed up with Mexico's Grammy-winning singer/songwriter Julieta Venegas. Though both musicians embody the geographic complexity of borders—Otto being of Dutch descent and Julieta having grown up in Tijuana—their participation in the soundtrack was incorporated as the gender–nationality inverse of the romantic leads, a duet between a Mexican woman and Brazilian male, and they recorded a soundtrack with songs mixing the two languages (Bolado, personal communication, December 2007).

What is at stake in this mirroring of traditional and contemporary cultural production becomes even more complex when factoring in casting. As part of the mystical aspect of the film and an homage to the 1959 film *Orfeu negro* (*Black Orpheus*, Marcel Camus), Bolado cast Mexican actor Damián Alcázar, the lead in his first film, as a personified *presagio de la muerte* (death omen) who touches Dolores three times throughout the film: dressed in drag in the Tijuana nightclub, dressed as a veiled Moor in the indigenous festival in Mexico, and wearing darkening makeup to appear African in a Candomblé ceremony in Bahía. While the director himself leans away from a political reading of the film and sees his casting choices to be among the many artistic idiosyncrasies of his body of work, the fact that one of Mexico's most recognized contemporary actors is literally *disguised* for his personification of three historically marginalized groups immediately recalls debates on identity and visibility politics. On the one hand, this triptych role is a repetition of the theme of

performance that highlights traditional and contemporary music and dance cultures in both countries, while on the other, the performative impersonation of these identities contradicts the story's authentication of heritage with land and bloodlines, and furthermore, on some level, responds to cultural protectionism's notion that identity cannot or should not be performed. At the same time, the centrality of mainstream, racially nondescript actors in lead roles and the relegation of visible racial difference to extras indicate that commercial viability and realistic representations of Latin American diversity are still clearly at odds.

The New International Division of Cultural Labor: *Maquila* Film Production in Mexico

The United States' relationship to coproduction is somewhat contradictory. While the government has signed no international coproduction treaties, Hollywood studios are active in industries throughout the world, as producers and distributors. Unofficial US coproductions include collaborations among public and private television broadcasters, independent film producers, and major Hollywood studios, the latter securing US distribution rights for the films. Encouraged by the market growth of the multiplex exhibition system, several major studios set up local offices in Mexico City to oversee production partnerships as well as the distribution and marketing of US films, while also scouting out new films for distribution in the US foreign/art-house niche market. The majority of the studios have focused investments on romantic comedies, including Miravista/Disney in *Cansada de besar sapos* (*Tired of Kissing Frogs*, Jorge Colón, 2006), Columbia TriStar in *Niñas mal*, and Warner Bros. Mexico in *Efectos secundarios* (O'Boyle 2007). One of the last studios set to open offices in Mexico was Paramount Pictures, who in 2007 intended to "focus on commercial films aimed at the Mexican aud[ience] while funneling art house projects to specialty arm Paramount Vantage" (O'Boyle 2007). Some major studios collaborate with local producers by offering first-look deals, in order to have the first opportunity to purchase rights to new projects. This was the case with Universal Pictures' specialty unit Focus Features, which signed a first-look contract with Canana Films in 2006 (Macauly 2008). Focus produced US director Cary Fukanaga's 2009 film *Sin Nombre*, and had on-the-ground production support from Canana when shooting in Mexico, a collaboration that has created a new model for high-budget films seeking an international Spanish-language market. It is important to note

that the studios' investment in the marketing of their own coproductions has been key in the success of the films: "The top six Mexican films [in 2008] were distributed by Universal, Fox, Warner Bros., Disney and Sony, selling a total of more than 11.4 million tickets" (Young 2009). This fact indicates that the failure of most Mexican productions in exhibition is not due to lack of audience interest, but rather to insufficient resources to promote films on the level that studio distributors do. Nevertheless, in more recent years, many of the major studios have reduced their investment in local cinema, focusing instead on mass dissemination of blockbusters, and many have therefore closed their Mexico offices.

In addition to investment in local projects, major studios have also taken advantage of Mexico for shooting foreign-location (also "runaway" or, as some critics have aptly dubbed them, "*maquila*") productions (Miller et al. 2005, 165; McIntosh 2008). The state of Durango was the main location for Westerns throughout the 1960s and 1970s, and several now-classic genre films were shot there in the 1980s (Miller et al. 2005, 164). However, given that production costs are relatively high compared to other Latin American countries and because, as of the 1970s, Canada has offered a number of state and federal tax incentives that lure US producers north instead ("Give Me [Tax] Shelter!" 1979), Mexico lost some of its appeal to studios. But the conditions of NAFTA helped to renew that appeal in allowing equipment and film stock to cross the border tariff free (Miller et al. 2005, 166). The same year NAFTA was signed, Paramount Pictures was already shooting *Clear and Present Danger* (Phillip Noyce) in Mexico; Focus (as USA films) filmed Soderbergh's *Traffic* there in 2000; and Twentieth Century Fox changed the setting from Italy to Mexico City in Tony Scott's 2004 remake of the 1987 *Man on Fire*, because the story focuses on kidnappings and would be more believable and timely in a Mexican setting (Davies 2010, 221). In 2006, Mel Gibson filmed his epic tale of the fall of the Mayan civilization, *Apocalypto*, in the jungles of Veracruz.

Reasons to shoot in Mexico may include the visual aspects of its locations, from colonial architecture to jungles, but the financial motivation is evidenced by the numerous in-studio shoots that have taken place not in Hollywood, but rather on nearby Mexican soil. Two years into NAFTA, Twentieth Century Fox began construction of Baja Studios for the production of James Cameron's US$200 million *Titanic* (1997), alongside a theme park dedicated to the film. Both enterprises were unsurprisingly located in Rosarito, just south of Tijuana, the United States' largest *maquiladora* zone outside of

Ciudad Juárez, and yet also a popular destination for US tourists from the Southwest region. Films produced subsequently in Baja Studios include *Tomorrow Never Dies* (Roger Spottiswoode, 1997), *Deep Blue Sea* (Renny Harlin, 1999), *Pearl Harbor* (Michael Bay, 2001), and *Master and Commander* (Peter Weir, 2003). In 2007, Fox sold the studios and closed the park in reaction to increased drug-cartel violence in the area; three years later, Calderón pledged US$20 million in tax rebates as an incentive for US production to return to Mexico (Marosi 2012).

In addition to free-trade arrangements, lower wages in Mexico for production technicians also attracts MPAA studios. While Falicov (2007, 270) cites various sources in summarizing that wages in Mexico are roughly one-fourth of those in Hollywood, these figures are generous; Miller et al., however, compare the wage of a union carpenter in Hollywood at roughly US$35/hour to a union carpenter in Mexico earning less than US$4/hour, and also compare the US$12/hour wage of construction workers on the San Luis Potosí set of *The Mexican* (Gore Verbinski, 2001) to Brad Pitt and Julia Roberts's US$40 million salaries (2005, 165). Filming overseas allows producers to avoid union regulations, such as adherence to safe work conditions and limits on hours worked per day, and complaints from extras and crew about exploitative practices have come from both location and studio shoots. United States and European audiovisual industries' unapologetic exploitation of production labor in developing nations is one segment of neoliberalism's broader labor-outsourcing trend across industries, including both overseas and domestic subcontracting as a way of large corporations to downsize by cutting full-time or long-term contractual positions. The New International Division of Cultural Labor (NICL) is a concept that recognizes the occurrence of this type of outsourcing in audiovisual media and throughout all creative industries (Miller et al. 2005, 7). Without employee status within media corporations or union representation, film laborers remain invisible and voiceless as contributors to cultural production. This is exacerbated if producers hire workers who do not speak the same language, for a short period of time, in a distant location: after a shoot, connections to the site and the workforce are easily dissolved and forgotten.

Many of the US blockbusters that edge national films out of screen time, aided by large budgets for publicity and film copies as well as the economic policies that created the current exhibition market, are the same films that save labor costs via *maquila* production. That is to say, neoliberal policy favors an MPAA film from start to finish. And while coproduction treaties promote cultural specificity as a defense against

globalization's threat of homogenization, in particular, against hege-monic Western values and lifestyles, they are not written to consider labor as something to be scrutinized for fair practices and equality in the same way that cultural representation is. Coproduction trea-ties classify audiovisual production as elite culture (the intellectual or artistic work of screenwriting, photography, acting, or directing), whereas technicians and laborers' contributions to the same cultural product are weighed as a single production unit. In essence, policy itself promotes a classist and Eurocentric definition of culture in its approach to protecting diversity. Miller et al. propose that cultural policy recognize labor as a cultural contribution and that representa-tives of audiovisual labor be able to participate in the negotiation of that policy: "a first step...would be to open up cultural-policy fora to bodies that represent culture-industry workers" as a way to "not only elevate the crucial issues of equitable working conditions, job stability and fair compensation, but bring a diversity of cultural affiliations to the exclusionary and taste-rigid bureaucratic boards that have domi-nated audiovisual decision-making" (2005, 210).

Apocalypto and *También la lluvia*: The Cost of Indigenous Labor

Gibson's *Apocalypto* illustrates an even more complex level of cultural exploitation that can develop when *maquila* productions justify loca-tion choices by fusing local history and heritage with a blockbuster's Western capitalist worldviews and mainstream audiovisual language. In the film, a Mayan village is pillaged by a group of warriors seek-ing to enslave and then sacrifice the villagers in a solar-eclipse ritual. A young leader from the village hides his wife and child in a deep pit before being taken captive; he is nearly killed atop a temple altar, but escapes his captors and rescues his family. The film ends as the fam-ily, just before entering the safety of the forest, sees Spanish galleons arrive on the shore. Gibson and his cowriter worked on the script with a respected scholar of Mayan history to imbue the story with cultural accuracy, but took liberties with the elaborate sets and costumes, mix-ing references to different eras of the Mayan civilization for dramatic effect. The violence of the Mayan leaders, a divisive point among many scholars who saw the film, is complemented with a depiction of the populous as naive spectators of this violence, and the civilization's highly developed knowledge of astronomy in the film is presented as nothing more than a tool for duping the masses into a submissive complacency and justifying sacrificial rituals.

The producers hired a large number of extras locally in Veracruz (Dittrich 2006), but gave lead and supporting roles to US and Canadian Native Americans, as well as to a few experienced US Latino and Mexican national actors. Dialogues were in Yucatec Maya, with extensive overdubbing in postproduction. The production was undoubtedly arduous for both set builders, creating replicas of classic-period Mayan pyramids, and for extras who participated in a large number of violent combat scenes involving grotesquely elaborate deaths with a number of props. Extras who worked on the film were paid US$430/ week for 12- to 15-hour days that required elaborate hair and makeup preparations: head shaving; fake piercings, scarring, and tattoos; prosthetic features; wounds and blood (Dittrich 2006).

This nearly 2.5-hour film consists principally of alternating chase and battle scenes: tribesmen hunting and disemboweling a wild tapir; a village being ravaged and burned, including rape of women and violent attacks on men; human sacrifice including organ removal; and the captors' very long pursuit of Jaguar Paw, which ends in a series of gruesome deaths. The final scene (referencing the film's title) frames all of this as a mild prelude to the devastation that would come with the Conquest. Whatever the intended moral of this ending, the filmmakers cite universality as more important than cultural specificity, and the fall of the Mayan civilization as a dispensable, or at least interchangeable, setting and historical context. Anna Roth, production manager and unit producer for *Apocalypto* (as well as at least five of the runaway productions mentioned previously) stated that the film "isn't a story about Mayan culture, not at all...It's an adventure about timeless values, a story of love, loyalty, vengeance, and pain—a story you could film in Mexico today or Paris in the eighteenth century"; Gibson is even less specific, calling it "a story about a man and his woman, his child, and his father, his community. He's put in an incredibly heightened, stressful situation...has to overcome tremendous obstacles" (cited in Dittrich 2006). One might conclude from these comments that the film's cultural and linguistic uniqueness is rather a vehicle for generic barbarism, exoticism, and the eroticism of muscular men in loincloths fighting with primitive weaponry, not to mention a pretext for reducing labor and location costs to allocate more of the budget toward special effects.

A collaboration between Spanish director Icíar Bollaín and Scottish screenwriter Paul Laverty, *También la lluvia* speaks of the exploitative tendencies of films such as *Apocalypto*, yet putting Spain at the center of (neo)colonial responsibility while also implicating the United States' extracinematic economic imperialism. Its multilayered story

self-consciously contemplates how the mechanisms of audiovisual production adhering to cultural protectionism and/or promoting historical memory can be at odds with that which the work seeks to protect or represent. In a setting referencing the true incidents of violent protests against water privatization in Bolivia, the film follows Mexican director Sebastián (García Bernal), Spanish producer Costa (Luis Tosar), and their cast and crew to Cochabamba, where they will shoot a film based on Christopher Columbus's diaries. The film runs a triangular analogy between the Spanish Empire's destruction of indigenous cultures during the Conquest, the neocolonial exploitation of natural resources in the developing world imposed by corporations such as Bechtel (United States) and Suez (France), and the exploitation of both labor and cultural exoticism in large-budget film productions shooting overseas, coming from both Europe and the United States.

García Bernal's stardom carries the film commercially and serves as the on-screen representation of Mexico in this coproduction. His character transmits the potential, and also the problematics, of the transnational filmmaker. Sebastián seems at first to ingenuously contemplate the scene of his own movie shoot, slow to absorb its irony and his own implication in the process. The story develops Sebastián's ethical crisis from naïveté to engagement, and Costa's transformation from racist indifference and economic motivation to compassion and heroic sacrifice. The dramatic tension builds on the financial stake that the two have in finishing the film, which is at risk because of the dangerous conditions of the riots and the filmmakers' own ethical imperatives to stop shooting the film.

An early scene reveals Sebastián and Costa's disagreement over the decision to film in Bolivia instead of the Caribbean to keep labor costs low (paying extras US$2/day)—and of course, because the real Conquest annihilated the Taíno people. The dialogues of Sebastián's film are in Castilian Spanish and Quechua, the latter standing in for Taíno as another indigenous language equally unintelligible to the film's primary audiences. The authenticity of landscape is also dubious, as Bolivian highlands replace Caribbean islands. The film presents a complex analysis of ideological colonization as a continuing process through audiovisual production and consumption, as well as of the contradictions of transnational political activism. A scene in which women clash with police over access to the water supply (one shot recalls Mexican photographer Pedro Valtierra's famous image from Chenalhó, Chiapas) is followed by another in which Quechua set-builders labor while the actors playing Bartolomé de las Casas and Antonio de Montesinos rehearse with the director. As Montesinos's

lines denounce the exploitation of indigenous labor to extract the
gold that adorns the Spanish churches, the Bolivian set builders con-
structing the fictitious church put down their hammers and listen.
The young actor playing Montesinos projects a voice of conscious-
ness raising that speaks out simultaneously against historical *and*
contemporary exploitation of natural resources (gold and water) and
human resources (slaves and set designers); yet ending his sermon in
the name of Christ reiterates that the Conquest was also cultural and
spiritual, an exploitation that Sebastián's film continues to perpetuate.
And yet, *También la lluvia*'s Brechtian method, seemingly intended
to absolve its producers of any political incorrectness of their own,
is far from unproblematic as a star vehicle and international copro-
duction seeking wide commercial audiences. Whereas Sebastián's film
uses the radical priests to separate Christian humanitarianism from
the Conquistadors' hypocritical violence and racism in the name of a
Catholic monarchy, Bollaín's film in some way imposes its own con-
servative ideologies. A nostalgic longing for a traditional family unit
softens Costa's cold, neoliberal heart, his paternal role allowing him to
identify across a divide of culture, class, and race. In the end *También
la lluvia* is a self-aware family melodrama, and Costa's sense of duty as
a European male who can rescue a young, injured Quechua girl from
her own society's violence is what saves the day and makes the film's
setting within a political and environmental catastrophe fade to the
background in the memories of spectators exiting the multiplex.

New Directions in Cultural Representation

Two Mexico–Spain coproductions funded more recently by Ibermedia
include *Cinco días sin Nora* (*Nora's Will*, Mariana Chenillo, 2008) and
Corazón del tiempo. Both of these films are accessible in genre con-
ventions (a dark comedy and a romance, respectively) and yet repre-
sent communities that are at once self-contained within their Mexican
locations but have an undeniable interaction with the national, as well
as with transnational networks of solidarity based on ethnic identi-
ties. *Cinco días sin Nora* depicts the Jewish community in Mexico
City, contrasting Mexico's default Catholic rituals around death with
the seemingly foreign rituals and language of Judaism. *Corazón del
tiempo*, as discussed in the introduction to this book, tells of the
romance between a young woman in an indigenous community in
Chiapas and a Zapatista insurgent. What is particularly interesting
about *Corazón del tiempo* is that despite having Ibermedia funding
as a coproduction with Spain, it was coproduced nationally with the

autonomous Zapatista community in which it was filmed, the Junta de Buen Gobierno "Hacia la Esperanza."[7] In its publicity, it self-describes as a coproduction between Hacia la Esperanza and the director's production company, Bataclán Cine. With or without Spanish funding, the film's transnational status exists in that the communities of Chiapas declared their rejection of the Mexican state and their desire to self-govern on the day NAFTA was signed. This coproduction is one that can be considered a success in that the community took an active role in the film, including representing themselves on-screen. It is in strong contrast to *Apocalypto*, and even to *Sin dejar huella*'s ironic but still commercial exploration of indigenous identity, which in the end gives little agency to Mayan actors beyond being suppliers of fake replicas of their own patrimony.

Representations of national identity are undoubtedly problematic, whether openly exploitative, historically reverent, or self-consciously ironic. Miller et al. lament,

> As legacies of nation-state formations under modernity, treaties measure cultural specificity by way of national borders, a demarcation that necessitates folding intra-national cultural diversity under an exclusionary sign of unity, failing to gauge supra-national cultural affiliations across borders…Such treaties institutionalise normative and static conceptions of national culture in the very process of international collaboration. (2005, 184)

With the knowledge that constructing cultural markers in front of the camera is often a gateway to tokenism and cliché, some funding sources and treaties are recognizing value in collaboration behind the camera, in postproduction, or in financial contributions. A trend following closely behind the rise of coproductions was a surge of funds from Europe and North America looking to support developing film industries throughout the world. Many of these funds are attached to major international film festivals or film institutions, such as Hubert Bals Fund developed through the International Film Festival Rotterdam. With an eye for films that can participate in their festivals once funded, most funds seek independent, auteur cinema, with more emphasis placed on artistic content and visual style than on conventional narrative. Like coproductions, these transnational fund productions offer a certain contrast to national cinemas, and nonetheless fall into their own repetitive paradigms. One example is a strong tendency toward vérité realism both as a continuation of European art-cinema movements (e.g., neorealism and Dogme 95)

and as a style that is inclusive of banal, quotidian, and idiosyncratic representation of human behavior and social contexts (Tierney 2013). The latter opposes the grandiose attempts at representing cultural specificity; filmmakers that have been a part of this countertrend in Mexico include Reygadas, Eimbcke, Escalante, and more recently Nicolás Pereda and Enrique Rivero. The success of these types of films is that universality and specificity are often interwoven in a way that is much less reductive than conventional storytelling language. However, the festivals' and funds' continued support for auteur cinema promotes its artistic uniqueness but the cultural elitism of privileging this work and the power dynamic inherent in "north–south" funding tend to remain unproblematized and are an emerging focus of transnational film scholarship.

Conclusion

Between Tragedy and Farce: Mexico and Its Cinema Relive History

As this book's manuscript was in its final stages, president-elect Enrique Peña Nieto and his new PRI administration were beginning their transition into government posts. Although this changing of state personnel every six years is common practice in Mexico, its effects on policy and on institutional continuity will very likely be more severe given that a new political party is taking office. But because a change of party has happened just once since the PRI first took power in 1929, one can only speculate. This final chapter will function as both conclusion and epilogue, seeking to insert some historical distance into the analysis of what was quite contemporary in the moment of research, while also bringing in Mexican cinema's most recent occurrences. Central to this merging of past and present is how the current political and economic conditions relate to the themes of censorship and violence explored in prior chapters.

What can one say about Mexican cinema in the twenty-first century, in the wake of a democratic transition that barely started, ephemeral electoral reform, a push toward transparency that came and went, and a plan for prosperity that has increased economic disparity? What can one say about the aesthetics of violence when the exiting administration's war on organized crime left more than 80 thousand dead and 300 thousand missing in the course of six years?[1] How can one talk about cinema in this context and what historical perspective can be taken when the present seems to move deeper on a daily basis into the once unthinkable? What is clear is that the urgency of current social issues combined with the recent possibility of regime change has created an increasingly embattled political sphere, fueled by the media and resulting in a heightened level of political content in cinema and

in everyday life. Since the 1990s, this focus on the political becomes even more pronounced every six years in the months prior to elections, when a film is able to invoke electoral participation as a right of citizenship and engage a level of nationalism that transcends distinctions of class and culture. Moving backward from the 2012 elections and looking at the roles of cinema and media at different moments reveals a crucial shift in the audiovisual market since the PRI left office.

Although Mexico's television networks are notorious for promoting their own political interests—especially national network Televisa's long history of favoring PRI candidates—the question of media's role in Mexican politics reached a new height during the 2012 electoral campaigns, thanks to two key incidents. The first was in May 2012, when students of the private Universidad Iberoamericana began to protest against Peña Nieto's visit to their campus. Students launched questions about the candidate's role in 2006, as governor of the State of Mexico, in ordering the federal police's repression of protesters in San Salvador Atenco, a conflict in which more than 25 women reported sexual assault by officers, hundreds of protestors were arrested and/or suffered police brutality, two were killed, and a number were sentenced to excessive prison sentences. From this incident sprang the student movement Yo Soy 132 (or #yosoy132), whose manifesto focused on freedom of speech and the democratization of the mass media with particular criticism directed at the main television networks' influence over campaign publicity. The next major incident involved the UK newspaper *The Guardian*, which reported "collusion" between Televisa and the PRI candidate based on documents that revealed both payments and strategy outlines for boosting Peña Nieto's profile while slandering PRD candidate López Obrador (Tuckman 2012). During this intense focus on the media within the media, cinema also took part in the game of persuading the masses.

Political Cinema: A New Market or Historical Fiction?

Like *Amores perros*, two politically critical films premiered a month prior to the 2012 elections, arousing curiosity as to what kind of buzz they might cause among voters. Kyzza Terrazas's *El lenguaje de los machetes* (*Machete Language*, 2011), an entirely independent film with a limited national release (13 copies) from distributor Interior 13, comments on the disillusionment, domestication, and dissolution of Mexico's militant left, embodied in the disintegrating relationship and convictions of a radical activist and his punk musician girlfriend. The script was written in response to the events of Atenco, reflecting

on the divisiveness of class and race relations among activists, and responding as well to the events of 9/11, contemplating the psychological state that leads to extremist acts. Set against the backdrop of different Federal District demonstrations, it concentrates on the tensions within the couple's insular world as they vacillate between a plan to start a family and one to suicide bomb the Basílica de Guadalupe, a landmark whose symbolic reference to Mexico's spiritual conquest parallels the World Trade Center's reference to global economic imperialism. Given the film's timing (released in several festivals in 2011 and early 2012) following the various Occupy movements and amid protests throughout Europe, it can be read as a somewhat cynical response to the impulses behind activism. While it reminds viewers of the events of Atenco, its ambivalent portrait of a radical activist from an upper-class family was prescient of the types of criticism used against Yo Soy 132, which started at a university with a primarily upper-class student body. Nonetheless, *El lenguaje de los machetes* is strongest in its performances, which convey emotionally the anger and frustration of a generation that witnessed the rise and fall of the possibility of social transformation.

Released a week after *El lenguaje de los machetes* but with 450 copies, Carlos Bolado's *Colosio: el asesinato* (*Colosio: The Assassination*, 2012) confronted Peña Nieto's political party directly with a fictionalized retelling of the Salinas administration's involvement in the assassination of 1994 PRI candidate Luis Donaldo Colosio. The script was based on extensive archival research into the case and the opening credits run over footage of the candidate being assassinated during a campaign rally in Tijuana, an image that many generations of Mexicans would recall seeing on television. The credits montage mixes the footage with actual newspaper clippings reporting other historical events from 1994, including the signing of NAFTA and Zapatista uprising and featuring photographs of key figures, such as Salinas. From there, the fictional story employs police-thriller genre conventions and the character of an intelligence specialist hired to investigate the case functions to guide the viewer through the various theories of whose criminal mind orchestrated the assassination plot. The narrative concludes with the protagonist walking through a restaging of the murder and clearly fingering all of the parties involved; it concludes that the murder was in fact ordered by high-level state officials within the Salinas administration, and several of the characters, while not explicit, reference the president, his chief advisor, his secretary of state, and his former brother-in-law José Francisco Ruiz Massieu, who was assassinated six months after Colosio. Before the final credits, text

graphics leave the viewers with facts surrounding the case and make a strong case for conspiracy and cover-up. The film's production values, casting, and narrative conventions all made it accessible and appealing to mainstream filmgoers, and hence a potential threat to the PRI's preelection approval ratings, and yet its use of fiction is successful at diluting its accusations and making it as much entertainment as denunciation. At the same time, this strategic fictionalization allowed the film a permanent disclaimer and a way to get around censorship, political opposition, and threats from a number of implicated groups and individuals. As of December 2012, *Colosio* had produced the biggest box-office draw that year from a national production, with over one million spectators.

Colosio was released two weeks before the Mel Gibson star-vehicle *Get the Gringo* (Adrian Grunberg, 2012) and five weeks before Oliver Stone's *Savages* (2012), both being glamorous, high-action, Hollywood versions of Mexico's lawlessness, putting US characters at risk at the hands of *narcos* and corrupt police. In *Get the Gringo*, federal police arrest Gibson's character after he crosses the border with a large sum of mob cash and send him to Mexican jail, where a young boy helps him navigate the various networks of villains. The film's glossy visual style emphasizes the grotesquely derelict conditions of the prison and its indistinguishable inmates and police officials. *Savages*, in contrast, glamorizes, stylizes, and sexualizes a story of conflict between California drug dealers and a Mexican cartel, the latter headed up by a sadistic Salma Hayek. Both *Savages* and *Get the Gringo*'s trailers ran before Bolado's film and offered desensitizing versions of the escalating levels of violence that could be attributed to the PAN administration's policies. When viewed within this context on a cineplex screen, *Colosio*'s takeaway message was contradictory: it presented a contrast to US blockbusters in its ability to offer a serious depiction of Mexico's political problems and yet it also fell into the trap of communicating these problems in an audiovisual language tailored to commercial consumption, diminishing its efforts at historical memory with the forgettable nature of mainstream cinema. Bolado's next film to be released, *Tlatelolco*, was scheduled to premiere on October 2 of the same year, but its release was delayed. Similar to *Colosio*, it presents controversial events of Mexico's recent history within a fictional story and accessible genre conventions, this time a tragic romance between a young leader of the 1968 student movement and the daughter of a wealthy government official complicit in the police repression of the movement.

The question that *Colosio* and *Tlatelolco* pose is whether the historical nature of their content gives them enough distance from the

present to be tolerated by the political powers that the films condemn, or if recent changes in the film market have broadened the spectrum of tolerance. If we consider a third case, Luis Estrada's macabre comedy *El infierno*, the second-biggest hit for a national film in 2010, the answer becomes more clear. Among a program of films intended to commemorate the centennial of the Mexican Revolution and bicentennial of its independence, *El infierno* deliberately refuses the distance that would separate the violence of these two historical events from that of the present day. The film is set in 2010 in a fictional town overrun with drug-cartel violence and the narrative leads up to that town's own bicentennial celebration. The film's tagline, used prominently in its marketing, reads, "México 2010: nada que celebrar" ("Mexico 2010: Nothing to Celebrate"). The content of *El infierno* is an uncomfortable tension between traditional Mexican comedy (via playful dialogue and known comedic actors) and the gruesomely graphic violence associated with drug cartels, including shootings, decapitations, dismemberment, torture, suffocation, and flesh-burning acid. The film makes no attempt to couch its criticism, of both the president's failure to curb drug violence and the state's excessive expenditure on patriotic celebrations at such a dire moment, in a historical framework. What we can see from these cases is that the tolerance for denunciatory films comes not from an analysis of their verisimilitude or relationship to the present, but from an analysis of their revenue potential.

The growth of the exhibition market since the mid-1990s and the investment in larger-budget films since 2006, within the context of political strife, has led to a commercialization of the political, particularly of controversy. The early examples of controversy being leveraged into both publicity and ticket sales explored in chapter 3, including Estrada's early entrance into the paradox of censorship, have set precedents for approaching potentially polemical films, and the continuation of this practice is seen most clearly in the case of documentary cinema's entrance into commercial exhibition. Looking broadly at the development of this trend over the past few decades, some key elements include (1) the privatization of the exhibition sector and subsequent growth multiplex chains; (2) a global upswing in the production of documentary films with political and social content, and in Mexico with new state support; and (3) the trend over the past decade of major exhibition chains to sponsor or host Mexico's film festivals, a type of niche marketing to art-house audiences while otherwise catering to Hollywood studio fare. The interaction between these elements can be seen clearly in multiplex chain Cinépolis's role in opening up a space within the theatrical market,

however limited, for feature documentaries. On the one hand, CEO Ramírez was one of the founders of the Morelia International Film Festival, which began in 2003 primarily as an outlet for nationally produced documentaries and short films. The multiplex chain is the festival's main venue and sponsor, and cites its support as evidence of its advocacy for political expression through cinema. Nonetheless, Cinépolis became the object of criticism when director Luis Mandoki and producer Federico Arreola accused the exhibitor of obstructing the release of the film *Fraude: México 2006*, a comprehensive exposé of electoral fraud during the 2006 presidential elections, including the role of Televisa in creating negative publicity campaigns. And yet, like *La ley de Herodes* and *El crimen del padre Amaro*, the controversy surrounding *Fraude* proved profitable. Despite the efforts to keep it out of theaters and thanks to the publicity brought by the filmmakers' denouncement of its censorship, *Fraude* eventually premiered with two hundred prints and more than three hundred thousand specta- tors attended screenings, allowing the film to recoup half of its cost in the first weekend (Tovar 2007; Salcedo Romero 2009, 26). A few years later, Ramírez took part personally in fund-raising for *Presunto culpable* (*Presumed Guilty*, 2008), a highly controversial documen- tary calling for legal reform in Mexico, which became Cinépolis's first venture into film distribution. Almost predictably, *Presunto culpable* generated its own media hubbub when a court ruled temporarily to pull it from theaters in 2011. In 2012, Cinépolis distributed Juan Carlos Rulfo's *¡De panzazo!*[2] a film critiquing Mexico's education sys- tem. Thus, political documentaries, once considered marginal within the commercial film industry, are becoming a sought commodity. The phenomenon can be understood as the successful implementa- tion of neoliberal economic policy and adaptation of US filmmaking and exhibition practices, although the test runs were done by film- makers genuinely under attack for the content of their films. This is not to say that censorship no longer exists, but rather that under the two PAN regimes, the financial aspects of cinema were weighed against its political threat with the consideration that the increased threat would equate to increased revenue.

The Changing Language of Violence

The notion of security drastically changed after Calderón took office and patterns of criminal activity also reconfigured the geography of the nation's violence. Even though drug trafficking had been going on for decades in Mexico, the state's war against the cartels and the

hierarchical restructuring of various crime networks increased the warfare in a number of states, but left Mexico City as one of the nation's few sanctuaries. Changes in filmic depictions of murder and other crimes followed these shifts in reality and in the media's coverage of that reality. As explored in chapter 4, the aesthetic trend as Mexican cinema moved into the new millennium was characterized by an increase in visual fragmentation, an emphasis on the photographic image, narratives driven by (failed) class ascension and by contingent destinies, and a thematic exploration of the relationship between institutional and quotidian violence, especially police corruption and urban crime. The paths taken from the millennial juncture veered in two opposite directions, and yet a handful of key films arrive, via different cinematic styles, at representations of violence with certain similarities. These similarities include a recognition that Mexico's contemporary spectator is largely desensitized to graphic images due to the drastic increase in violence—in daily life and in the media—throughout the last *sexenio*, and for that reason the explicitness of violent acts has greatly increased in cinema. Yet filmmakers working in different genres have still found ways to inquire into the nature of violence itself.

The more immediate countertrend to the boom in aestheticized violence was most visible in the work of internationally acclaimed auteurs Reygadas and Escalante, who used slow-paced realism, including long takes with minimal dramatic action, to depict situations of latent or repressed violence; here violence builds as potential rather than kinetic energy. Although all of Reygadas's four features include the death of a principal character, *Batalla en el cielo* and *Post Tenebras Lux* (2012) are most representative of this narrative style, building tension around subtle conflicts of social class and race, which results in a rupture of violence coming from the character representing the more oppressed group. *Batalla en el cielo* begins with the young, fair-skinned daughter of a general seducing the family's chauffeur and culminates in him stabbing her to death; *Post Tenebras Lux* tells the story of a wealthy architect and his family living in rural Mexico and its surreal climax shows a local worker committing suicide by decapitating himself with his bare hands after learning he has killed his boss. Escalante, assistant director to Reygadas for *Batalla en el cielo*, uses a similar pattern in his two features: in *Sangre*, a man's banal and humiliating life builds up to the accidental death of his drug-addict daughter, leading him to dispose of her body at the dump; *Los bastardos*, set in the United States, ends when a Mexican immigrant literally and visibly blows a woman's head off with a shotgun. Common

to all of these films is the impact of a single instance of devastating violence within a feature film's worth of seemingly unremarkable minutiae.

Colosio and *El infierno* are opposite in tone and style but both can be categorized as reflecting the Mexican spectator's increasing tolerance for carnage. *Colosio*'s central violent act is the assassination of the title character and the opening sequence includes the footage of gun being put to the candidate's head and fired. As the characters investigate the case, we see the footage repeated with blown-up, slowed-down, and reversed fragments. Throughout the film, other characters—both fictional and reality based—are shot in the head with varying degrees of in-frame visibility. While nowhere near the number of casualties as a Hollywood action film, *Colosio* operates within a melodramatic framework and these scenes, highlighted by the repetition of this particular type of execution and by the mixed assemblage of real and performed deaths, take on a tone of tragedy. The result, especially considering the time of the film's release, is a complex statement on the role of media and cinema in historical memory.

El infierno combines humor and violence, employing both political satire and physical comedy, but its violent images are more jarring and grisly than funny, inserting a solemn pause into the spectator's laughter. For example, in one of the final scenes, the protagonist, Benny, comes home to find his lover, the film's female lead and one of the few sympathetic characters, lying in bed with her head detached from her body and a note pinned to her. Tragedy and comedy intertwine in the tone of the film's climax as well, in a slow-motion sequence in which Benny opens fire on the inaugural ceremony of the bicentennial celebrations, killing everyone surrounding the podium in a rain of bullets. Costume and makeup make caricatures of the villains (drug lords and government officials) and a few brief gestures, such as the *capo*'s attempt to use his wife as a body shield, poke fun at a seemingly omnipotent character's cowardice. But this ridicule of macho culture is at odds with the simultaneous gunfire and bloodshed in this slow and detailed scene. *El infierno*'s novelty is the uncomfortable juxtaposition of comedy and violence, but the visibility of the violence creates a much more volatile mix than in earlier satires, such *Todo el poder* and the two earlier films in Estrada's trilogy.

A thread that joins *Los bastardos*, *El infierno*, and *Post Tenebras Lux* is arguably the most horrific trends in classifications of homicides to emerge in recent years: decapitation. *El infierno*'s decapitation scene is the most literal and the most clearly linked to *narco* violence, and is also the moment that pushes the character to the edge

of his rational tolerance of his situation, when he becomes delirious (figuratively losing his own head) and unleashes his vengeance on the cartel family. *Post Tenebras Lux*'s oneiric style presents everything in its narrative as a blurring of conscious and subconscious images. The decapitation is literal and extremely visible, but shocking and absurd as a self-inflicted act. Given the film's deliberate ambiguity toward waking reality, the literal and symbolic readings are indistinguishable. In some ways, it reflects a marker of Reygadas's auteurist obsessions, referencing one of the first sequences in *Japón*: the protagonist takes a bird from a young boy and decapitates it, and the sequence ends framing just the head, its beak moving as it struggles to breathe with no body. But if the scene in Reygadas's first film reflects its protagonist's callous cruelty before the innocent eyes of a child, his most recent film's self-decapitation might be read as a subconscious guilt for one's own subjugation, or for allowing the culture of violence to reach its current apex, hence the beheading is a penance that only perpetuates that which it seeks to curtail. The shocking climax of *Los bastardos*, while not a decapitation by typical methods, nonetheless recalls in its minimalist mise-en-scène numerous references to the factors that have fueled *narco* violence: young men hired as hit men when they have no socioeconomic alternatives, the indifference of US drug consumers, firearms provided by the United States, and NAFTA's negative impact on the Mexican economy (drawing more migrant workers to the United States). In this case, the decapitation is a tragic, if inevitable, accident resulting from these circumstances.

NAFTA and Other Challenges for the Future of a National Cinema

Given the concerns over security in Mexico, especially in the border regions, and the polemics around immigration and drug trade in Mexico, there is little chance that NAFTA will be redrawn to increase trade, loosen travel restrictions, or favor economic development in Mexico.[3] As the transition into the new administration takes place, some film-industry advocates are still negotiating legislation to protect national cinema. The likelihood that the new Mexican government will have the leverage to increase protectionist policy for its own cinema is minimal, although investment stimuli and tax incentives could be increased or reformed, and would be likely to pass if open to international corporations. Like all incoming administrations, the new PRI will assess their position on subsidizing the cultural industries, and the budget for CONACULTA will reflect that position.[4]

Over the course of the prior *sexenio*, the state awarded more than Mex$3.9 billion in funding to film production, which included 405 feature films and 137 short films (IMCINE 2012c, 3). Most of that funding came through the EFICINE tax credits, whose productions have generated Mex$1.8 million at the box office (IMCINE 2012a, 10). While this investment in funding is not yet self-sustaining in financial terms, IMCINE sees a larger concern that while production has increased, so has the dependence on state support (see chapter 1), and when compounded with the problems of distribution, the results have a negative impact on cinematic production itself with regard to the creative content and the talent:

> If one knows *a priori* that one cannot recoup an investment, there is no incentive to try to generate high box-office sales, and as a result no real connection to the audience. This has become a vicious cycle, due to the fact that whenever the State is the majority coproducer, almost all of the film's earnings will be returned to the fund and the producers and creative talent will not reap the benefits of the financial success of their films. (IMCINE 2012b, 18)

The film institute hopes that the new government will not only maintain the support for production already in place, but also create legislation to allow national films to compete fairly in the market.

Although distribution remains as the central concern, new media channels are beginning to open a space for alternative cinema with the potential for broader dissemination than theatrical exhibition can offer. Two sites recently launched in Mexico to showcase independent and national cinema include Nuflick and Cinema Open. International companies such as Netflix and Vudu (owned by Walmart) have also launched membership-based streaming sites, and Mexico's telecommunications company Tel-Cel has plans to launch one in 2013. For theatrical distribution, a few independent distributors, including Canana, Interior 13, and ND Mantarraya, continue to be the primary providers of international and domestic art-house and independent cinema. Proposals set forth to diversify exhibition and expand online distribution and new media include the need of a television channel and VOD platform, both dedicated exclusively to Mexican cinema; incentives for these mediums to exhibit national films; and legislation to govern online content to protect authorship rights (IMCINE 2012b, 37).

Another challenge that the new administration will face is how to preserve the strides made within the state film agency and its funding programs toward transparency and democratizing public access

to financial support. This threat of falling back into old practices was already a concern within the prior regime, based on the questionable decision of the director of CONACULTA since 2009, Consuelo Sáizar, to allocate funds to large-budget films without channeling them through IMCINE and without making them openly available to all applicants. In an open letter written by the Academia Mexicana de Artes y Ciencias Cinematográficas (AMACC) in February 2012 and directed to the SEP and to CONACULTA, the filmmaking community expressed its concerns:

> In recent years, the president of [CONACULTA] initiated a new concept known as CONACULTA CINE. Through this mechanism, logo, or brand, though not a public institution, there has been a recurrence of the bad habits and practices that the film community had thought eradicated, such as the wielding of influence, the use of public resources awarded without an open competition and based on personal judgment, without following the existing standards of state agencies and without offering appropriate explanations. ("Carta abierta" 2012)

According to the letter, *Colosio* received this special funding, as did Antonio Serrano's *Morelos* (2012), and the latter was criticized for having received at least Mex$65 million, more than the total yearly funds awarded by FOPROCINE. The AMACC's letter declares on behalf of Mexican filmmakers, "We do not want public monies to be awarded to friends. We do not want the return of the bad practices of the past" ("Carta abierta 2012").

Reflecting on the Past as a Path toward the Future

Among the most relevant and lucid reflections, in form and content, on audiovisual media's role in the political sphere is Alejandro Lubezki's documentary *El ingeniero* (*The Engineer*, 2012). Lubezki was given the task of recording on camera a year of the 2000 presidential campaign of Cuauhtémoc Cárdenas Solórzano, who ran as the PRD candidate in three consecutive campaigns (1988, 1994, and 2000). Being the main challenger to the PRI running against Salinas and Zedillo, Cárdenas is recognized as having been instrumental in opening up the potential for a change in political party, and yet lost the elections to the PAN when this change finally did take place in 2000. Lubezki's film selects moments from over four hundred hours of footage documenting the months leading up to this final loss—the flip side of celebrations around the fall of the PRI—from inside of the PRD campaign headquarters. Most notable is the film's editing, which incorporates

unusually long segments, such as meetings to select the best campaign ads and a nearly 25-minute sequence of a press conference involving a stalemate in determining the date and guidelines for televising the presidential debates. The filmmaker chose to reproduce "real time" in these segments to allow for minimal manipulation of key conflicts, between candidates and among the campaign organizers.[5] Aside from some revelations about Fox's hypocritical tendency toward truth bending while campaigning on transparency, *El ingeniero*, unlike *Fraude*, does not incite controversy. What comes across is the anticlimactic surprise that in 2000 there was no election fraud. And this is the moment when history changed.

In the film, campaign organizers continually analyze voter polls, which give a strong indication of a country in want of change. The fact that that change came in the form of a more conservative candidate is likely a matter of image, evidenced in the polls stating that Mexico's youth—its primary media consumers in the past two decades—were favoring Fox, whereas seniors were Cárdenas's primary supporters. To consult on publicity, the Cárdenas campaign hired Argos Comunicación CEO Epigmenio Ibarra. In offering advice, Ibarra makes continued reference to the boldness of the *telenovela Mirada de mujer*, Argos and director Serrano's television precursor to *Sexo, pudor y lágrimas*. But the PRD's traditionalists of the campaign were skeptical of the ability of television campaigning, as mediated populism, to transmit the candidate's sincerity to audiences, and they instead prioritized rallies in small remote towns over television ads or appearances. This fact comes across as Cárdenas's tragic flaw for the spectator who views these fragments shortly after having lived through the 2012 elections, in which the winning candidate was the incarnation of a Televisa production, accompanied by a *telenovela* actress as his first lady.

It is impossible to know what the return of the PRI holds for Mexico's future. The optimists insist that Mexico's path toward democracy has not ended, but is just beginning. Lubezki's film ends as Cárdenas accepts his last defeat amid continued applause from his campaign workers and supporters. His response, speaking to the task of political reform and social transformation, is an inspirational metaphor on the future of activism and scholarship around Mexico's cultural policies: "Esta lucha no ha de terminar, hay que seguirle" ("This fight doesn't have to end, we must keep it going").

Acronyms

	Spanish	English
AC	Acción Católica	Catholic Action
AECID	Agencia Española de Cooperación Internacional para el Desarrollo	Spanish Agency for International Development Cooperation
AMACC	Academia Mexicana de Artes y Ciencias Cinematográficas	Mexican Academy of Cinematic Arts and Sciences
BNC	Banco Nacional Cinematográfico	National Film Reserve
CACI	Conferencia de Autoridades Cinematográficas de Iberoamérica	Conference of Iberoamerican Film Authorities
CANACINE	Cámara Nacional de la Industria Cinematográfica	National Chamber for the Film Industry
CCC	Centro de Capacitación Cinematográfica	Center for Film Training
CIE	Corporación Interamericana de Entretenimiento	
CIESAS	Centro de Investigación y Estudios Superiores en Antropología Social	Center for Research and Advanced Study in Social Anthropology
COFEMER	Comisión Federal de Mejora Regulatoria	Federal Commission for Regulatory Improvement
CONACINE	Corporación Nacional Cinematográfica	National Film Corporation
CONACITE II	Corporación Nacional Cinematográfica de Trabajadores y Estado Dos	National Film Corporation of Workers and State II
CONACULTA	Consejo Nacional para la Cultura y las Artes	National Council for Culture and the Arts
COTSA	Compañía Operadora de Teatros S. A.	

	Spanish	English
CSS	Centro de Contraloría Social y Estudios de la Construcción Democrática	Center for Social Auditing and Studies of Democratic Construction
CUEC	Centro Universitario de Estudios Cinematográficos	University Center for Film Studies
EFICINE / EFICINE 226*	Estímulo Fiscal a Proyectos de Inversión en la Producción Cinematográfica Nacional	Fiscal Stimulus on Projects for Investment in National Film Production
EZLN	Ejército Zapatista de Liberación Nacional	Zapatista Army of National Liberation
FIDECINE	Fondo de Inversión y Estímulos al Cine	Film Investment and Stimulus Fund
FONCA	Fondo Nacional de Cultura y las Artes	National Fund for Culture and the Arts
FOPROCINE	Fondo para la Producción Cinematográfica de Calidad	Fund for Quality Film Production
ICAA	Instituto de la Cinematografía y de las Artes Audiovisuales	Film and Audiovisual Arts Institute
IFC		Independent Film Channel
IMCINE	Instituto Mexicano de Cinematografía	Mexican Film Institute
INAH	Instituto Nacional de Historia y Antropología	National Institute of History and Anthropology
INEGI	Instituto Nacional de Estadística y Geografía	National Statistics and Geography Institute
LFC	Ley Federal de Cinematografía	Federal Film Law
LMD	La Legión Mexicana de la Decencia	Mexican Legion of Decency
MPAA		Motion Picture Association of America
NAFTA		North American Free Trade Agreement
NICL		New International Division of Cultural Labor
OSC	Organizaciones de la Sociedad Civil	Organizations of Civil Society
PAN	Partido Acción Nacional	National Action Party
PEL-MEX	Películas Mexicanas	
PEL-NAL	Películas Nacionales	
PRD	Partido de la Revolución Democrática	Democratic Revolution Party

	Spanish	English
PRI	Partido Revolucionario Institucional	Institutional Revolutionary Party
RLFC	Reglamento de la Ley Federal de Cinematografía	Regulation of the Federal Film Law
RTC	(Dirección General de) Radio Televisión y Cinematografía	(Bureau of) Radio, Television and Film
SEGOB	Secretaría de Gobernación	Secretariat of Governance
SEP	Secretaría de Educación Pública	Secretariat of Public Education
TLCAN / TLC	Tratado de Libre Comercio de América del Norte	North American Free Trade Agreement
TVE	Televisión Española	Spanish Television
UNAM	Universidad Nacional Autónoma de México	National Autonomous University of Mexico
VOD		Video on Demand

*Because EFICINE is a fund created through the modification of Article 226 of the Ley del Impuesto sobre la Renta (Income Tax Law), it was referred to in its early years as Ley 226 or el 226, and now as either EFICINE or EFICINE 226.

Notes

Introduction *Una época fatal*: An Era of Fatality, Tragic Endings, and New Beginnings

1. Bartra (2002).
2. My translation; English translations throughout are my own unless otherwise noted.
3. Here *commercial* refers to all feature films circulating theatrically, not to categories of financing or artistic value.
4. In Spanish, Tratado de Libre Comercio de América del Norte (TLCAN, but more commonly "el TLC").
5. From the time of the original research to the time of publication, commercial DVD sales in Mexico declined significantly while Internet access rose. As of late 2012, industry analysts saw Video on Demand (VOD) as an emerging market and DVD as a near-defunct market, despite restricted growth of the former due to limited access to Internet and to credit cards.
6. For example, films already released on DVD were much easier to obtain and view, even at the film archives.
7. See MacLaird (2013).
8. Literal translation is "And Your Mother, Too," although it was released on the English-language market under the Spanish title.
9. Bartra notes that the sections of this essay were written chronologically between 1994 and 1999, with each section reflecting a certain development in his contemplation of the Chiapas uprising's influence on Mexican culture.
10. For an excellent account of documentaries made in response to the 1997 massacre in Acteal, see Rabasa (2010).

1 Industry and Policy: Privatizing a National Cinema

1. Caballero won the award for best achievement in art direction for his work on *El laberinto del fauno*.
2. CANACINE functioned as a public, nongovernment organization for several decades. Under Echeverría, it received support from the

state in the form of membership for the two national theater chains (Lay Arellano 2005, 47).

3. For example, *Babettes gæstebud* (*Babette's Feast*, Gabriel Axel, 1987); *Yin shi nan nu* (*Eat, Drink, Man, Woman*, Ang Lee, 1994); *Tampopo* (Juzo Itami, 1985); *Mùi du du xanh* (*The Scent of Green Papaya*, Tran Anh Hung, 1993); *The Cook, the Thief, His Wife, and Her Lover* (Peter Greenaway, 1989).

4. Current law allows IMCINE to participate as coproducer with up 80 percent of a film's total budget.

5. The third article of the *Transitorios* section of the 1992 LFC lays out the yearly decrease in screen quota.

6. IMCINE website, http://www.imcine.gob.mx, accessed June 2007.

7. According to its website, COFEMER is "a deconcentrated administrative agency, with technical and operational autonomy," functioning as part of SEGOB. Started in 2000, its mission is to "promote transparency in the development and application of regulations in such a way that they produce benefits beyond their costs and a maximum benefit for society." http://www.cofemer.gob.mx, accessed July 5, 2012.

8. Distributors in Mexico owned by Hollywood studios and part of major media conglomerates include Columbia TriStar Films (Sony), Buena Vista International (Walt Disney), Warner Mexico (Time Warner), Paramount (Viacom), and Universal Pictures International (GE/Vivendi). Videocine (under Televisa), Corazón Films (as of 2008), and Artecinema Gussi are Mexico's primary national distributors.

9. In February 2013, theater operator Cinemex bought Cinemark's Mexican 31 theaters, leaving just the former and Cinépolis as the country's primary exhibitors.

10. The Federal District passed legislation legalizing same-sex marriage in 2006. In December 2012, Mexico's Supreme Court ruled unanimously that any bans on same-sex marriage in individual states (such as Oaxaca) were unconstitutional.

11. The investigation was made by the Centro de Contraloría Social y Estudios de la Construcción Democrática (CSS) and the Centro de Investigación y Estudios Superiores en Antropología Social (CIESAS) on Organizaciones de la Sociedad Civil (OSC) with regard to "Instancias Públicas de Deliberación" in 2008.

2 Audiences and Target Markets: On Spectatorship and Citizenship

1. According to Forbes, Carlos Slim was ranked the "richest person in the world" from 2010 to 2012, and has been among the top three since 2006.

2. See Foster's (2002) assessment of the use of soap-operatic elements in constructing the film's reality, especially as compared to Serrano's theatrical production of the same story.

3. See Sergio de la Mora (2006) for a more in-depth discussion of the treatment of homosexuality in Mexican cinema.
4. The movie's double-entendre humor is reflected in the title, which can also be translated as *A Movie with Balls.*
5. Athié's film was eight years in the making and included coproducers from Germany, France, and Spain.
6. Original research on marketing was conducted in 2006, when Internet usage was limited to around 19 percent of Mexico's population. As of 2012, Internet usage had increased to include roughly 36 percent of the population.

3 Censorship and Sensationalism: "el neotremendismo autoritario"

1. The original quote from the 1986 English-language film is "Laughter kills fear, and without fear there can be no faith, because without fear of the Devil there is no more need of God."
2. See the sixteenth edition (Siglo Ventiuno Editores, 2002) of Jorge Carpizo's *El presidencialismo mexicano* for an analysis of Mexico's long tradition of concentrated executive power.
3. Article 21 of LFC, published in the *Diario Oficial de la Federación,* December 29, 1992.
4. For a discussion of the relationship between presidentialism and the Mexican press, see Mraz (2001).
5. In April 2002, Fox passed the Ley Federal de Transparencia y Acceso a la Información Gubermental (Federal Law for Transparency and Access to Government Information).
6. Metz concludes, paradoxically, that only those films that are entirely faithful to genre codes and do not attempt to insert truth into genre are capable of avoiding the pitfalls of plausibility. It is not genre, per se, that limits the Plausible, but convention and an interested conformity to convention in the development of cinematic content.

4 Hyperrealism and Violence: Fatal Aesthetics

1. Original Spanish: "*De la grandilocuencia a la grandeza del cine mexi-cano. A imagen y semejanza de sus títulos programáticos, grandilocuen-cia de humanísticas películas zoofílicas y zoosóficas que irrumpen, se abalanzan desde la primera imagen, embisten sin reposo, ladran y muerden, rompen antes de articular; rasgan violentamente sin el auxi-lio de ningún instrumento racional y desgarran al montarse para ayuntarse.*"
2. Note on translation: roughly "dark moods," but also refers to the black bile, or melancholia, of cardinal humors.
3. For an in-depth look at both the circularity of the narrative and the importance of urban landscape in *Lolo,* see Foster 2002.

4. This highly stylized version was filmed in Mexico in 1996, with Brigitte Broch as set decorator. Broch would go on to be one of Mexico's most respected art directors, working on *Sexo, pudor y lágrimas* (as art director) and *Amores perros* (as production designer).
5. Salles, public lecture, University of California, Berkeley, March 2005.
6. In Spanish, *grito*. Connotes political rebellion and uprising in Mexican history, including Mexico's declaration of a war of independence (El Grito de Dolores) and to the documentary *El grito*, detailing the government's violent oppression leading up to the 1968 student massacre in Mexico City, a film that was censored by the government when it was released.
7. Branigan cites Edward Bullough's theories on the psychology of spectatorship, published originally in *The British Journal of Psychology 5* (1912–13), and republished with renewed interest in 1977.
8. Both "(the animals) tear each other up while mounting each other to copulate" and "(the images) get torn up while being edited in order to get spliced back together."

5 Independence and Innovation: Indie Film and the Youth Market

1. King notes that this is not a completely new phenomenon. The US cinema of the 1970s distinguishes itself for the level of creative control and risk allowed to directors working within the major studios (2009, 4).
2. King (2005) cites David Rosen's *Off-Hollywood: The Making and Marketing of Independent Film* (1990), noting that the increase in investment capital during the Reagan years also fueled the industry, as well as the increase in audience as the "baby boom" generation became the principal media consumers.
3. The Independent Spirit Awards are quite strict about financial demarcations, and narrative, formal, and generic experimentation are disregarded if a film is thought to have been made with too many monetary resources (King 2005).
4. Podalsky (2008) divides recent Mexican cinema between *mainstream* and *alternative*, including both Altavista and Televisa in the former category, rejecting Altavista's self-branding. She points out that dividing films by their producers does not match up perfectly with corresponding ideological or political categories for the film's content (specifically the representations of youth culture).
5. "Niños Héroes" refers to several teenage soldiers who died defending Mexico City against invading US forces in 1847. According to the story, when all the others had been killed, the last boy threw himself from the top of Chapultepec Castle wrapped in the Mexican flag to keep it from being taken by the enemy.

6. In the 2009 Berlinale, Hernández won the award a second time with the film *Rabioso sol, rabioso cielo* (*Raging Sun, Raging Sky*).
7. From director's comments in DVD bonus material.

6 Coproduction and Transnationalism: National Cinema in a Global Market

1. Television interview with Jorge Ramos, Univision, July 2008, online access.
2. Agencia Española de Cooperación Internacional para el Desarrollo (Spanish Agency for International Development Cooperation, AECID) is part of Spain's Ministry of Foreign Affairs.
3. Article III, *Convenio de Integración Cinematográfica Iberoamericana* (Iberoamerican Film Integration Agreement), signed in Venezuela, 1989.
4. Bolado, originally from Mexico City, has worked extensively as an editor in its film industry, including on *Como agua para chocolate* (1992). He resided in Northern California for more than ten years before returning to Mexico to direct two of the industry's largest budget films in recent history, *Colosio: el asesinato* (2012) and *Tlatelolco* (2012).
5. For a discussion of Mendieta's *Glass on Body* or *Siluetas* series, see Jane Blocker (1999).
6. At the same festival, Damián points out the costumed "*moros*" on horseback, reminding us that the religious conquest of Mexico and the syncretic practices that arose are themselves the result of complex reinterpretations of historical accounts of Spain's own *Reconquista*.
7. *Hacia la Esperanza* (Toward Hope) is the name of this particular *Junta de Buen Gobierno* (Council of Good Government), which is the term for the regional assemblies of representatives from different autonomous municipalities overseen by the EZLN.

Conclusion Between Tragedy and Farce: Mexico and Its Cinema Relive History

1. As president Calderón was leaving office, a debate spurred about the final body count resulting from the administration's war on organized crime. The government made the "institutional decision" to stop tallying (López 2012). Some news sources reported 88,361 homicides (Díaz 2012), whereas the Instituto Nacional de Estadística y Geografía (INEGI) reported more than 95 thousand during Calderón's *sexenio* (Zúñiga 2012).
2. The title refers to a colloquial expression for just barely passing, meeting minimum requirements due in part to pure luck.
3. Past proposals, both by Fox and by Robert Pastor (a policy advisor to presidents Clinton and Obama), suggested expanding NAFTA to the point of creating a North American Community, similar to the

European Community. Pastor's proposal included an investment on the part of the United States to develop better shipping infrastructure in Mexico as well as more fluidity across the US–Canada and US–Mexico borders, shifting the border security to the continental perimeter (see Pastor 2008).

4. At the time of publication, the PRI reappointed Tovar y de Teresa as head of CONACULTA. He had left the position in 2000 when the PAN administration took over.

5. Alejandro Lubezki's comments following a public screening of *El ingeniero*, Mexico City, November 2012.

Bibliography

Aguayo, Sergio. 2000. "The 'External Factor.'" *Journal of Democracy* 11.4: 33–36.

Altamirano, Ana Lucía. 2012. "Rebasa la demanda a la ley 226 de apoyo a cintas mexicanas." *Milenio*, January 23.

Alvaray, Luisela. 2011. "Are We Global Yet? New Challenges to Defining Latin American Cinema." *Studies in Hispanic Cinemas* 8.1: 69–86.

Amara, Luigi. 2006. "El irresistible espectáculo de los hierros retorcidos [¿Cuál es el misterio de estar en el "lugar de los hechos" y la fascinación por contemplar una catástrofe?]." *Revista Etiqueta negra* 40 (September): 52–57.

Aviña, Rafael. 2004. *Una mirada insólita: Temas y géneros del cine mexicano.* Mexico City: Editorial Oceano.

Ayala Blanco, Jorge. 1989. "Retes y las excrecencias del rencor social." *El financiero*, October 25, sec. Cultura: 76.

———. 2001. *La fugacidad del cine mexicano.* Mexico City: Editorial Oceano.

———. 2004. *La grandeza del cine mexicano.* Mexico City: Editorial Oceano.

———. 2006. *La herética del cine mexicano.* Mexico City: Editorial Oceano.

Badillo, Juan Manuel. 2001. "Censuran a *Y tu mamá también.*" *El economista*, May 30, sec. La plaza.

———. 2011. "'¿Que el cine mexicano es malo: según quién?': Marina Stavenhagen." Correcamamaar.com.mx (online). Accessed November 14, 2012.

Baer, Hester, and Ryan Long. 2004. "Transnational Cinema and the Mexican State in Alfonso Cuarón's *Y tú mamá también.*" *South Central Review* 23.1: 150–68.

Barriga Chávez, Ezequiel. 1989. "Desde la butaca: Ciudad al desnudo." *El excelsior* October 20, sec. Cultural.

Bartra, Roger. 1998. "Sangre y tinta del kitsch tropical." *Fractal* 3.8: 13–46.

———. 2002. *Blood, Ink, and Culture: Miseries and Splendors of the Post-Mexican Condition,* trans. Mark Alan Healy. Durham, NC: Duke University Press.

Bentes, Ivana. 2002. "O Copyright da miséria e os discursos da exclusão." *Lugar Comum: Estudos de mídia, cultura e democracia*, 15–16: 85–95.

Blocker, Jane. 1999. *Where Is Ana Mendieta?: Identity, Performativity, and Exile*. Durham, NC: Duke University Press.

Bonfil, Carlos. 1999a. "Sexo, pudor y lágrimas." *La jornada*, June 20, sec. Cultura: 27.

———. 1999b. "La ley de Herodes." *La jornada*, December 5, sec. Cultura: 28.

———. 2000. "Amores perros." *La jornada*, June 25, sec. Cultura: 4.

———. 2006. "Cansada de besar sapos." *La jornada*, December 24, sec. Espectáculos: 9.

Branigan, Edward. 1984. *Point of View in the Cinema: A Theory of Narration and Subjectivity in Classical Film*. Berlin; New York; and Amsterdam: Mounton Publishers.

Butler, Judith. 1997. *The Psychic Life of Power: Theories in Subjection*. Stanford, CA: Stanford University Press.

Carreño, Dalila. 2007. "Suena Del Castillo para dirigir Imcine." *Reforma*, January 11.

"Carta abierta de la AMACC a la SEP y al Conaculta." 2012. Published online in *Cine Toma* blog, http://revistatoma.wordpress.com/, February 3.

Casas, Armando. 2005. "Bertha Novarro: 'La sobrevivencia de nuestro cine está en juego.'" In *Producción cinematográfica*, vol. 3. Cuadernos de Estudios Cinematográficos. Mexico City: Universidad Nacional Autónoma de México.

———. 2006. "El cine mexicano y la excepción cultural: apuntes." *Estudios cinematográficos* 29 (February–April): 74–78.

"'Cilantro y perejil': Un filme mexicano exitoso." 1997. *El sol de México*. sec. Escenario: 2. October 6.

Comisión Federal de Mejora Regulatoria [COFEMER]. 2011. "Efectos de la regulación en la industria cinematográfica en México: un análisis retrospectivo." (Documentos de Investigación en Regulación No. 2011–09). October.

"Conquista la cinta mexicana Amores perros a la prensa extranjera en Cuba." 2000. *La jornada*, December 14.

"'Corazón del tiempo' retrata la verdadera realidad del zapatismo." 2008. *Gara*, September 27.

Coria, José Felipe. 1989. "Retes y las víceras urbanas." *Uno más uno*, October 21.

Creel Miranda, Santiago. 2002. "Acuerdo mediante el cual se expiden los criterios para la clasificación de películas cinematográficas." *Diario Oficial de la Federación*. Mexico City: SEGOB.

Davies, Paul. 2010. "'Be Not Overcome by Evil but Overcome Evil with Good': The Theology of Evil in *Man on Fire*." In *Producing and Promoting Evil*, ed. N. Billias, 211–226. Amsterdam: Rodopi Publishers.

De la Mora, Sergio. 2006. *Cinemachismo: Masculinities and Sexuality in Mexican Film*. Austin, TX: University of Texas Press.

De la Vega Membrillo, Camilo. 2011. "Falacias del cine mexicano: entrevista con Jorge Ayala Blanco." *La otra gaceta* (http://www.laotrarevista.com /tag/gaceta46/). 46 (January).

Deleuze, Gilles. 1989. *Cinema 2: The Time-Image*, trans. Hugh Tomlinson and Robert Galeta. Minneapolis, MN: University of Minnesota Press.

Díaz, Gloria Leticia. 2012. "Primer corte preelectoral: 88 mil 361 muertos en el sexenio." *Proceso*, June 2.

Díaz Rodríguez, Verónica. 2000. "Simetrías de la violencia: Amores perros de Alejandro González Iñárritu al Festival de Cannes." *El financiero*, April 28.

Dittrich, Luke. 2006. "Who the Hell Is Luke Dittrich and Why Is He Snooping around the *Apocalypto* Set?" *Esquire*, April 30.

"Divide Amaro." 2002. *El universal*, August 13, sec. Espectáculos.

Dorland, Michael. 1996. "Policy Rhetorics of an Imaginary Cinema: The Discursive Economy of the Emergence of the Australian and Canadian Feature Film." In *Film Policy*, ed. Albert Moran, 111–124. New York and London: Routledge.

Dreyfus, Hubert L., and Paul Rabinow. 1983. *Beyond Structuralism and Hermeneutics*. Chicago: University of Chicago Press.

Estrada, Luis. 2000. "¿Por qué no quieren que la veas?" *Reforma*, February 18, sec. Gente: 17.

Falicov, Tamara. 2007. "Programa Ibermedia: Co-Production and the Cultural Politics of Constructing an Ibero-American Audiovisual Space." *Spectator* 27.2 (Fall): 21–30.

———. 2008. "Latin America: How Mexico and Argentina Cope and Cooperate with the Behemoth of the North." In *The Contemporary Hollywood Film Industry*, ed. Paul McDonald and Janet Wasko. Malden, MA: Wiley-Blackwell, 264–76.

Fernández Almendras, Alejandro. 2005. "Entrevista al cineasta mexicano Fernando Eimbcke." *Mabuse: Revista de cine*, August 4.

Fernández, José Antonio. 2001. "Entrevista con Gerardo Tort: ¿Cómo y por qué filmó De la calle?" *Revista Canal 100*, 5 (February). Retrieved from http://www.canal100.com.mx.

"Filman los dramas 'De la calle.'" 2000. *Reforma*, June 30, sec. Gente.

Foster, David William. 2002. *Mexico City in Contemporary Mexican Cinema*. Austin, TX: University of Texas Press.

Foucault, Michel. 1990. *The History of Sexuality, Volume I: An Introduction*, trans. Robert Hurley. New York: Vintage Books.

Franco Reyes, Salvador. 2001. "Demandará a RTC y Gobernación." *El universal*, June 10, sec. Espectáculos.

Freire, Paulo. 1997. *Pedagogia da Autonomia: Saberes necessários à prática educativa*. São Paulo: Paz e Terra.

Galicia Miguel, Renato. 2000. "Reflexiones para el debate sobre la censura." *El financiero*, February 15, sec. Cultura: 56–57.

Galindo, Alejandro. 2007a. "Cine y moralidad." *Históricas: Boletín del Instituto de Investigaciones Históricas*, UNAM 78, 20–23.

Galindo, Alejandro. 2007b. "La censura cinematográfica pone en evidencia a México." *Históricas: Boletín del Instituto de Investigaciones Históricas*, UNAM 78, 24–26.

———. 2007c. "Cine y censura." *Históricas: Boletín del Instituto de Investigaciones Históricas*, UNAM 79, 19–25.

García Canclini, Néstor. 1995. *Hybrid Cultures: Strategies for Entering and Leaving Modernity*, trans. Christopher L. Chiappari and Silvia L. López. Minneapolis, MN: University of Minnesota Press.

———. 1997. "Will There be a Latin American Cinema in the Year 2000? Visual Culture in a Postnational Era." *Framing Latin American Cinema: Contemporary Critical Perspectives*. Minneapolis, MN: University of Minnesota Press.

García, Carla. 2002. "¡A seguir picando piedra!—Tort." *Reforma*, March 28, sec. Gente.

García Tsao, Leonardo. 2000. "El amor en tiempos de rabia." *La jornada*, June 23, sec. Espectáculos: 16.

———. 2004. "Chi Ride Ultimo? I Generi nel Cinema Messicano Odierno." *Oltre la Frontiera: Il Cinema Messicano Contemporaneo*. Bologna: Revolver s.r.l.

"Give Me (Tax) Shelter!" (from television program *The Fifth Estate*). The CBC Digital Archives Website. Canadian Broadcasting Corporation. (http://archives.cbc.ca/)

Gómez García, Rodrigo. 2005. "La industria cinematográfica mexicana, 1992–2003: estructura, desarrollo, políticas y tendencias." *Estudios sobre las culturas contemporáneas* (Universidad de Colima) 11.22: 249–73.

Granados Chapa, Miguel Ángel. 2002. "El crimen del secretario Creel." *Reforma*, August 12, sec. Plaza Pública.

Higbee, Will, and Song Hwee Lim. 2010. "Concepts of Transnational Cinema: Towards a Critical Transnationalism in Film Studies." *Transnational Cinemas* 1.1 (January): 7–21.

Hind, Emily. 2004. "Post-NAFTA Mexican Cinema, 1998–2002." *Studies in Latin American Popular Culture* 23: 96–111.

Hoefert de Turégano, Teresa. 2004. "The International Politics of Cinematic Coproduction: Spanish Policy in Latin America." *Film and History* 34.2: 15–24.

Instituto Mexicano de Cinematografía [IMCINE]. 2009. "Reconocimiento al FIDECINE como una de las entidades públicas con más alta efectividad en la inclusión y participación de la sociedad civil" (press release). Mexico City.

———. 2011. *Anuario estadístico de cine mexicano / Statistical Yearbook of Mexican Cinema*. Mexico City.

———. 2012a. "Análisis y diagnóstico del EFICINE" (report). Mexico City: December.

———. 2012b. "Diagnóstico y propuestas" (report). Mexico City: December.

———. 2012c. "Informe de actividades sexenales 2007–2012" (report). Mexico City: December.

Israde, Yanireth. 1999. "La cinta La ley de Herodes será retirada de carteleras esta semana." *La jornada*, December 6, sec. Cultura.

Joseph, Gilbert, Anne Rubenstein, and Eric Zolov. 2001. *Fragments of a Golden Age: The Politics of Culture in Mexico since 1940*. Durham, NC, and London: Duke University Press.

Joskowicz, Alfredo. 2009. "La distribución y la exhibición de cine en los últimos 15 años: u problema multifactorial." *Cine-Toma: revista mexicana de cine* 4 (May–June): 17–19.

Joyner, Alfredo. 2006. "Las noticias de la tragedia." *El universal*, October 1, C5.

King, Geoff. 2004. "Weighing Up the Qualities of Independence: 21 Grams in Focus." *Film Studies* 5 (Winter): 80–91.

———. 2005. *American Independent Cinema*. Bloomington, IN: Indiana University Press.

———. 2009. *Indiewood, USA: Where Hollywood Meets Independent Cinema*. London: I. B. Tauris.

Kraniauskas, John. 2006. "Amores perros y la mercantilización del arte (bienes, tumba, trabajo)." *Revista de crítica cultural*, 33 (June): 12–19.

Lara, Gerardo. 2005. "Producción y quehacer cinematográfico." *Producción cinematográfica*, vol. 3. Cuadernos de Estudios Cinematográficos. Mexico City: Universidad Nacional Autónoma de México.

Lay Arellano, Tonatiuh. 2005. *Análisis del proceso de la iniciativa de ley de la industria cinematográfica*. Guadalajara, Mexico: University of Guadalajara.

———. 2009. "La Ley Federal de Cinematografía. Un recuento a diez años de su publicación." *CineForever* (www.cineforever.com), August 22.

Lazcano, Hugo. 1999. "La ley de Herodes libra la censura." *Reforma*, December 10, sec. Gente: 2.

Lomnitz, Claudio. 2003. "The Depreciation of Life during Mexico City's Transition into 'the Crisis.'" In *Wounded Cities: Destruction and Reconstruction in a Globalized World*, ed. Jane Schneider and Ida Susser. Oxford, UK, and New York: Berg, 47–69.

López, Ana M. 1994. "A Cinema for the Continent." In *The Mexican Cinema Project*, ed. Chon A. Noriega and Steven Ricci. Los Angeles: University of California, 7–12.

López, Lorena. 2012. "El gobierno federal dejó de contar muertos para no prejuzgar a víctimas." *Milenio*, November 15.

Macauly, Scott. 2008. "Canana Means Business." Retrieved from Focus Features website (http://focusfeatures.com), May 21.

Maciel, David R. 1997. "Serpientes y Escaleras: The Contemporary Cinema of Mexico, 1976–1994." In *New Latin American Cinema*, ed. Michael T. Martin, vol. 2. Detroit: Wayne State University Press, 94–119.

MacLaird, Misha. 2010. "Y tu mamá también." *Cinema Tropical Presents: The Ten Best Latin American Films of the Decade*. New York: Jorge Pinto Books.

———. 2013. "Documentaries and celebrities, democracy and impunity: Thawing the revolution in twenty-first-century Mexico," *Social Identities: Journal for the Study of Race, Nation and Culture*. doi: 10.1080/13504630.2013.774131.

Marosi, Richard. 2012. "Baja Wants the Movie Spotlight Again." *Los Angeles Times* January 3.

"Más sobre la censura en México." 2007. Agencia Periodística de Información Alternativa (APIA Virtual).

McIntosh, David. 2008. "Waiting for Hollywood: Canada's Maquila Film Industry." *Canadian Dimension* (online magazine), October 29.

Mendoza, Carlos. 2009. "El cine de nunca jamás: cuando el gremio permitió que se desmantelara su industria." *Cine-Toma: Revista mexicana de cine* 4 (May–June): 24–26.

Metz, Christian. 1974. *Film Language: A Semiotics of the Cinema*, trans. Michael Taylor. New York: Oxford University Press.

"Mexico's Government Proposes Arts Funding Cuts; Some Fear U.S. Cultural Invasion." 2003. *Associated Press*, November 14.

Meyer, Lorenzo. 1995. *Liberalismo autoritario: Las contradicciones del sistema político mexicano*, Con una cierta mirada, ed. Rogelio Carvajal Dávila. Mexico City: Editorial Océano.

Miller, Toby. 2007. *Cultural Citizenship: Cosmopolitanism, Consumerism, and Television in a Neoliberal Age*. Philadelphia, PA: Temple University Press.

Miller, Toby, and George Yudice. 2002. *Cultural Policy*. London: Sage Publications.

Miller, Toby, Nitin Govil, John McMurria, Ting Wang, and Richard Maxwell. 2005. *Global Hollywood 2*. London: British Film Institute.

Monsiváis, Carlos. 2002. "De cómo el laicismo no ha cambiado de domicilio (El triunfo del Padre Amaro)." *Proceso*, August 18, 22.

———. 2006. "Y tu filmografía también (Política cultural y saberes fílmicos)." *Nexos*, September. Retrieved from http://www.nexos.com.mx/.

Montaño Garfias, Ericka. 2003. "Distribuidores de EU amenazan a Fox por el cobro de un peso en taquilla." *La jornada*, February 20.

Montiel Pagés, Gustavo. 2010. "Cinematic Production in Mexico under the Sign of Crisis." In *The Film Edge: Contemporary Filmmaking in Latin America*, ed. Eduardo A. Russo. Buenos Aires: Teseo, 47–64.

Mraz, John. 2001. "Today, Tomorrow, and Always: The Golden Age of Illustrated Magazines in Mexico, 1937–1960." In *Fragments of a Golden Age: The Politics of Culture in Mexico since 1940*, ed. Gilbert Joseph, Anne Rubenstein, and Eric Zolov. Durham, NC, and London: Duke University Press, 116–157.

Musi, Alejandra. 2005. "Las batallas de Reygadas." *Vuelo*, August, 34–38.

"Niega SEP piratear al 'Fauno.'" 2006. *Reforma*, December 5.

Noble, Andrea. 2005. *Mexican National Cinema*. London: Routledge.

O'Boyle, Michael. 2005. "Mexico: Horror Scares Up Impressive Returns." *Variety*, October 30, sec. Territory Report.

———. 2007. "Paramount Sets Up Shop in Mexico." *Variety*, March 26.

Olivares, Juan José. 2007. "La juventud debe ser crítica para que las cosas cambien: Gael y Diego." *La jornada*, August 12.

Olvera González, Silvia. 2010. "Gastón Pavlovich, un estudiante sonorense." *El sol de San Luis*, February 20.

Pastor, Robert A. 2008. "The Future of North America: Replacing a Bad Neighbor Policy." *Foreign Affairs*, July–August, 84–98.

Peguero, Raquel. 2009. "El IETU 'apaga' al cine mexicano." *CNNexpansion. com*. January 5.

Peredo Castro, Francisco. 2004. *Cine y propaganda para Latinoamérica: México y Estados Unidos en la encrucijada de los años cuarenta*. Mexico City: Universidad Nacional Autónoma de México.

Perez Torrent, Tomás. 1995. "The Studio." In *Mexican Cinema*, ed. Paulo Antonio Paranagua, trans. Ana M. López. London: British Film Institute, 133–145.

Podalsky, Laura. 2004. "De la pantalla: jóvenes y el cine mexicano contemporáneo." *El ojo que piensa: Revista virtual de cine iberoamericano* 6.

———. 2008. "The Young, the Damned, and the Restless: Youth in Contemporary Mexican Cinema." *Framework* 49.1:144–60.

Preston, Julia. 1999. "Standing Up to Censors, Mexican Film Finds Its Voice." *New York Times*, December 16.

Rabasa, José. "On Documentary and Testimony: The Revisionists' History, the Politics of Truth, and the Remembrance of the Massacre at Acteal, Chiapas." In *Without History: Subaltern Studies, the Zapatista Insurgency, and the Specter of History*. Pittsburgh, PA: University of Pittsburgh Press, 2010.

Rea, Daniela, and Juan Veledíaz. 2006. "El hombre que captura tragedias [retrato de un fotógrafo en negativo]." *Revista Etiqueta negra* 39 (August): 12.

Saavedra Luna, Isis. 2007a. *Entre la ficción y la realidad: Fin de la industria cinematográfica mexicana 1989–1994*. Mexico City: UAM-Xochimilco.

———. 2007b. "El fin de la industria cinematográfica mexicana, 1989–1994." *Estudios Interdisciplinarios de América Latina y el Caribe* (http://www1.tau.ac.il/eial/). 17.2 (July–December).

Salcedo Romero, Gerardo. 2009. "Luz y paradojas: una mirada al documental contemporáneo mexicano." *Cine-Toma: Revista mexicana de cine* / (November–December): 24–27.

Sánchez, Francisco. 2002. *Luz en la oscuridad: Crónica del cine mexicano*. Mexico: Cineteca Nacional.

Sánchez Ruiz, Enrique E. 1998. "Cine y globalización en México: el desplome de una industria cultural." *Comunicación y Sociedad*. (DECS, Universidad de Guadalajara), 33, 47–91.

Searle, Adrian. 2003. "Crime Scene Investigator." *The Guardian*, July 22.

Slocum, J. David. 2005. "Cinema and the Civilizing Process: Rethinking Violence in the World War II Combat Film." *Cinema Journal* 44.3: 35–63.

Smith, Paul Julian. 2003a. *Amores Perros*. BFI Modern Classics. London: British Film Institute.

———. 2003b. "Transatlantic Traffic in Recent Mexican Films." *Journal of Latin American Cultural Studies* 12.3: 389–400.

Solórzano, Fernanda. 1999. "Sexo, pudor y lágrimas, de Antonio Serrano." *Uno más uno*, June 19, sec. Sábado: 13.

———. 2007. "El lugar del espectador ¿Para quién es el cine mexicano reciente?" *Letras libres*, Abril, 62–66.

Sorvino, Mira. 1997. "Creepy-Crawly Cracker: Interview with Filmmaker Guillermo Del Toro." *Interview*, August 1.

Tierney, Dolores. 2007. *Emilio Fernández: Pictures in the Margins*. Manchester, UK, and New York: Manchester University Press.

———. 2009. "Director without Borders: Alejandro González Iñárritu" *New Cinemas: Journal of Contemporary Film* 7.2:101–17.

———. 2014 (forthcoming). *Contemporary Latin American Cinema: New Transnationalisms*. Edinburgh, UK: Edinburgh University Press.

Tovar, Luis. 2000a. "Las artes sin musa: O te chingas o te jodes." *La Jornada*, January 2, sec. Revista Semanal: 12.

———. 2000b. "Cinexcusas: los Cannes y los perros." *La Jornada*, June 25, sec. Revista Semanal: 11.

Tovar, L. (2007). '¿Por qué no quiere que se vea?' *La jornada*. December 2, sec. Revista Semanal. Retrieved from http://www.jornada.unam.mx.

Tovar y de Teresa, Rafael. 1994. *Modernización y política cultural*. México, D. F.: Fondo de Cultura Económica.

Tuckman, Jo. 2012. "Computer Files Link TV Dirty Tricks to Favourite for Mexico Presidency." *The Guardian*, June 7.

Ugalde, Víctor. 2000. "El TLC: la otra conquista." In *Industrias culturales y TLC: Impactos y retos de la apertura*, ed. Javier Esteinou Madrid, Víctor Osorio, and Enrique E. Sánchez. Mexico City: Fronteras Comunes, RMALC, and SOGEM, 85–105.

———. 2003. "Censura Cinematográfica: La Punta Del Iceberg." *Revista Palabras malditas* (www.palabrasmalditas.net) December.

———. 2007. "El cine despreciado." *Etcétera*, March, 44–47.

———. 2009. "¿Fiesta o responso? Tres lustros de la implementación del TLCAN." *Cine-Toma: Revista mexicana de cine* 4 (May–June): 20–23.

Vargas, Juan Carlos. 2005. "Agonía postindustrial: 1990–2005." *Proceso*, September (Special Edition 17): 16–18.

Young, James. 2009. "Mexican Market Grows, Ups Output" *Variety*. March 12.

Yudice, George. 1998. "The Globalization of Culture and the New Civil Society." In *Cultures of Politics/Politics of Cultures: Re-visioning Latin*

American Social Movements, ed. Sonia Álvarez, Evelina Dagnino, and Arturo Escobar. Boulder, CO: Westview Press Inc., 353–79.

Zermeño Padilla, Guillermo. 1997. "Cine, censura y moralidad en México. En torno al nacionalismo cultural católico, 1929–1960." *Historia y grafía* (Departamento de Historia, Universidad Iberoamericana) 8 (June): 77–102.

Zúñiga, Juan Antonio. 2012. "En 2011 se perpetraron 27 mil 199 homicidios en México: Inegi." *La jornada*, August 21.

Index